# THE BOYDELL SHAKESPEARE PRINTS

# THE BOYDELL SHAKESPEARE PRINTS

ARNO PRESS / NEW YORK / 1979

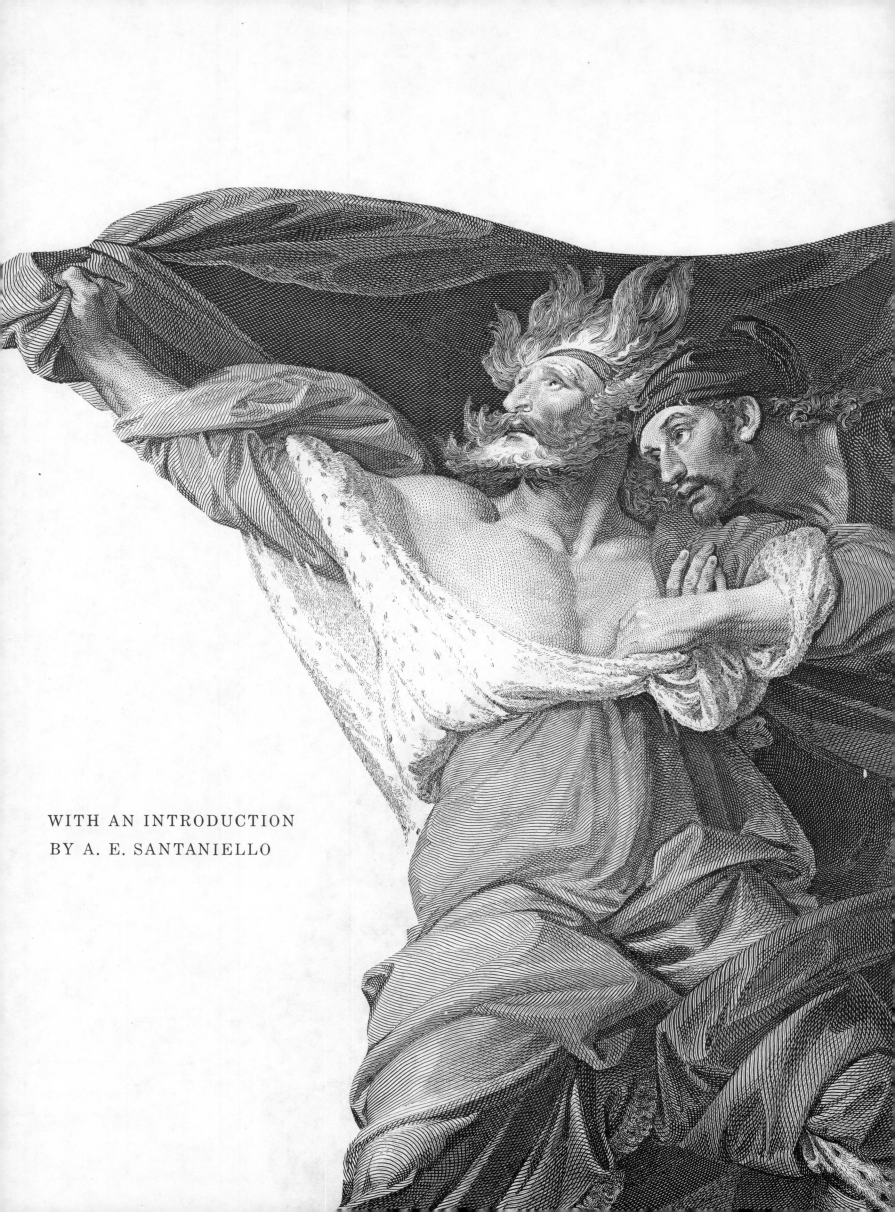

WITH AN INTRODUCTION
BY A. E. SANTANIELLO

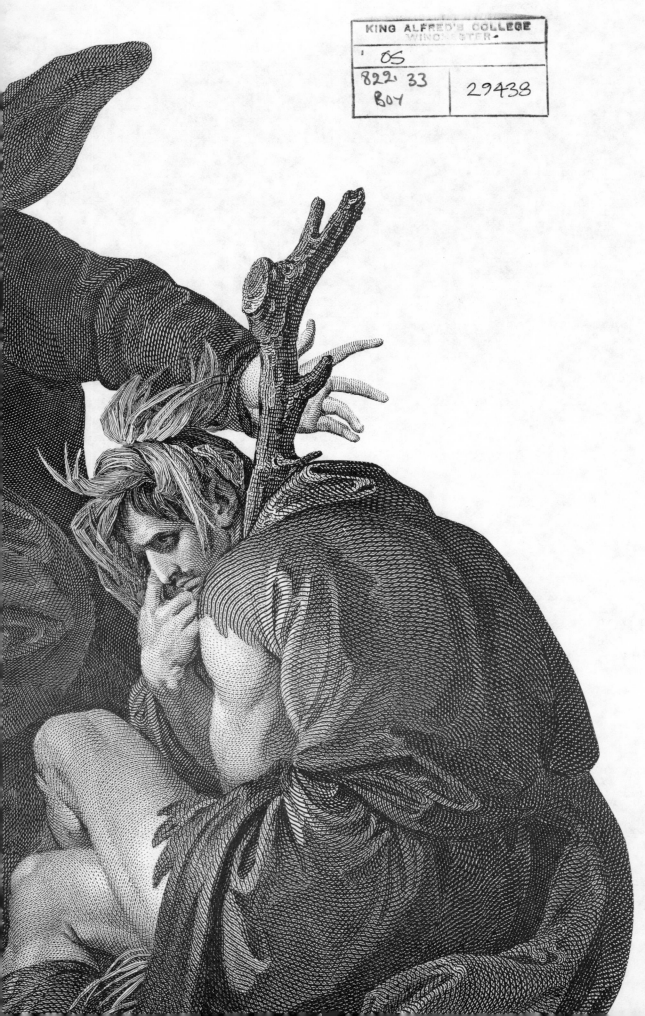

First published in 1803
Reissued in 1968 by Benjamin Blom, Inc.

Reprint edition 1979 by Arno Press Inc.

**Library of Congress Cataloging in Publication Data**
Main entry under title:
The Boydell Shakespeare prints.

    Reprint of 47 plates from the 1968 ed. published
by B. Blom, New York.
    1.    Shakespeare, William, 1564-1616—Illustrations
I.    Boydell, John, 1719-1804.    II.    Boydell, Josiah
1752-1817.
PR2883.B632    1979      822.3'3      79-12234
ISBN 0-405-12297-7

Manufactured in the United States of America

# INTRODUCTION

To FOUND A GREAT national school of painting, a uniquely English school, on inspiration drawn from that inexhaustible source of sublime moral ideas, the great national poet, Shakespeare; and not only to have this school inspired by his English genius, but to have its very thematic material based directly on his immortal text — this surely would be the perfect union of two arts, and evidence that England's painters were worthy of the international renown already accorded her poets. In this lofty purpose lay the origin of one of the most lavish enterprises in the history of English painting: the Boydell Shakespeare Gallery, an entire building dedicated to the exhibition of new paintings based on Shakespeare's works, which was opened to the public "on the site of Mr. Dodsley's House" in Pall Mall in 1789. In addition to the Gallery and the especially commissioned paintings, the Boydell venture would be responsible for two landmarks in the history of English publishing: the nine-volume folio "National" edition of the complete dramatic works, edited by George Steevens and published in 1802 in a magnificent format designed and executed by the great typographer William Bulmer; and a huge atlas folio volume consisting of one hundred engraved prints after paintings in the Gallery, published in 1803[5] as *A Collection of Prints from Pictures painted for the purpose of illustrating the dramatic works of Shakspeare by the Artists of Great Britain.*

The present volume, entitled *The Boydell Shakespeare Prints,* contains all one hundred plates in the *Collection of Prints,* taken from the larger paintings in the Gallery, as well as the one hundred separate engraved prints in the nine-volume edition of the plays, all of which were based on smaller paintings. *The Boydell Shakespeare Prints* thus recreates almost in its entirety the now dispersed Gallery. Of the approximately two hundred drawings and paintings in the collection, no more than forty can be positively identified today, and many of these are in poor condition. The surviving engraved prints are the only adequate record of the Gallery and, because of the unique importance of the Gallery, a record of the achievements and limitations of much of English art at the end of the eighteenth century. They give us, as no other collection of graphic art of the period can, an invaluable insight into the tastes and attitudes of the art-conscious public; and within the limitations of the engraving medium they reveal the aesthetic theories and techniques of almost every recognized artist of the day. They are an indication of the impact of Shakespeare on the imagination of English artists, and a chapter in the long history of efforts to create a pictorial counterpart to the familiar characters and scenes in the plays.

The Boydell Shakespeare Gallery and the two publications that came from it were an extraordinary combination for that or any era—at once a business venture, an assertion of national pride, and an artistic declaration of independence. The project unfolded with a display of energy and fanfare that captivated attention and

still leaves us with questions about the complex motivation of its originators. Sponsored by John Boydell, the most successful and honored (as well as generous) publisher and patron of English engravers, fed by the talents of the acknowledged master artists (and many of the minor ones) of the time, and supported by a seemingly endless fund of money, the entire venture had a largeness of imagination that intrigued the public and aroused the greatest of expectations.

How could the Gallery *not* be a topic of discussion among the amateurs and connoisseurs of art? It was soon known that Boydell would command (and pay well for the privilege) the services of the lofty Sir Joshua Reynolds, and Romney, and Benjamin West, and a veritable host of others, most prominent among them Northcote, Opie, Matthew Peters, Francis Wheatly, and Fuseli. And if Boydell could capture painters by the dozens, he could certainly gather engravers by the horde. From the opening exhibition in 1789 to the end of the venture in 1805, the paintings and the engraved prints were looked at, were argued over in gossip column and Academy discussion, were praised and condemned and even caricatured with an interest that kept surprisingly alive for almost two decades. The number of years during which the Gallery was in existence meant, of course, that it would live inevitably through a change in artistic tastes; those who viewed the paintings at the end of the period and in the next generation would look upon the praise of the past decades as unfathomable and find the paintings decidedly not to their taste. The honorable and altruistic motives of the Gallery's founders would even be questioned, and the great and merciless James Gillray would design one of his splendid apocalyptic visions showing a greedy Boydell presiding over the sacrifice of Shakespeare's works, a sacrifice to the god Money-Bags, with several of the Gallery's most popular paintings readily identifiable in the smoke. And of course there would be the resistance of those romantics, Charles Lamb at their head, who thought any effort to grasp the ineffable genius of Shakespeare in paint sheer effrontery. To these, of course, the Gallery was a failure from its conception.

But much of this criticism took shape late in the Gallery's career. In the beginning the venture met with wide approval. Year after year paintings were commissioned and displayed, engravings made and sold, the vast undertaking of the National edition of the plays carried on, and the monumental atlas edition of engraved plates created, all with an assured and stately pace entirely in keeping with the grand ideals that had inspired the Gallery's creators.

From our vantage point there is something in the ample breadth of the project and in its unstinting application of material things for altruistic and idealistic ends, with the certainty that such means would necessarily produce such ends, that seems at once remote, a manifestation of that envied "assurance" and stately order of the eighteenth century, and at the same time very familiar, an early manifestation, perhaps, of the "cultural center" syndrome.

The audacity, or even the naïveté, of the whole undertaking is inescapable: to offer to create an entire school of painting, inaugurating at one blow a tradition that had taken years to mature on the Continent, and to guarantee success by the obvious device of liberal commissions and commodious exhibition space. Full exposure would be given to the school thus created by the great collection of engravings and by the National edition, itself well illustrated. (Seen purely as "advertising," the happy use of Shakespeare's name on the venture could not be improved upon.) It was expected that English artists would rise to the occasion; generally ignored or treated with contempt abroad, they would soon prove themselves capable of the final test of genius—historical painting, composed according to the rules of the great art capitals, Rome and Bologna. Boydell and his fellows were certain, as were all connoisseurs, that historical painting was the challenge that had to be met. Only here would those awful and sublime emotions, made fruitful through a healthy didactic purpose and well ordered by the most rational rules of composition, create in the viewer the satisfaction proper to great art. The moral intentions of historical painting were in no way impaired when it was found that the word "historical" could be rather loosely interpreted. Since Benjamin West's successful application of the canon of historical painting rules to a relatively contemporary event (in his painting of the death of General Wolfe, exhibited in 1771), the artist began to look closer to home for his subject matter. West had been historical; he had, of course, been "correct" in his composition, but more important, he had put modern dress on his figures, and even included an Indian or two for authenticity. He showed that nationalism, or at least national interests, could live harmoniously with the ideals of classical composition. To the serious and Academy-trained artist, the Boydell Gallery provided an excellent chance for experimentation. With West's great triumph in mind, suddenly he was offered Shakespeare. The connection is not as remote as one would imagine. Shakespeare was primarily a national poet, a treasure of historical scenes, patriotic sentiment, authentic national character. He was a convenient bridge between the artist and the goal of a national school of historical painting. Philosophically, of course, Shakespeare was already on those moral heights toward which historical painting struggled. In certain of the comedies, where the moral might not be too much in evidence, there was still a wealth of narrative detail that was extremely useful, since narrative was a valued part of the desired good painting.

There were other reasons why Shakespeare was the inevitable choice for those looking for the cornerstone of a national school. Throughout the eighteenth century the growing adulation accorded the poet had taken many forms, the most commendable of which was the labor spent in creating a reliable, accurate, and clear text. From the first commentary of Nicholas Rowe in 1709, through the progressively more scholarly and critical editions of Pope, Theobald, Hammer, Warburton, Steevens, Copell, and Malone, the poet absorbed the attention of the best English scholars. Accompanying this effort to establish a text was the task of finding a visual counterpart to the great scenes and characters. The public's appetite for an "illustrated" Shakespeare had been fed by publisher after publisher: Tonson's 1714 edition, the 1744 edition of Sir John Hammer, with engravings by Francis Hayman, John Bell's low-priced 1773 and 1785-87 editions, the Bellamy and Robarts 1791 edition, and various books devoted exclusively to plates, among

them the *Picturesque Beauties of Shakespeare,* with 40 plates, by Smirke and Stothard, published in 1783. As Professor T.S.R. Boase has amply demonstrated, the Englishman's preferred edition of Shakespeare was an edition with pictures; pictures, moreover, that kept pace with the changing trends in acting, and costume and stage design. The pictures inevitably kept pace as well with the changes in aesthetic ideas and artistic techniques. The Boydell paintings, a novel enterprise for the time, thus had roots in the tradition of Shakespeare illustration throughout the century. The project, Gallery, text edition, and prints, epitomizes several aspects of thought in the century: the glorification of Shakespeare as the great national poet, the concern for a sound text presented in an appropriately stately format, the search for an English tradition in painting, and the attitude toward historical painting.

The Boydell Shakespeare Gallery was not able to unite the many different forces at work in English art into one school which dutifully followed the recognized tradition of historical painting. But if Boydell and his artists failed in this respect, they did succeed in creating an atmosphere within which English art would develop for several decades. The impact of the Gallery paintings would be felt for many years after the Gallery itself had ceased to be.

For the artist of the time, however, there were immediate benefits from the Gallery that made up for the failure of its ideal end. The existence of the Gallery gave the artist the needed exhibition hall for his work. Gallery-going was an essential feature of London's cultural life in the 1780's, and the galleries provided the artist with the opportunity to confront his public, and to be confronted by it. The kind of commission the Gallery gave allowed the artist a wider field of experimentation than he usually had. This was still the era of the portrait, and for many artists the average commission was for a likeness. With the Boydell commissions came a chance to draw upon a myriad of characters and a range of dramatic incidents of every degree of emotional intensity. The possibilities for composition, for expressive gesture and mood were extraordinary. The paintings in the Gallery could be faulted on many points, but few critics have denied their variety and liveliness. For more than fifteen years the Gallery displayed a series of canvases that showed what the English artist would attempt if he had freedom from the economic necessity of portrait painting. The importance of this aspect of the Gallery can be appreciated when it is realized that the main body of recognized English artists was at one time or another working under its commission.

To match this chance for experimentation with a wide range of thematic material were the generous stipends set by Boydell. Boydell's liberality to the engravers who had made his print publishing firm the foremost supplier of English engravings gave him an unrivaled reputation as a patron of the arts. He was, in the words with which Edmund Burke toasted him, England's "Commercial Maecenas." No historian of the Boydell enterprise has failed to note how unusual for the time were these commissions. Benjamin West was given 1,000 guineas for his "King Lear in the Storm," and Reynolds the same for the "Death of Cardinal Beaufort." This was the highest fee; in lower brackets were Romney, who was given 600 guineas for his painting of a scene from *The Tempest,* and Joseph Wright of Derby, whose services were valued at 300 pounds. Boydell said that the entire operation — Gallery, text edition, paintings and drawings, and copperplates—had cost 300,000 pounds, of which 42,266 was spent on paintings alone. It was an unprecedented amount of money to be expended on one artistic venture by a private group, and certainly an extraordinary sum to be spent with such little restriction on the artists' freedom. Northcote summed up the attitude of many of the Gallery's painters when he wrote: "Boydell did more for the advancement of the arts in England than the whole mass of the nobility put together."

The origin of the idea of the Shakespeare Gallery has been debated: the painter Romney and the printer and bookseller George Nicoll both claimed the idea as their own. Fuseli insisted that he had first thought of the plan, and Northcote claimed that he had provided the impulse to set the venture going by his own successful career as a historical painter. What is certain amid these claims and conjectures is that the idea for a grand series of Shakespeare paintings in the historical manner was the topic of conversation at a dinner given in November of 1786 by John Boydell's nephew and partner, Josiah. When one of the guests congratulated Boydell on his successful efforts to give English engravings an international reputation he is said to have replied that "old as he was, he would like to wipe away the stigma which all foreign countries threw on this nation, that we have no genius for historical paintings."

Boydell saw the low repute of English painting as the same kind of challenge he had met when he first began to publish engravings in the middle of the century. Then the art of the engraver was at its lowest ebb and England was importing thousands of pounds' worth of French prints annually while exporting none of her own. By 1786, mainly as a result of Boydell's enterprise, exports of English engraved prints had climbed to 200,000 pounds annually, while imports had sunk to 100 pounds. Boydell had proved "to the French nation that an Englishman could produce a print of equal merit." A vigorous industry had been established, a reputation for artistic excellence won, and a comfortable private fortune made—Boydell's profits from one print alone, William Wollett's engraving after West's "Death of Wolfe," came to 15,000 pounds. The Shakespeare Gallery idea offered an opportunity to crown with the title of founder of English historical painting his secure reputation as the first and greatest of fine arts publishers in England. When the scheme was broadened to include plans for a folio edition of the plays there came another opportunity: to show the nation and the world a superb example of English typography and book design.

The man who would bring about the necessary union between art and commerce and insure the venture's success was born in Shropshire in 1719, the son of a land surveyor, whose trade he followed until, still a youth, he saw an engraving by W. H. Toms. He was so captivated by the art that he walked to London and apprenticed himself to Toms for seven years, to become an engraver himself. After six years he bought up his apprenticeship, and by 1751 had opened his own shop, largely out of the profits from his book of engraved views of the English and Welsh countryside.

Ultimately his publishing firm would employ the best engravers of the time, and would produce a mass of prints estimated in the company's catalogue at some 4,432 plates (2,293 of these were after works by English painters). About 250 engravers worked for Boydell at one time or other during his long career; and he gave the art a popularity and reputation it had never known. For Boydell, civic honors followed artistic and commercial success: in 1782, he became an alderman of the City of London, in 1785, Sheriff, and in 1790, Lord Mayor. The Shakespeare Gallery and the two published memorials to it—the folio edition of the plays and the volume of one hundred prints—were to be the summation of a lifetime spent in fostering English art at home and abroad.

But the Gallery failed to create a national school of painting and, of more immediate consequence, failed to become economically viable. The lavish spending that went into the various projects and the length of time it took to produce the text and plates left Boydell poorly provided for the unexpected: when the prolonged conflict with France closed that market for the Gallery engravings, he was placed in straitened circumstances. Close to bankruptcy, Boydell petitioned Parliament for a National Lottery to raise money on the Gallery and its paintings. About 45,000 pounds was realized through the sale of two-guinea tickets and when the lottery was held it was won by a Mr. Tassie, a famous maker of cameos and medallions in wax. Tassie in turn sold the paintings at auction in 1805. A mere 6,181 pounds was all the paintings could fetch, a depressing end to such noble expectations. This sad conclusion has perhaps cast its shadow over the entire history of the Boydell enterprise. The dispersal of the paintings and the damage done by time to the few that can be positively identified today have joined with the hostility to "historical" painting in general to prejudice the case against the Gallery and have made it somewhat difficult to gauge its real position in the development of English painting.

The Gallery must be considered from several points of view, some of which have already been suggested. Its importance in the history of Shakespeare illustrations cannot be denied. Even if the paintings as a whole failed to create a unique style in the visual interpretation of Shakespeare, the best of them are illuminating comments on the plays and brilliant realization of character. One can turn to the engraved prints of West's "King Lear in the Storm," Northcote's "Burial of the Two Princes," Fuseli's "Titania and Bottom in the Wood," the luscious, satiny ladies depicted by Matthew Peters, Wheatly's delightful crowded scenes, and the brisk, Hogarthian comedy of Smirke as examples of completely satisfying graphic art which is at the same time faithful to the source of its inspiration. One feels that the artist has grasped the reality of Shakespeare's character and has understood the complex emotional structure of his scene. The successful paintings are visions of the essential Shakespeare, visions freed of the limits of a particular style of stage presentation, of acting or of costuming. It cannot be denied that many of the paintings do not reach this level of genius. Many are hack work, full of stock figures in carefully arranged settings, faithful perhaps to the stage practices of the day but as dated as those practices seem to us now. In many instances it is

obvious that the artist had grappled with emotions that were too large for his talents. The results are the expected bombast and rant, sad examples of the failure of the artist to do more than mirror the current vogue of heroic gesture and flamboyant characterization. And, just as the poorer artists reflected the most artificial stage practices, so too did they build their paintings strictly according to the "correct" rules of composition. Few of the less talented painters could survive this double liability. And yet, for all the negative judgments that can be made, the Gallery paintings are invaluable as one of best composite views of English art in the last decades of the eighteenth century.

Any evaluation of the Gallery is of course hampered by the loss of so many of its paintings. It is therefore to the engraved prints that one must turn, for here the Gallery exists almost in its entirety. From 1789 to almost the end of the venture, large folio proofs and prints were being published in a uniform size of 20 by 27 inches. The original plan for publication had called for seventy-nine smaller prints to illustrate the text volumes, a number later increased to one hundred. The separate folio volume of prints after the larger paintings was a connoisseur's book, elaborately designed and priced at sixty guineas. In creating the prints Boydell ran into unexpected delays and difficulties: many of the best engravers were already engaged and he could not draw upon their services. As a result the engravings contain few examples by such acknowledged masters as Bartolozzi and Schiavonetti. The bulk of the work fell to less prominent but generally competent craftsmen, among them Robert Thew, J. Peter Simon, James Parker, and Thomas Ryder. The choice of engraving technique, the stipple method, has been criticized frequently on several counts. The engraver John Landseer, whom Boydell had not employed on the Shakespeare prints, insisted that the art of engraving had suffered as a result of the popularity of stipple, a popularity that came out of its use in the Boydell Shakespeare prints. The stipple engravings have also been criticized for the dullish and blurred results, evident in a number of prints. But when varied with line engraving, as frequently happened, stipple proved highly effective.

In spite of the weakness of a number of the prints, many, particularly those after paintings by Northcote, Fuseli, Benjamin West, Peters, and Smirke, are masterpieces of their kind. Often the engraving seems to be more successful than the original painting, revealing the best qualities of the artist—usually in composition—and minimizing the defects of faulty coloring and lack of texture characteristic of many of the Boydell artists. Among the best engravings in the series are those after Fuseli; they stand forth without any loss of that extraordinary relationship between line and overall pattern that is one of Fuselli's most telling qualities. Thomas Wright of Derby was also well served by his engraver. His unique handling of masses of light and darkness is seen to advantage in the prints. The billowing gowns of Peters' Merry Wives of Windsor, engraved by Thew, are as sensuous and captivating in the print as on the canvas; and those artists who specialized in the more homely scenes, domestic or rural, among them William Hamilton and Francis Wheatly, lend themselves to the engraver's technique with particular charm. As a masterly example of the

way in which the engraver captured the bold design and dramatic contrast of the original canvas, Northcote's "Burial of the Two Princes," engraved by Skelton, must be acknowledged as a work of genius, one of the most rewarding in the entire collection of two hundred prints. The qualities that give it greatness can be seen in scores of the other engravings as well.

The entire collection of prints, for all the defects of execution and limitations of technique, offers a panorama of brilliant scenes and fully realized characters. They are, to our taste perhaps, "theatrical" in a very unfavorable sense of the word. This is Shakespeare on the grand scale, the Shakespeare of titanic emotion, of compelling gesture and vivid gaze. Little is underplayed here, and naturalistic pose or gesture is unthinkable. The dangers of this grand style are obvious, and the results sometimes appear to be merely ranting tragedians, coy comedians, and limp romantics. To the twentieth century Shakespeare suggests other meanings and comes dressed in other robes; we have lost the particular attitude toward him and toward his "sublime" and awful moral ideas that made the Boydell paintings and engravings possible. But even this radical difference in taste becomes insignificant before the greatest of the engravings; they are by any standard powerful works with an inescapable emotional force behind them. They speak directly to us in spite of the remoteness of the style and attitudes that created them.

A word should be said about the edition of the complete dramatic works that Boydell issued in 1802. Here all critics agree the Boydell venture had an unqualified success, creating a masterpiece of typography, perfectly in harmony with the aesthetic ideals of the age. This project was as elaborately conceived and executed as the Gallery itself, and the series of prints. A special printing plant was built, new type designed, and even a new ink created for the folio volumes. Boydell had the services of the typographer and printer William Bulmer, who set up the new Shakespeare Printing Office and, with William Martin, began work on the volumes. The results were magnificent from every aspect; by setting the dialogue in roman and stage directions in italic Bulmer achieved a constantly varying pattern with a strongly unified basis. The widely spaced and leaded types reinforced the stately dignity of the ample page. The presswork was on the same order of excellence, with scarcely a perceptible shade of variation in color of ink, hue of paper, or clearness of types. The nine volumes, first announced in a prospectus in 1789, were finally published in 1802, at the very low price of 37 pounds, 16 shillings. Boydell had the Shakespeare monument he desired: a great National edition, where the text found a setting that was a tribute to its imperishable beauty.

*The Boydell Shakespeare Prints* recalls a distant chapter in the history of English art, a chapter generally left unread. The tide of feeling that had turned, even by the time the Gallery was dispersed, against historical painting, has never fully restored that school to favor. There are signs today, however, that a re-evaluation of late eighteenth- and nineteenth-century painting is taking place. In England and in America paintings that were once dismissed as mere narrative or anecdote, rule-bound compositions of little merit, are being looked at with fresh eyes. In galleries and museums and in scholarly publications attention is once more coming to focus on this neglected era, in an effort to see it without the prejudices of the twentieth century. Criticism can easily detect the faults in the Boydell paintings and trace the limitations of all the painters, and criticism can also reveal that these works, as they survive in the engraved prints, are valid statements, significant works of art that transcend the limits of their own time.

*A. E. Santaniello*

## BIBLIOGRAPHICAL NOTE

THE FOLLOWING BOOKS and essays, used in this Introduction, contain the best available accounts of John Boydell and the Boydell Shakespeare Gallery.

The article on John Boydell in the *Dictionary of National Biography* is the standard reference source for most of the information known about his life and the founding of the Gallery. There is no full-scale biography. The accounts of Boydell contained in other essays are generally indebted to the *DNB*. The best study of Shakespeare illustrations and of the influence of the Boydell venture is found in T.S.R. Boase's essay, "Illustrations of Shakespeare's Plays in the Seventeenth and Eighteenth Centuries," in the *Journal of the Warburg Institute*, 1947, Volume 10. Professor Boase also examines the paintings of the Gallery and adds a list of the present locations or recent history of the surviving paintings. W. Moelwyn Merchant's *Shakespeare and the Artist* has a very useful chapter on Boydell and the tradition of Shakespeare illustration. Other accounts of the same nature can be found in Malcolm C. Salaman's *Shakespeare in Pictorial Art* and Sadakicki Hartmann's *Shakespeare in Art*. Essays that give a brief survey of either Boydell or the Boydell paintings are: Thomas Bolston's "John Boydell, Publisher: 'The Commercial Maecenas,'" in *Signature*, 1948, Volume 8; and Lawrence Thompson's "The Boydell Shakespeare: An English Monument to Graphic Arts," in the Princeton University Library Chronicle, 1940, Volume I. Algernon Graves' "Boydell and His Engravers," which appeared in *The Queen* magazine from July to December of 1904, is an account of all the engravers who were employed by Boydell.

For the Boydell edition of the complete dramatic works, a valuable study and evaluation is D. B. Updike's *Printing Types*. And for an examination of English art in the period, a most important volume is Ellis Waterhouse's *Painting in Britain, 1530 to 1790*.

# COLLECTION OF PRINTS,

## FROM PICTURES PAINTED FOR THE PURPOSE OF ILLUSTRATING

### THE

# DRAMATIC WORKS

### OF

# SHAKSPEARE,

### BY THE

## ARTISTS OF GREAT-BRITAIN.

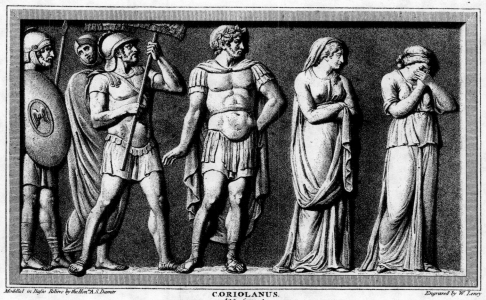

Modelled in Basso Rilievo by the Hon.ble A. S. Damer.

**CORIOLANUS.**
Act 2. Scene 1.

Engraved by W. Leney.

Pub. June 4. 1803, by J. & J. Boydell, at the Shakspeare Gallery, Pall Mall, & N.º 90, Cheapside, London.

## VOLUME I.

---

### LONDON:

**PUBLISHED BY JOHN AND JOSIAH BOYDELL,**

SHAKSPEARE GALLERY, PALL-MALL, AND NO. 90, CHEAPSIDE.

PRINTED BY W. BULMER AND CO. CLEVELAND ROW, ST. JAMES'S.

MDCCCIII.

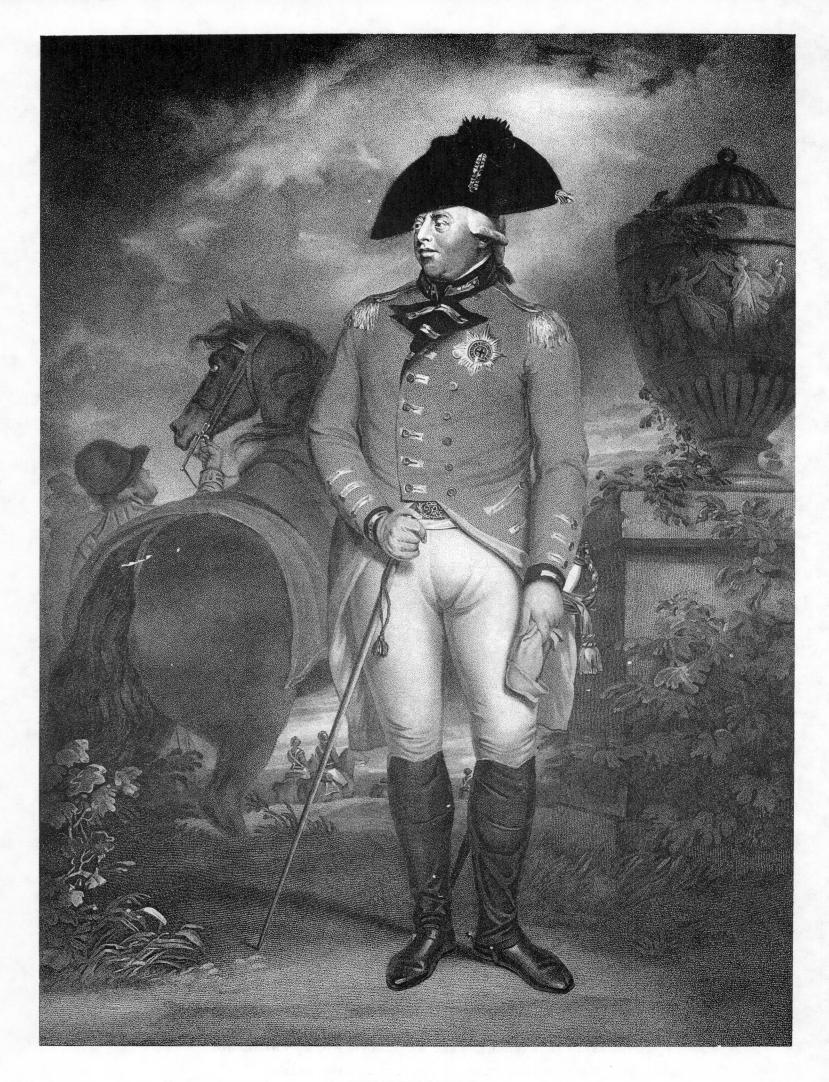

**FRONTISPIECE.**

Portrait of His Majesty GEORGE III.

Painted by Sir W. Beechey, R. A.   Engraved by B. Smith.

# TO

# THE KING'S

## MOST EXCELLENT MAJESTY.

————————

*IN presenting this Volume of the* SHAKSPEARE PRINTS *to Your* MAJESTY, *I only fulfil the Intentions of my departed Relation, Mr.* ALDERMAN BOYDELL; *who, in all his Arduous Endeavours to improve the Fine Arts in this, his Native Country, always found in Your* MAJESTY's *Goodness, a kind and encouraging Patronage, that animated him to struggle with all his Difficulties.—He has taken every opportunity to proclaim, with gratitude, that Patronage, with which he was so highly honoured. I therefore flatter myself, Your* MAJESTY *will be graciously pleased to receive this his last Labour, from the hands of*

## YOUR MAJESTY'S

*Dutiful and Devoted Subject and Servant,*

*JOSIAH BOYDELL.*

*London, March 25, 1805.*

# P R E F A C E.

IT has unfortunately fallen to my lot, by the death of my late much-lamented uncle, Mr. Alderman Boydell, to give the Subscribers to the Shakspeare some account of the rise and progress of that Work; a Work, which, for its magnitude and expense, is certainly unparalleled in any age or country; and bears much more the appearance of a National Undertaking, executed at the public expense, than the enterprise of the branches of one private family.

I cannot, perhaps, give this account more truly, or with more propriety, than in the words of those who were principally concerned with me. The whole Undertaking originated in a conversation, that took place at my house, in the end of the year 1787, as appears by a Paper, written and printed by Mr. Nicol, giving some account of what he had done for the improvement of printing in this country.

"IT is perhaps proper to explain to the Public, why I have stepped out of the line of my profession, to attempt improvements in Type-founding, Ink-making, and Printing.—The following lines will explain that matter, as well as give a short sketch of the origin of the Shakspeare undertaking, so far as it depends upon me.

"When I first proposed to Messrs. Boydell to publish a national edition of Shakspeare, ornamented with designs by the first artists of this country, it must be confessed, I did not flatter myself with seeing it carried into immediate execution. The idolatry with which I have ever regarded the works of that inspired Poet has often prompted me to make similar propositions. Perhaps so frequently, that my more intimate friends have much to complain of, on the score of reiteration.

"At so early a period of my life as the Jubilee at Stratford, the proposal was made to Mr. Garrick, that great histrionic commentator on our author. Why it was then neglected is not now easy to say: I attribute it more to the youth and inexperience of the proposer, than to any want of propriety in the plan:—The event has indeed shewn the proposal was neither improper nor impracticable.

"The conversation that led to the present undertaking was entirely accidental; it happened at the table of Mr. Josiah Boydell, at West End, Hampstead, in November, 1787: the company consisted of Mr. West, Mr. Romney, and Mr. P. Sandby; Mr. Hayley, Mr. Hoole, Mr. Braithwaite, Alderman Boydell, and our Host. In such a company it is needless to say, that every proposal to celebrate genius, or cultivate the fine arts, would be favourably received.

"At the moment of the proposition, I had no idea of having any concern in the execution of the work,—and only offered to contribute my mite to so great and so expensive an undertaking. It was very soon however foreseen, that having involved my friends in so arduous a task, it was incumbent on me to lend every assistance in my power to the completion of it. The typographical part alone was the department wherein I could be of any use: of the mechanical part of printing indeed I knew but little;* but from the general line of my profession, and my particular admiration of fine printing, I was acquainted with all the beauties, and all the defects of the most eminent artists, from John Fust of Mentz, to John Baskerville of Birmingham.

"The declining state of printing in London had been long very generally lamented, particularly when contrasted with the rapid progress of improvement it had lately made in foreign countries. The first attempt I made to remedy this evil was in the summer 1784, when I was honoured with his Majesty's command, to procure the second edition of Captain Cook's last Voyage to be better printed than the first; the publication of which work I had undertaken, under the direction of that great promoter of every useful art in this country, Sir Joseph Banks."

* Mr. Bulmer has so perfectly supplied this defect, in the execution of the typographical part of the Shakspeare, that he has left nothing to desire: in so much, that it may be truly said, that no Printing Press, which has hitherto existed, ever produced a work *in nine large volumes in folio* so *uniformly* beautiful.

The rest of the paper relates entirely to Mr. Nicol's progress in the improvement of Printing, and therefore irrelative to the present subject.

Early in the year 1789—the undertaking was so far advanced, that a great number of the Pictures were painted; and a Gallery built on the site of Mr. Dodsley's house, in Pall-mall, to receive them. Previous to the exhibition of these pictures, the Alderman published a descriptive catalogue of them, with appropriate quotations from Shakspeare, so as to enable the Public to judge how well the painter had pourtrayed the characters of the poet. To that catalogue the following preface was added, giving the Subscribers some idea of the progress of the work.

"I cannot permit this catalogue to appear before the public, without returning my sincere thanks to the numerous Subscribers to this undertaking, who, with a liberality, and a confidence unparalleled on any former occasion, have laid me under the most flattering obligations. I hope, upon inspection of what has been done, and is now doing, the Subscribers will be satisfied with the exertions that have been made, and will think that their confidence has not been misplaced; especially when they consider the difficulties that a great undertaking, like the present, has to encounter, in a country where Historical Painting is still but in its infancy—To advance that art towards maturity, and establish an *English School of Historical Painting*, was the great object of the present design.

"In the course of many years endeavours, I flatter myself I have somewhat contributed to the establishment of an *English School of Engraving*. These exertions have not been unnoticed at home—But in foreign countries they have been estimated, perhaps, above their value.—When I began the business of publishing and selling Prints, all the fine Engravings sold in England were imported from foreign countries, particularly from France.—Happily, the reverse is now the case: for few are imported, and many are exported, to a great annual amount. I mention this circumstance, because there are of those, who, not putting much value on the advancement of National Taste, still feel the advantage of promoting the Arts, in a commercial point of view.

"I flatter myself that the present undertaking, in that, and many other points of view, will essentially serve this country. The more objects of attraction and amusement held out to Foreigners, that may induce them to visit this Metropolis, the more are our manufactures promoted; for every one, on his return, carries with him some specimen of them: and I believe it will be readily granted, that the manufactures of this country need only be seen and compared, to be preferred to those of any other.—The great number of Foreigners who have of late visited this country, may in some degree be attributed to the very flourishing state of our commerce; and accounts for that great demand for English manufactures, which at present so universally prevails all over the Continent.—At least I can with certainty say, I feel the effect of this circumstance in my own branch of business.*

"That the love of the fine Arts is more prevalent abroad than in this country, cannot be denied; but I still hope to see them attain (advanced in years as I am) such a state of perfection in England, that no man in Europe will be entitled to the name of a Connoisseur, who has not personally witnessed their rapid progress—And that their progress has been wonderfully rapid in this country, within these twenty years, the whole world will readily allow.—This progress we principally owe to his present Majesty; who, sensible of their importance in every point of view, has cultivated the fine Arts with a success that the annals of no other country, in the same space of time, can produce. The enterprise and liberality of several individuals also have not been wanting to contribute to so great an end.—For my own part, I can with truth say, that the Arts have always had my best endeavours for their success; and my countrymen will I hope give me credit, when I assure them, that where I failed, I failed more from want of power, than from want of zeal.

"In this progress of the fine Arts, though foreigners have allowed our lately acquired superiority of Engraving, and readily admitted the great talents of

* That Gothic revolution which broke out about this time, and still convulses the whole Continent, soon made an end of those happy days.

the principal Painters, yet they have said, with some severity, and, I am sorry to say, with some truth, that the abilities of our best Artists are chiefly employed in painting Portraits of those who, in less than half a century, will be lost in oblivion—While the noblest part of the Art—HISTORICAL PAINTING—is much neglected. To obviate this national reflection was, as I have already hinted, the principal cause of the present undertaking—An undertaking, that originated in a private company, where Painting was the subject of conversation.—But as some short account of the rise and progress of the whole work may at a future time be given to the Subscribers, it is not now necessary to say, who first promulgated the plan—who has promoted it—or who has endeavoured to impede its success.—Suffice it to say, at present, that the Artists, in general, have, with an ardour that does them credit, contributed their best endeavours to carry into execution an undertaking, where the national honour, the advancement of the Arts, and their own advantage, are equally concerned.

" Though I believe it will be readily admitted, that no subjects seem so proper to form an English School of Historical Painting, as the scenes of the immortal Shakspeare; yet it must be always remembered, that he possessed powers which no pencil can reach; for such was the force of his creative imagination, that though he frequently goes beyond nature, he still continues to be natural, and seems only to do that which nature would have done, had she o'erstep'd her usual limits—It must not, then, be expected, that the art of the Painter can ever equal the sublimity of our Poet. The strength of Michael Angelo, united to the grace of Raphael, would here have laboured in vain——For what pencil can give to his airy beings " a local habitation, and a name?"

" It is therefore hoped, that the spectator will view these Pictures with this regard, and not allow his imagination, warmed by the magic powers of the Poet, to expect from Painting what Painting cannot perform.

" It is not however meant to deprecate Criticism—Candid Criticism is the soul of improvement, and those Artists who shut their ears against it, must never expect to improve——At the same time, every Artist ought to despise and contemn the cavils of Pseudo-critics, who, rather than not attempt to shew their wit, would crush all merit in its bud.—The discerning part of the Public, however, place all these attempts to the true account—malignity.—But as the world was never entirely free from such critics, the present undertaking must expect to have its share.

" Upon the merits of the Pictures themselves, it is not for me to speak; I believe there never was a perfect Picture, in all the three great requisites of Composition, Colouring, and Design—It must not therefore be expected that such a phænomenon will be found here.—This much, however, I will venture to say, that in every Picture in the Gallery there is something to be praised, and I hope sufficient marks of merit, to justify the lovers of their country, in holding out the fostering hand of Encouragement to native Genius.—I flatter myself, on the present occasion, that the established Masters will support and increase their former reputation, and that the younger Artists will daily improve, under the benign influence of the public patronage.—They all know that their future fame depends on their present exertions: for here the Painter's labours will be perpetually under the public eye, and compared with those of his cotemporaries—while his other works, either locked up in the cabinets of the curious, or dispersed over the country, in the houses of the different possessors, can comparatively contribute but little to his present fortune or future fame.

" I must again express my hopes, that the Subscribers will be satisfied with the progress made in this arduous undertaking, for it is to be considered, that works of genius cannot be hurried on, like the operations of a manufactory, and that Engraving, in particular, is a work of very slow and laborious progress——I confess, I am anxious on this subject, for I could wish the Subscribers to be convinced (of what indeed is the fact) that not a moment of time has been lost.

" It happens indeed unavoidable in this undertaking, that the Artists employed on the 2d, 3d, 4th, 5th, and subsequent Numbers, are as far advanced as those employed on the first. And it is difficult to retard the one, or accelerate the other——This much, however, the Subscribers may rely on—that every exertion will be made, consistent with that excellence which is aimed at, to publish the first Number with all possible speed;—after that, the work will go on uninterruptedly.

" I cannot conclude this Address, without mentioning the very great assistance the work receives from the unwearied exertions of my nephew and partner, Mr. Josiah Boydell, whose knowledge in the elementary part of Painting enables him to be of singular service in conducting this undertaking—Indeed his love and enthusiasm for the fine Arts peculiarly qualify him for the conduct of works of this nature; and without that love and enthusiasm for the Arts, such an undertaking can never be carried on with becoming spirit——His numerous avocations in the management of the various branches of our business, particularly in making drawings from the pictures, for the most capital engravings in our Collection—have not allowed him much time to pursue the practical part of Painting—nevertheless, willing to contribute his mite to this great work—(in the management of which he has so considerable a share) he has made an attempt in this line of the Art. Under these circumstances, I hope the Public will have the candour to receive his performances.

" The Typographical part of the Work, (of which a specimen may now be seen) is under the direction of Mr. Nicol, his Majesty's Bookseller, whose zeal for the improvement of Printing in this country is well known——The Types, &c. are made in his own house—and I flatter myself, that, with the assistance

he has, in the various branches, upon which the Beauty of Printing depends, he will be able to contribute something towards restoring the reputation of this country in that most useful Art.—At present, indeed, to our disgrace be it spoken, we are far behind every neighbouring nation, many of whom have lately brought the Art of Printing to great perfection.—In his present endeavour, he has had the assistance and advice of some gentlemen, who, were I at liberty to mention their names, would do him honour, and the undertaking credit.

" The Public are so well acquainted with the merits of Mr. Steevens, in elucidating the text of our Author, that it would be impertinent in me to say a syllable on this part of the subject.—I cannot, however, omit mentioning the readiness he has always shewn, to contribute his labours to this National Edition of the Works of Shakspeare."

JOHN BOYDELL.

*Shakspeare Gallery, May 1, 1789.*

Since that period the work has been progressively going on, as well as the tempestuous times, that have shaken all Europe to its centre, would permit; and it has at least shewn, that, in more favourable times, English Genius may arise to excellence, in Historical Painting, as well as in the other branches of the fine Arts, upon proper encouragement being held forth.—That liberal encouragement has not been wanting in the present undertaking, the Subscribers will readily conceive, when they are informed, that there are some single Prints in this numerous collection, which cost upwards of 1500 guineas.

The effect these unfavourable times had upon our undertakings, the late Alderman has so truly and so feelingly described, in his Letter to Sir John William Anderson, on his application to Parliament, that I think it proper to insert it here.

" *To Sir JOHN WILLIAM ANDERSON, Bart. Alderman, and one of the Representatives of the City of London.*

DEAR SIR, *Cheapside, Feb. 4, 1804.*

" THE kindness with which you have undertaken to represent my Case, calls upon me to lay open to you, with the utmost candour, the circumstances attending it, which I will now endeavour to do as briefly as possible.

" It is above sixty years since I began to study the Art of Engraving, in the course of which time, besides employing that long period of life in my profession, with an industry and assiduity that would be improper in me to describe, I have laid out with my brethren, in promoting the commerce of the fine Arts in this country, above *three hundred and fifty thousand pounds*.

" When I first began business, the whole commerce of prints in this country consisted in importing foreign prints, principally from France, to supply the cabinets of the curious in this kingdom. Impressed with the idea that the genius of our own Countrymen, if properly encouraged, was equal to that of Foreigners, I set about establishing a *School of Engraving in England;* with what success the Public are well acquainted. It is, perhaps, at present, sufficient to say, that the whole course of that commerce is changed; very few prints being now imported into this country, while the foreign market is principally supplied with prints from England.

" In effecting this favourite plan, I have not only spent a long life, but have employed near forty years of the labour of my nephew, Josiah Boydell, who has been bred to the business, and whose assistance, during that period, has been greatly instrumental in promoting a School of Engraving in this country. By the blessing of Providence, these exertions have been very successful; not only in that respect, but in a commercial point of view; for the large sums I regularly received from the Continent, previous to the French Revolution, for impressions taken from the numerous plates engraved in England, encouraged me to attempt also an *English School of Historical Painting.*

" I had observed, with indignation, that the want of such a School had been long made a favourite topic of opprobrium against this country, among foreign writers on National Taste. No subject, therefore, could be more appropriate for such a national attempt, than England's inspired Poet, and great Painter of Nature, Shakspeare; and I flatter myself the most prejudiced foreigner must allow, that the Shakspeare Gallery will convince the world, that Englishmen want nothing but the fostering hand of encouragement, to bring forth their genius in this line of art. I might go further, and defy any of the Italian, Flemish, or French Schools, to show, in so short a space of time, such an exertion as the Shakspeare Gallery; and if they could have made such an exertion in so short a period, the pictures would have been marked with all that monotonous sameness which distinguishes those different Schools. Whereas, in the Shakspeare Gallery, every Artist, partaking of the freedom of his country, and endowed with that originality of thinking, so peculiar to its natives, has chosen his own road, to what he conceived to be excellence, unshackled by the slavish imitation and uniformity that pervade all the foreign schools.

" This Gallery I once flattered myself with being able to have left to that generous Public, who have for so long a period encouraged my undertakings; but unfortunately for all those connected with the fine Arts, a Vandalick Revolution has arisen, which, in convulsing all Europe, has entirely extinguished

# PREFACE.

except in this happy Island, all those who had the taste or the power to promote the fine Arts; while the Tyrant that at present governs France, tells that believing and besotted nation, that, in the midst of all his robbery and rapine, he is a great patron and promoter of the fine Arts; just as if those arts, that humanise and polish mankind, could be promoted by such means, and by such a man.

" You will excuse, I am sure, my dear Sir, some warmth in an old man on this subject, when I inform you, that this unhappy Revolution has cut up by the roots that revenue from the Continent, which enabled me to undertake such considerable works in this country. At the same time, as I am laying my case fairly before you, it should not be disguised, that my natural enthusiasm for promoting the fine Arts, (perhaps buoyed up by success), made me improvident. For had I laid by but ten pounds, out of every hundred pounds my Plates produced, I should not now have had occasion to trouble my Friends, or appeal to the Public; but on the contrary, I flew with impatience to employ some new Artist, with the *whole* gains of my former undertakings. I see too late my error; for I have thereby decreased my ready money, and increased my stock of copper-plates to such a size, that all the printsellers in Europe could not purchase it, especially at these times, so unfavourable to the Arts.

" Having thus candidly owned my error, I have but one word to say in extenuation :—my receipts from abroad had been so large, and continued so regular, that I at all times found them fully adequate to support my undertakings at home—I could not calculate on the present crisis, which has totally annihilated them—I certainly calculated on some defalcation of these receipts, by a French or Spanish war, or both; but with France or Spain I carried on but little commerce—Flanders, Holland, and Germany, (and these countries, no doubt, supplied the rest of Europe), were the great Marts; but alas! they are now no more. The convulsion that has disjointed and ruined the whole Continent I did not foresee—I know no man that did. On that head, therefore, though it has nearly ruined me and mine, I can take but little blame to myself.

" In this state of things, I throw myself with confidence upon that Public, who have always been but too partial to my poor endeavours, for the disposal of that, which, in happier days, I flattered myself to have presented to them.

" I know of no means by which that can be effected, just now, but by a Lottery; and if the Legislature will have the goodness to grant a permission for that purpose, they will at least have the assurance of the even tenour of a long life, that it will be fairly and honourably conducted. The objects of it are my Pictures, Galleries, Drawings, &c. &c. which, unconnected with my Copper-plates and Trade, are much more than sufficient to pay, if properly disposed of, all I owe in the world.

" I hope you, my dear Sir, and every honest man, at any age, will feel for my anxiety to discharge my debts; but at my advanced age, of *eighty-five*, I feel it becomes doubly desirable.

I am, DEAR SIR, with great regard, your obedient and obliged Servant,

JOHN BOYDELL.

One hint in this letter so peculiarly regards the Subscribers to the Shakspeare, that some explanation seems necessary.—It certainly was the Alderman's intention, as well as my own, to have presented the Shakspeare Gallery to the Public, for the improvement of young Artists in Historical Painting: the whole to have been immediately under the patronage of the Subscribers to the Shakspeare.—But the imperious circumstances of the times, as he has truly stated, rendered his liberal and patriotic purpose abortive.——I shall conclude this preface, with an extract from our last advertisement, which finishes this great undertaking.

*March 7th*, 1805.

" Messrs. Boydell and Nicol beg leave to inform the Subscribers to the Shakspeare, that the Medal, which they mean to have the honour of presenting to them, is now finished at the Mint of that ingenious and valuable member of society Mr. Boulton of Birmingham. It has been somewhat delayed by his great public undertakings in this line; but they flatter themselves that its beauty will make amends for the delay.

" They intend that the name of each Subscriber to the Shakspeare shall be engraven on the Medal presented; and that this may be done with accuracy, they entreat the favour of every Subscriber to sign his name, with his own hand, on sheets of vellum, which will be presented to him for that purpose. Or this may be done at No. 90, Cheapside, or No. 58, Pall-Mall, where the Medal may be seen.

" And now this great National Work is concluded, they cannot take leave of their Subscribers without returning them their most grateful thanks, for their long continued and generous support,—they once thought of doing more— as it is, they must content themselves with knowing, that they have put it in the power of every Subscriber to possess, in his own Library, a Monument to the Memory of the immortal Shakspeare, which has cost them considerably above ONE HUNDRED THOUSAND POUNDS. The encouragers of this great national undertaking will also have the satisfaction to know, that their names will be handed down to Posterity, as the Patrons of Native Genius, enrolled with their own hands, in the same book, with the best of Sovereigns—the Father of his People—the Encourager of all good Works. They flatter themselves, that, some hundred years hence, the Autographs of all the first Men of Taste, who lived in England at the end of the eighteenth and the beginning of the nineteenth century, with their SOVEREIGN at their head, will be deemed no small curiosity, especially when this circumstance is celebrated by a Medal, struck for that especial purpose."

JOSIAH BOYDELL.

*March 25th*, 1805.

# A LIST OF THE LARGE PLATES

## TO ILLUSTRATE THE

# SHAKSPEARE.

## VOL. I.

---

### FRONTISPIECE.

Portrait of His Majesty GEORGE III.

Painted by Sir W. Beechey, R. A.  Engraved by B. Smith.

### VIGNETTE IN THE TITLE.
### CORIOLANUS.
#### ACT II. SCENE I.

*Coriolanus, Menenius, Sicinius, Volumnia, Virgilia, &c.*

Engraved by J. Hellyer, after a Basso-Relievo, by the Hon. Anne S. Damer.

### I.

### THE ALTO-RELIEVO,

In the Front of the SHAKSPEARE GALLERY, PALL-MALL,

Represents SHAKSPEARE seated on a Rock, between *Poetry* and *Painting*. *Poetry* is on his Right-hand, addressing and presenting him with a Wreath of Bays, while she celebrates his Praise on her Lyre.  Her Head is ornamented with a double Mask, to shew she has bestowed the double Power of *Tragedy* and *Comedy* upon her favourite Son.  SHAKSPEARE is represented as listening to her with Pleasure and Attention. On his Left is *Painting*, who is addressing the Spectator, with one Hand extended towards SHAKSPEARE's Breast, pointing him out as the proper Object of her Pencil, while he places his Left-hand on her Shoulder, as if accepting her Assistance.

Executed by J. Banks, R. A.  Engraved by B. Smith.

### II.

### THE INFANT SHAKSPEARE,
#### ATTENDED BY
### NATURE AND THE PASSIONS.

Painted by G. Romney.  Engraved by B. Smith.

---

### III.

### THE TEMPEST.
#### ACT I. SCENE II.
##### THE ENCHANTED ISLAND: BEFORE THE CELL OF PROSPERO.

*Prospero and Miranda.*

Painted by G. Romney.  Engraved by B. Smith.

### IV.

#### ACT I. SCENE II.
##### THE ENCHANTED ISLAND: BEFORE THE CELL OF PROSPERO.

*Prospero, Miranda, Caliban, and Ariel.*

Painted by H. Fuseli, R. A.  Engraved by P. Simon.

### V.

### THE TEMPEST.
#### ACT IV. SCENE I.
##### PROSPERO'S CELL.

*Prospero, Ferdinand, Miranda ; a Masque exhibiting Iris, Ceres, Juno, Nymphs ; Caliban, Trinculo, and Stephano, at a Distance.*

Painted by J. Wright, of Derby.  Engraved by R. Thew.

### VI.

#### ACT V. SCENE I.

*The Entrance of the Cell opens, and discovers Ferdinand and Miranda playing at Chess.*

Painted by F. Wheatley, R. A.  Engraved by Caroline Watson.

---

### VII.

### TWO GENTLEMEN OF VERONA.
#### ACT V. SCENE III.
##### A FOREST.

*Valentine, Proteus, Silvia, and Julia.*

Painted by A. Kauffman, R. A.  Engraved by L. Schiavonetti.

---

### VIII.

### MERRY WIVES OF WINDSOR.
#### ACT I. SCENE I.
##### BEFORE PAGE'S HOUSE.

*Anne Page, Slender, and Simple.*

Painted by R. Smirke, R. A.  Engraved by J. P. Simon.

### IX.

#### ACT II. SCENE I.
##### BEFORE PAGE'S HOUSE.

*Mrs. Page with a Letter.*

Painted by the Rev. W. Peters, R. A.  Engraved by R. Thew.

### X.

#### ACT III. SCENE III.

*Mrs. Page, Mrs. Ford, and Falstaff.  Falstaff goes into the Basket ; they cover him with foul Linen.*

Painted by the Rev. W. Peters, R. A.  Engraved by P. Simon.

### XI.

#### ACT IV. SCENE II.

*Ford, Shallow, Page, Caius, Sir Hugh Evans, Falstaff, as the old Woman of Brentford, Mrs. Ford, and Mrs. Page.*

Painted by J. Durno.  Engraved by T. Ryder.

# LIST OF THE LARGE PLATES

## XII.

### MERRY WIVES OF WINDSOR.

#### ACT V. SCENE V.

##### WINDSOR PARK.

*Falstaff (disguised with a Buck's Head on), Fairies, Mrs. Ford, Mrs. Page, Quickly, Pistol, Sir Hugh Evans, Fenton, and Anne Page.*

Painted by R. Smirke, R. A.  Engraved by I. Taylor, Jun.

---

## XIII.

### MEASURE FOR MEASURE.

#### ACT II. SCENE I.

##### ANGELO'S HOUSE.

*Escalus, a Justice, Elbow, Froth, Clown, Officers, &c.*

Painted by R. Smirke, R. A.  Engraved by T. Ryder and C. G. Playter.

## XIV.

#### ACT V. SCENE I.

*Duke in a Friar's Habit, Varrius, Lords, Angelo, Escalus, Lucio, and Citizens. Isabella, Peter, Mariana, Provost, &c.*

Painted by T. Kirk.  Engraved by P. Simon.

---

## XV.

### COMEDY OF ERRORS.

#### ACT V. SCENE I.

##### A STREET BEFORE THE PRIORY.

*Merchant, Angelo, Lady Abbess, Adriana, Courtezan, Duke, Ægeon, Antipholus and Dromio of Syracuse, Antipholus and Dromio of Ephesus, Headsman, &c.*

Painted by J. F. Rigaud, R. A.  Engraved by C. G. Playter.

---

## XVI.

### MUCH ADO ABOUT NOTHING.

#### ACT III. SCENE I.

##### AN ORCHARD.

*Hero, Ursula, and Beatrice.*

Painted by the Rev. W. Peters, R. A.  Engraved by P. Simon.

## XVII.

#### ACT IV. SCENE I.

##### A CHURCH.

*Don Pedro, Don John, Leonato, Friar, Claudio, Benedick, Hero, and Beatrice.*

Painted by W. Hamilton, R. A.  Engraved by P. Simon.

## XVIII.

#### ACT IV. SCENE II.

##### A PRISON.

*Dogberry, Verges, Boracchio, Conrade, the Town Clerk, and Sexton.*

Painted by R. Smirke, R. A.  Engraved by J. Ogborne.

## XIX.

### LOVE'S LABOUR LOST.

#### ACT IV. SCENE I.

##### A PAVILION IN THE PARK, NEAR THE PALACE.

*Princess, Rosaline, Maria, Katherine, Lords, Attendants, and a Forester.*

Painted by W. Hamilton, R. A.  Engraved by T. Ryder.

---

## XX.

### MIDSUMMER-NIGHT'S DREAM.

#### ACT IV. SCENE I.

##### A WOOD.

*Titiana, Queen of the Fairies, Bottom, Fairies attending, &c. &c.*

Painted by H. Fuseli, R. A.  Engraved by P. Simon.

## XXI.

#### ACT IV. SCENE I.

*Oberon, Queen of the Fairies, Puck, Bottom, Fairies attending, &c.*

Painted by H. Fuseli, R. A.  Engraved by T. Ryder.

---

## XXII.

### MERCHANT OF VENICE.

#### ACT II. SCENE V.

##### SHYLOCK'S HOUSE.

*Shylock, Jessica, and Launcelot.*

Painted by R. Smirke, R. A.  Engraved by P. Simon.

## XXIII.

#### ACT V. SCENE I.

##### BELMONT: A GROVE OR GREEN PLACE BEFORE PORTIA'S HOUSE.

*Jessica, Lorenzo, and Stephano.*

Painted by W. Hodges, R. A.  Engraved by J. Browne.

---

## XXIV.

### AS YOU LIKE IT.

#### ACT I. SCENE II.

##### BEFORE THE DUKE'S PALACE.

*Rosalind, Celia, Orlando, Duke, and Attendants, &c. Charles carried off.*

Painted by J. Downman, R. A.  Engraved by W. Leney.

## XXV.

#### ACT II. SCENE I.

##### FOREST OF ARDEN.

*Jaques and Amiens.*

Painted by W. Hodges, R. A.  Engraved by S. Middiman.

# TO ILLUSTRATE THE SHAKSPEARE.

## XXVI.

### AS YOU LIKE IT.
#### ACT IV. SCENE III.
##### A FOREST.

*Orlando and Oliver.*

Painted by R. West.    Engraved by W. C. Wilson.

## XXVII.

#### ACT V. SCENE IV.
##### A FOREST.

*Duke Senior, Amiens, Jaques, Orlando, Oliver, Celia, Rosalind, Audry, Clown, Silvius, Phebe, Hymen, &c.*

Painted by W. Hamilton, R. A.    Engraved by P. Simon.

## XXVIII.

### TAMING OF THE SHREW.
#### INDUCTION.
#### SCENE II.
##### A ROOM IN THE LORD'S HOUSE.

*Sly, with Lord and Attendants; some with Apparel, Bason and Ewer, and other Appurtenances.*

Painted by R. Smirke, R. A.    Engraved by R. Thew.

## XXIX.

#### ACT III. SCENE II.
##### BAPTISTA'S HOUSE.

*Petruchio, Katherine, Bianca, Hortensia, Baptista, Grumio, and Train.*

Painted by F. Wheatley, R. A.    Engraved by P. Simon.

## XXX.

### ALL'S WELL THAT ENDS WELL.
#### ACT V. SCENE III.

*King, Countess, Lafeu, Lords, Attendants, &c. Bertram guarded, Diana, and Widow.*

Painted by F. Wheatley, R. A.    Engraved by G. S. and J. G. Facius.

## XXXI.

### TWELFTH NIGHT.
#### ACT III. SCENE IV.
##### OLIVIA'S HOUSE.

*Olivia, Maria, and Malvolio.*

Painted by H. Ramberg, Professor of Painting at Hanover. Engraved by T. Ryder.

## XXXII.

#### ACT V. SCENE I.
##### THE STREET.

*The Duke, Viola, Antonio, Officers, Olivia, Priest, and Attendants.*

Painted by W. Hamilton, R. A. Engraved by F. Bartolozzi, R. A.

## XXXIII.

### WINTER'S TALE.
#### ACT II. SCENE III.
##### A PALACE.

*Leontes, Antigonus, Lords, Attendants, and the Infant Perdita.*

Painted by J. Opie, R. A.    Engraved by P. Simon.

## XXXIV.

#### ACT III. SCENE III.
##### A DESERT PLACE NEAR THE SEA.

*Antigonus pursued by a Bear.*

Painted by J. Wright, of Derby.    Engraved by S. Middiman.

## XXXV.

#### ACT IV. SCENE III.
##### A SHEPHERD'S COT.

*Florizel, Perdita, Shepherd, Clown, Mopsa, Dorcas, Servants, Polixenes, and Camillo disguised.*

Painted by F. Wheatley, R. A.    Engraved by J. Fittler.

## XXXVI.

#### ACT V. SCENE III.
##### PAULINA'S HOUSE.

*Leontes, Polixenes, Florizel, Perdita, Camillo, Paulina, Lords, and Attendants. Hermione as a Statue.*

Painted by W. Hamilton, R. A.    Engraved by R. Thew.

## XXXVII.

### MACBETH.
#### ACT I. SCENE III.
##### A HEATH.

*Macbeth, Banquo, and three Witches.*

Painted by H. Fuseli, R. A.    Engraved by J. Caldwall.

## XXXVIII.

#### ACT I. SCENE V.
##### INVERNESS. A ROOM IN MACBETH'S CASTLE.

*Lady Macbeth with a Letter.*

Painted by R. Westall, R. A.    Engraved by J. Parker.

## XXXIX.

#### ACT IV. SCENE I.
##### A DARK CAVE, IN THE MIDDLE A CAULDRON BOILING.

*Three Witches, Macbeth, Hecate, &c.*

Painted by Sir Joshua Reynolds, late President of the Royal Academy.    Engraved by R. Thew.

# LIST OF THE LARGE PLATES, &c.

## AS YOU LIKE IT.

### ACT II. SCENE VII.

## THE SEVEN AGES.

Painted by Robert Smirke, R.A.

*Jaques.* All the world's a stage,
And all the men and women merely players :
They have their exits, and their entrances ;
And one man in his time plays many parts,
His acts being seven ages.

XL.             No. 1.   *Engraved by P. W. Tomkins.*

                    At first the infant,
Mewling and puking in the nurse's arms :

XLI.            No. 2.   *Engraved by J. Ogborne.*

And then, the whining school-boy, with his satchel,
And shining morning face, creeping like snail
Unwillingly to school :

XLII.           No. 3.   *Engraved by R. Thew.*

                    And then, the lover ;
Sighing like furnace, with a woeful ballad
Made to his mistress' eyebrow :

XLIII.          No. 4.   *Engraved by J. Ogborne.*

                    Then, a soldier ;
Full of strange oaths, and bearded like the pard,
Jealous in honour, sudden and quick in quarrel,
Seeking the bubble reputation
Even in the cannon's mouth ;

LXIV.           No. 5.   *Engraved by P. Simon.*

                    And then, the justice
In fair round belly, with good capon lin'd,
With eyes severe, and beard of formal cut,
Full of wise saws and modern instances,
And so he plays his part :

XLV.            No. 6.   *Engraved by W. Leney.*

                    The sixth age shifts
Into the lean and slipper'd pantaloon ;
With spectacles on nose, and pouch on side ;
His youthful hose well sav'd, a world too wide
For his shrunk shank ; and his big manly voice
Turning again toward childish treble, pipes
And whistles in his sound :

XLVI.           No. 7.   *Engraved by P. Simon.*

                    Last scene of all,
That ends this strange eventful history,
Is second childishness and mere oblivion ;
Sans teeth, sans eyes, sans taste, sans every thing.

# I.

## THE ALTO-RELIEVO,

In the Front of the SHAKSPEARE GALLERY, PALL-MALL,

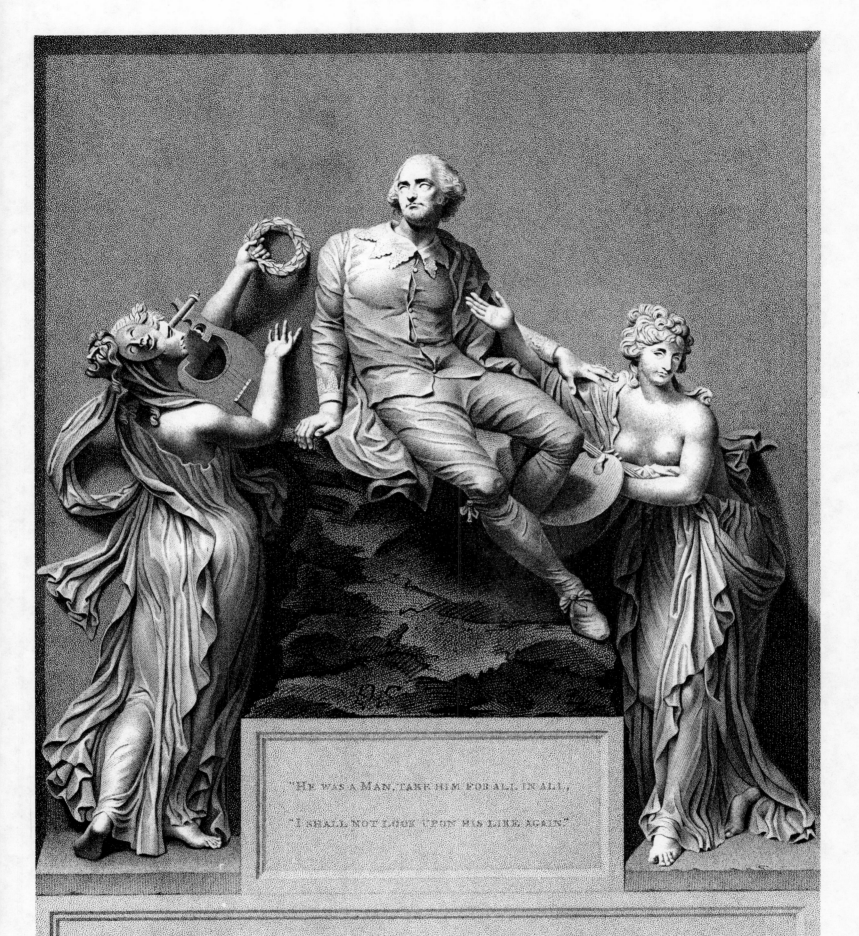

"HE WAS A MAN, TAKE HIM FOR ALL IN ALL;

"I SHALL NOT LOOK UPON HIS LIKE AGAIN."

THE ALTO RELIEVO
IN THE FRONT OF THE SHAKSPEARE GALLERY,
PALL-MALL.

II.

THE INFANT SHAKSPEARE,

ATTENDED BY

NATURE AND THE PASSIONS.

Painted by G. Romney.   Engraved by B. Smith.

III.

# THE TEMPEST.

## ACT I. SCENE II.

THE ENCHANTED ISLAND: BEFORE THE CELL OF PROSPERO.

*Prospero and Miranda.*

Painted by G. Romney.   Engraved by B. Smith.

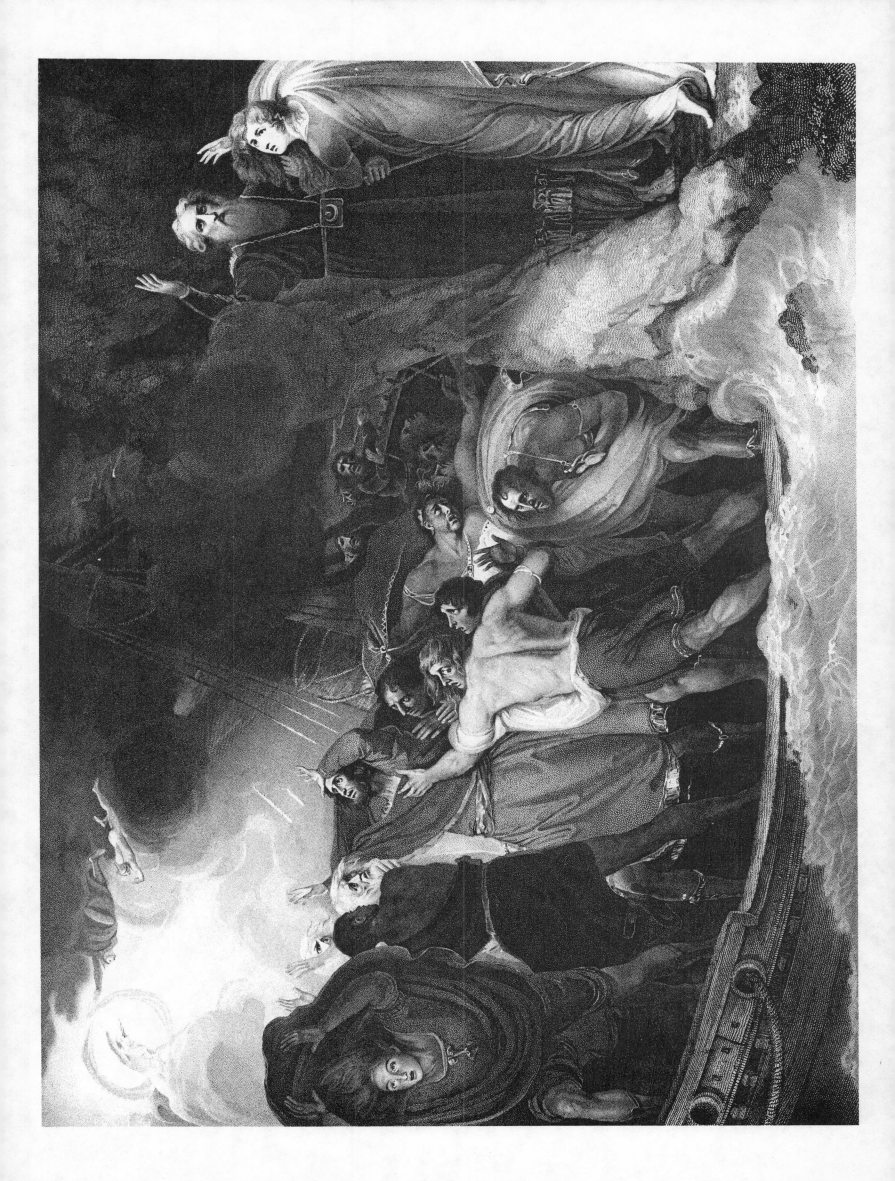

# IV.

## ACT I. SCENE II.

THE ENCHANTED ISLAND: BEFORE THE CELL OF PROSPERO.

*Prospero, Miranda, Caliban, and Ariel.*

Painted by H. Fuseli, R. A.    Engraved by P. Simon.

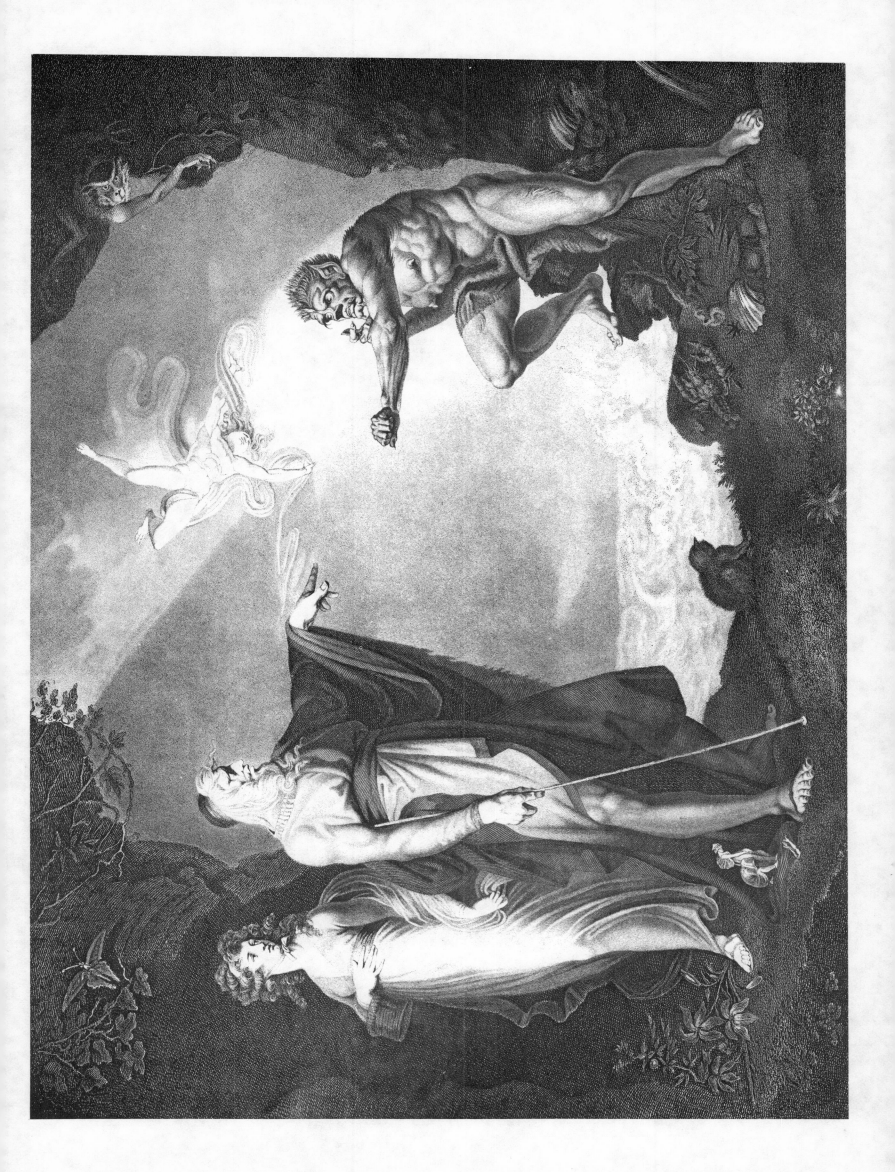

V.

# THE TEMPEST.

## ACT IV. SCENE I.

### PROSPERO'S CELL.

*Prospero, Ferdinand, Miranda; a Masque exhibiting Iris, Ceres, Juno, Nymphs; Caliban, Trinculo, and Stephano, at a Distance.*

Painted by J. Wright, of Derby.    Engraved by R. Thew.

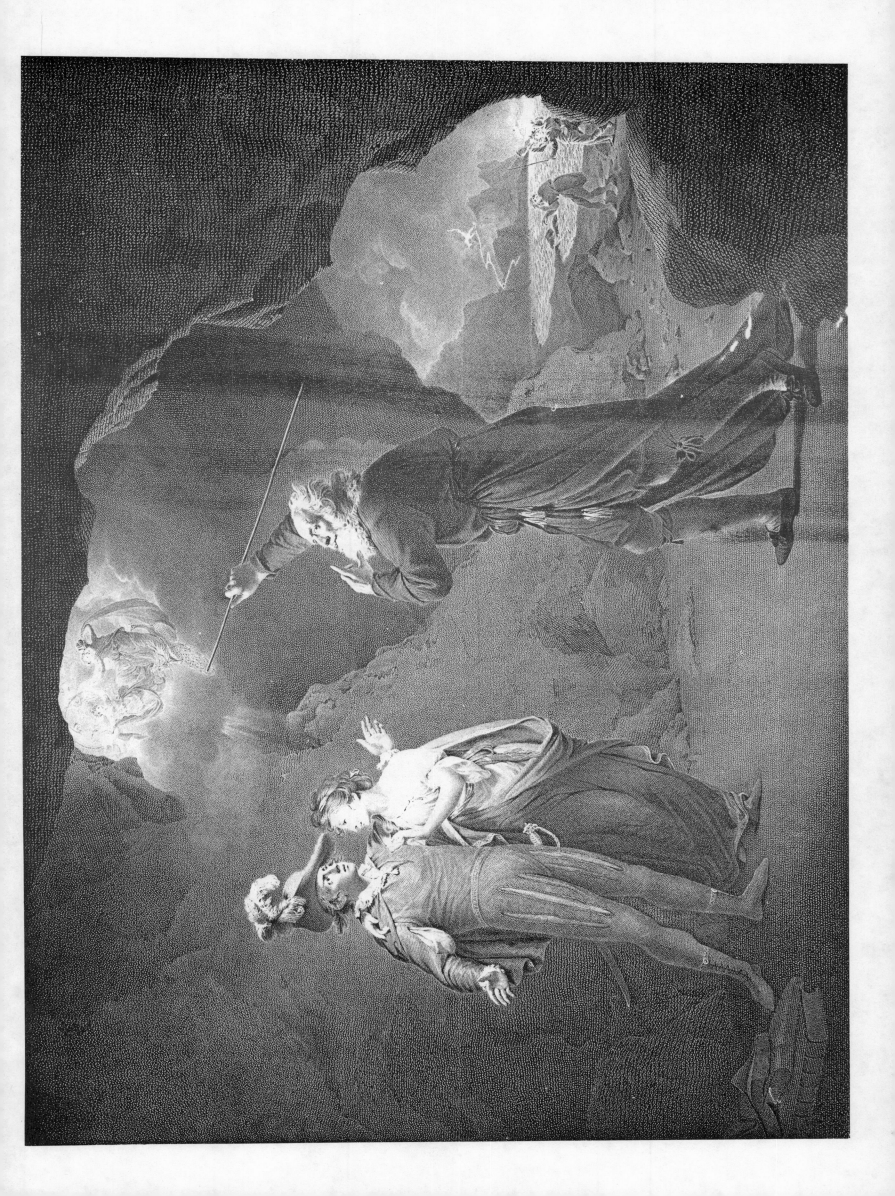

# VI.

## ACT V. SCENE I.

*The Entrance of the Cell opens, and discovers Ferdinand and Miranda playing at Chess.*

Painted by F. Wheatley, R.A. Engraved by Caroline Watson.

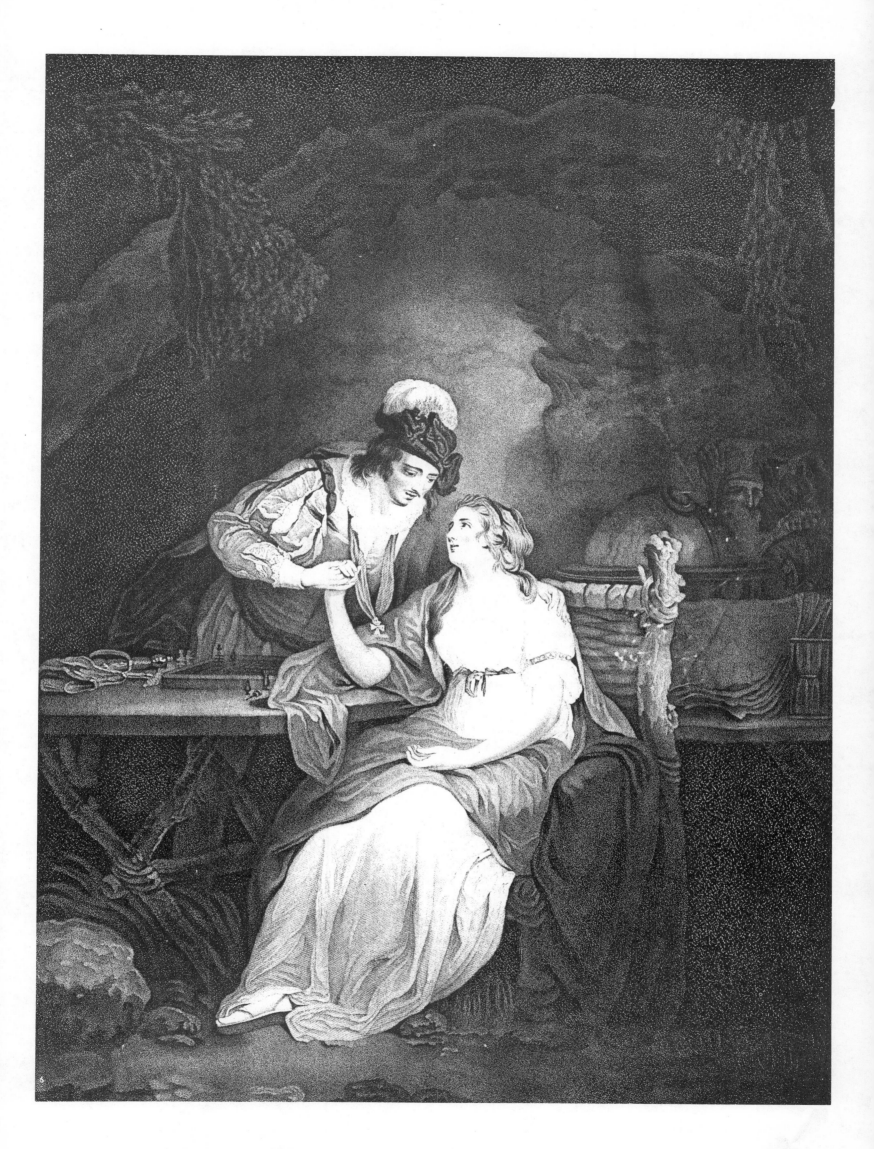

VII.

# TWO GENTLEMEN OF VERONA.

## ACT V. SCENE III.

A FOREST.

*Valentine, Proteus, Silvia, and Julia.*

Painted by A. Kauffman, R. A.   Engraved by L. Schiavonetti.

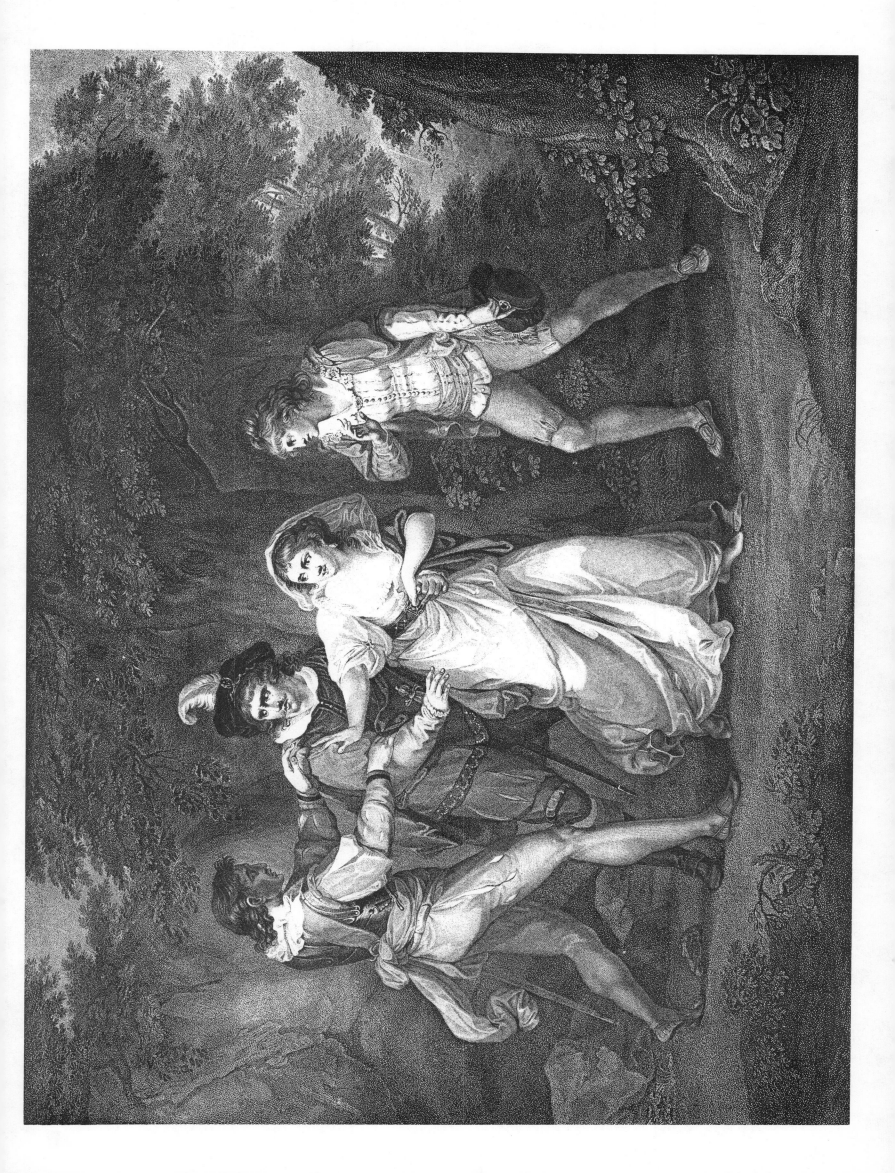

## VIII.

## MERRY WIVES OF WINDSOR.

### ACT I. SCENE I.

BEFORE PAGE'S HOUSE.

*Anne Page, Slender, and Simple.*

Painted by R. Smirke, R. A.  Engraved by J. P. Simon.

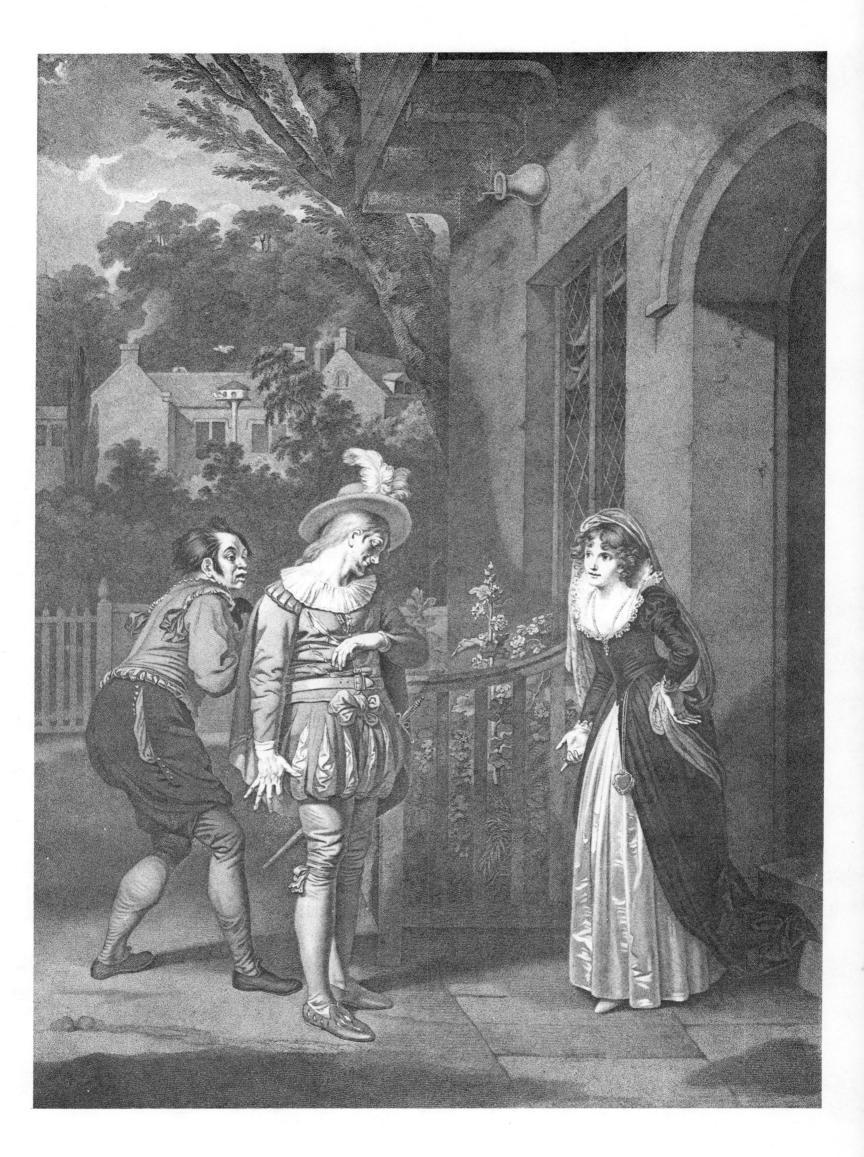

# IX.

## ACT II. SCENE I.

BEFORE PAGE'S HOUSE.

*Mrs. Page with a Letter.*

Painted by the Rev. W. Peters, R. A. Engraved by R. Thew.

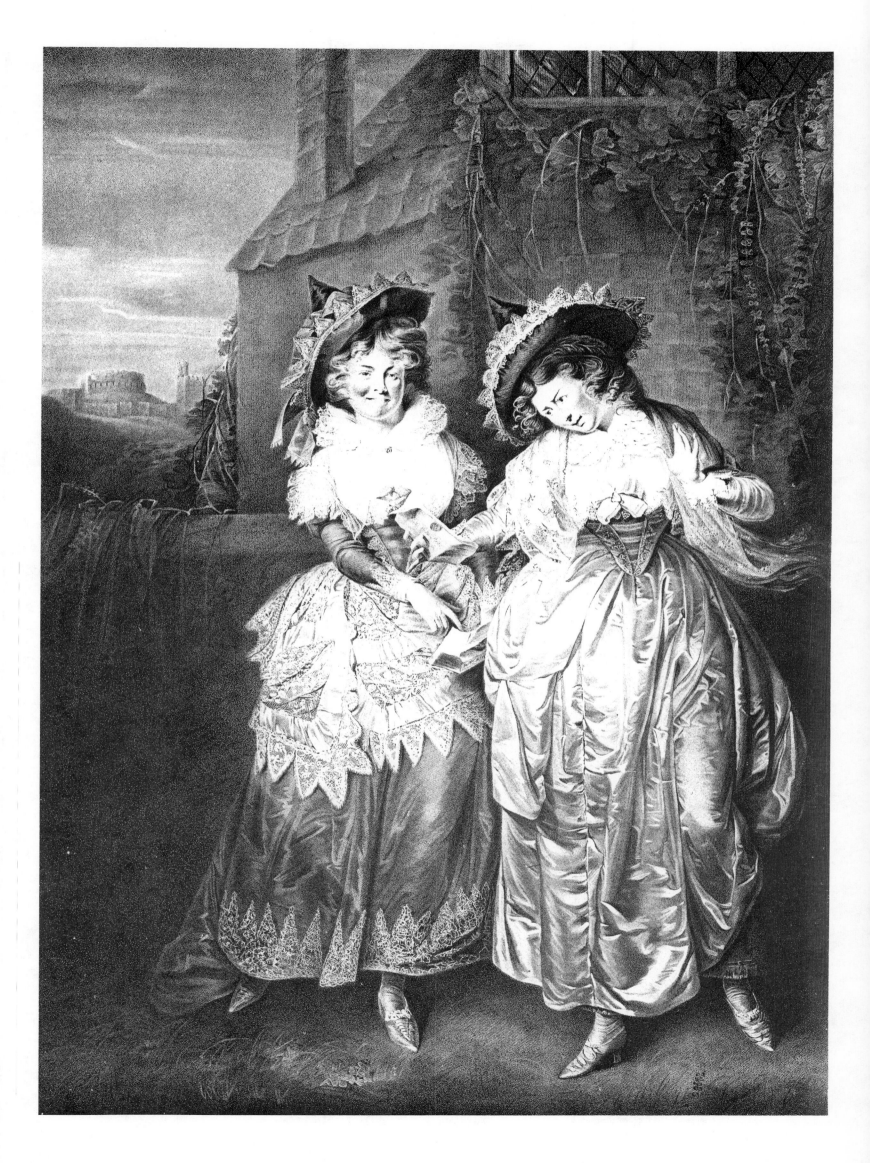

# X.

## ACT III. SCENE III.

*Mrs. Page, Mrs. Ford, and Falstaff.   Falstaff goes into the Basket ; they cover him with foul Linen.*

Painted by the Rev. W. Peters, R. A.  Engraved by P. Simon.

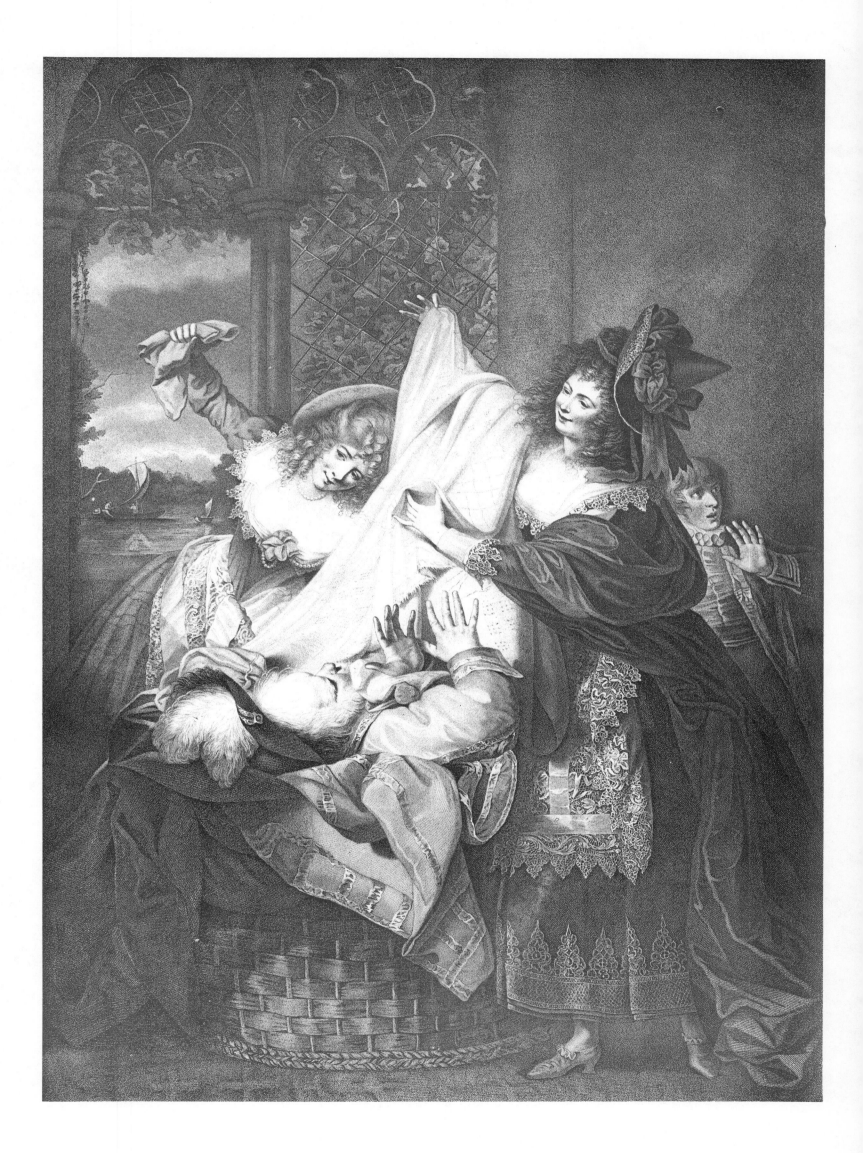

XI.

ACT IV. SCENE II.

*Ford, Shallow, Page, Caius, Sir Hugh Evans, Falstaff, as the old Woman of Brentford, Mrs. Ford, and Mrs. Page.*

Painted by J. Durno.    Engraved by T. Ryder.

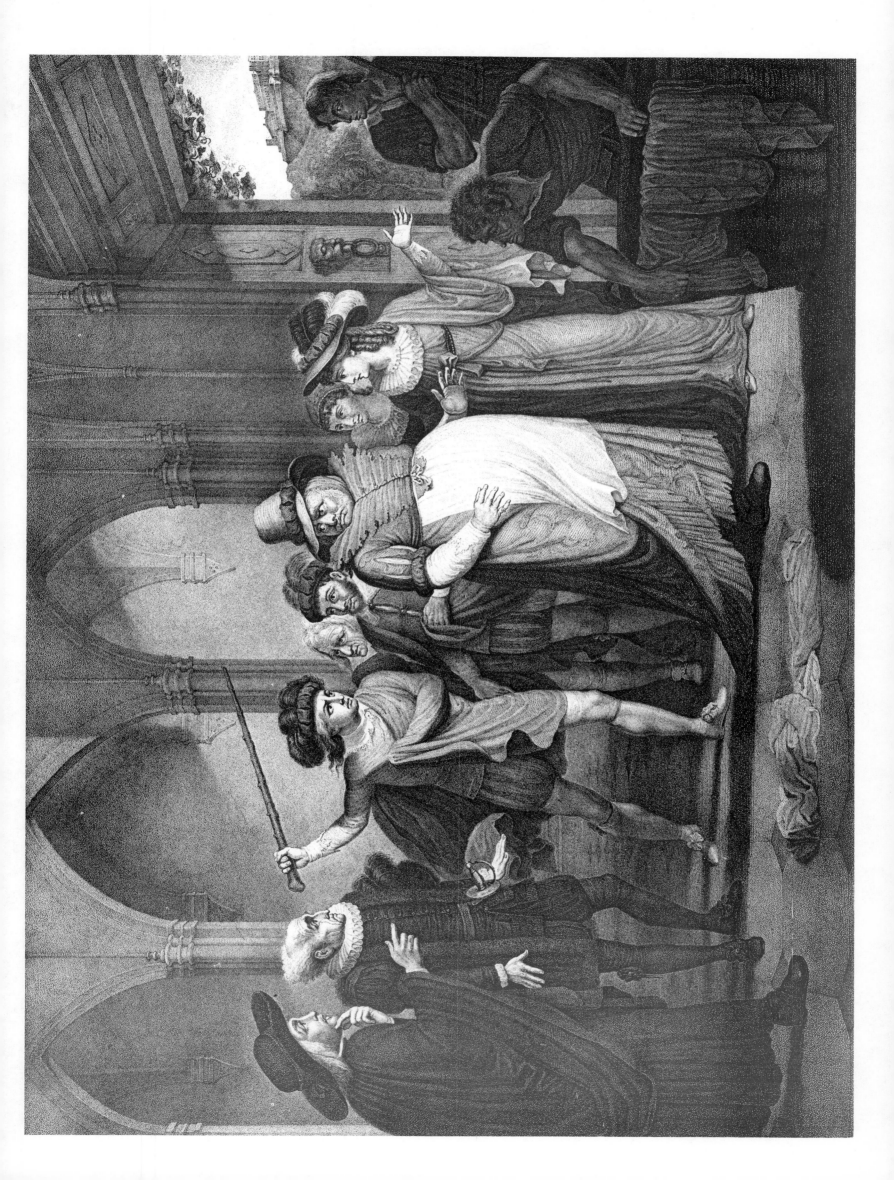

XII.

# MERRY WIVES OF WINDSOR.

## ACT V. SCENE V.

WINDSOR PARK.

*Falstaff (disguised with a Buck's Head on), Fairies, Mrs. Ford, Mrs. Page, Quickly, Pistol, Sir Hugh Evans, Fenton, and Anne Page.*

Painted by R. Smirke, R. A.  Engraved by I. Taylor, Jun.

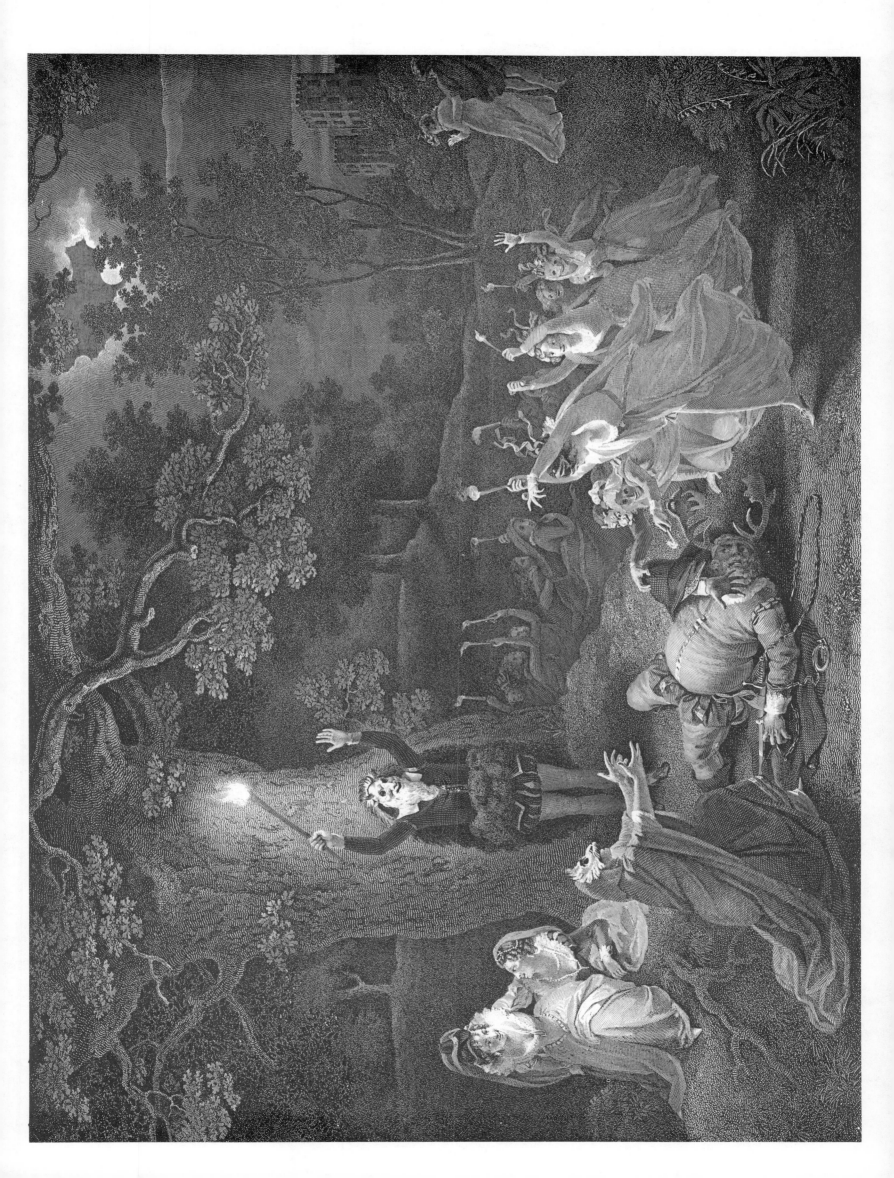

XIII.

# MEASURE FOR MEASURE.

## ACT II. SCENE I.

ANGELO'S HOUSE.

*Escalus, a Justice, Elbow, Froth, Clown, Officers, &c.*

Painted by R. Smirke, R. A.  Engraved by T. Ryder and
C. G. Playter.

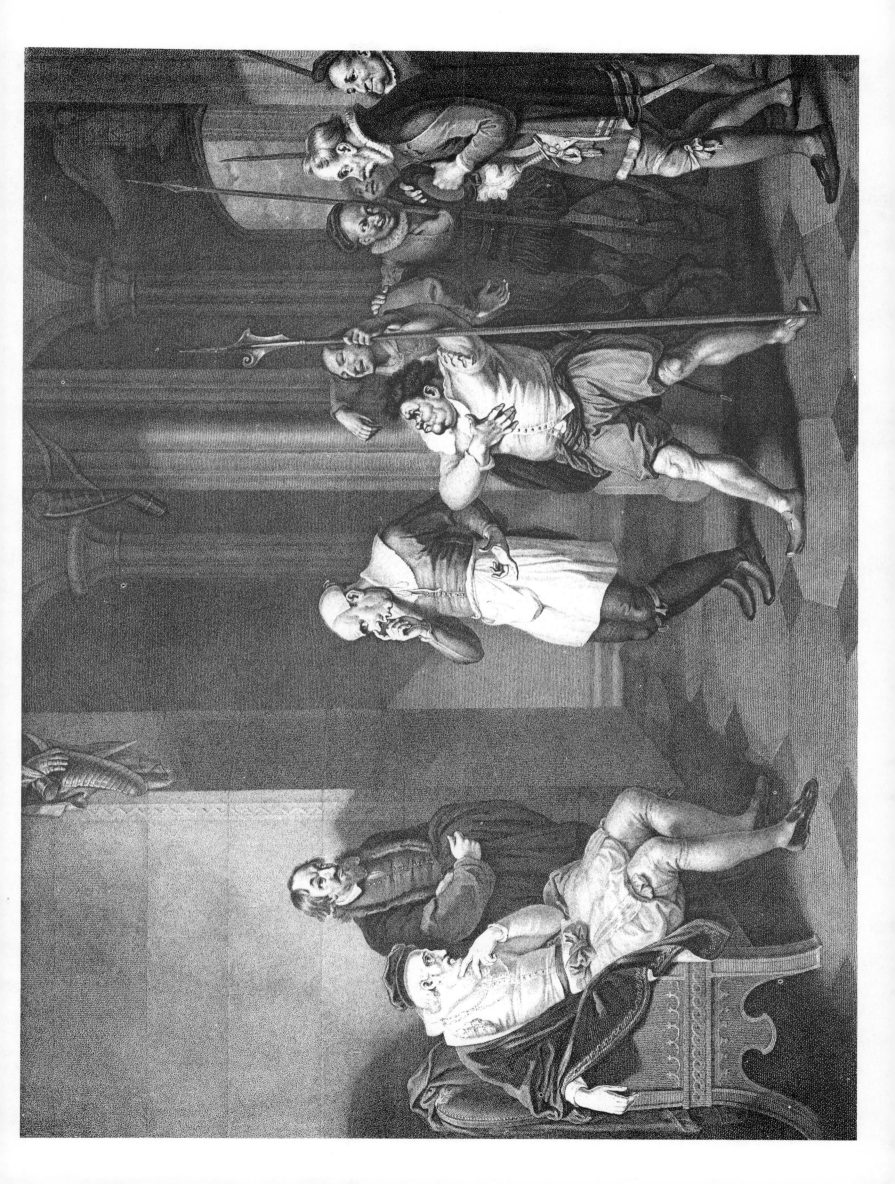

XIV.

ACT V. SCENE I.

*Duke in a Friar's Habit, Varrius, Lords, Angelo, Escalus, Lucio, and Citizens. Isabella, Peter, Mariana, Provost, &c.*

Painted by T. Kirk.    Engraved by P. Simon.

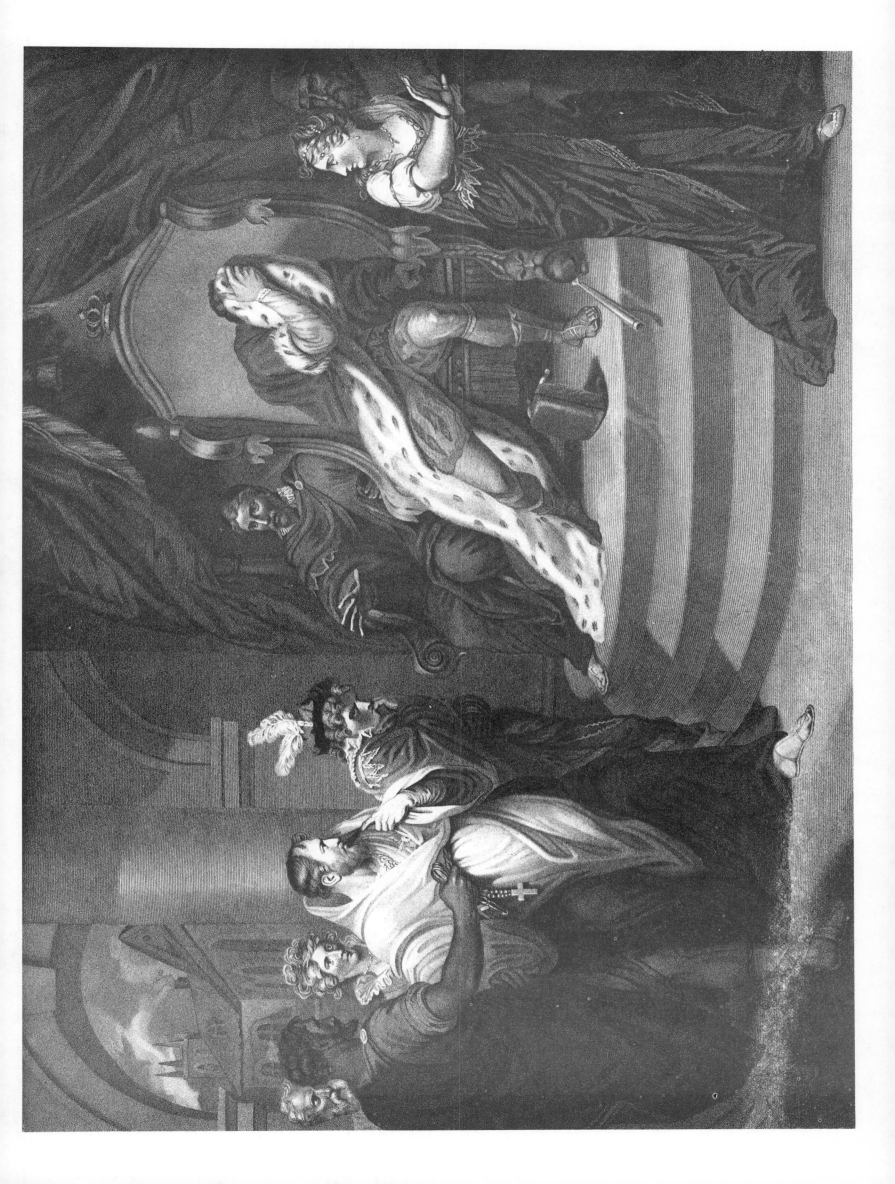

XV.

# COMEDY OF ERRORS.

## ACT V. SCENE I.

A STREET BEFORE THE PRIORY.

*Merchant, Angelo, Lady Abbess, Adriana, Courtezan, Duke, Ægeon,*
*Antipholus and Dromio of Syracuse, Antipholus and Dromio of*
*Ephesus, Headsman, &c.*

Painted by J. F. Rigaud, R. A.   Engraved by C. G. Playter.

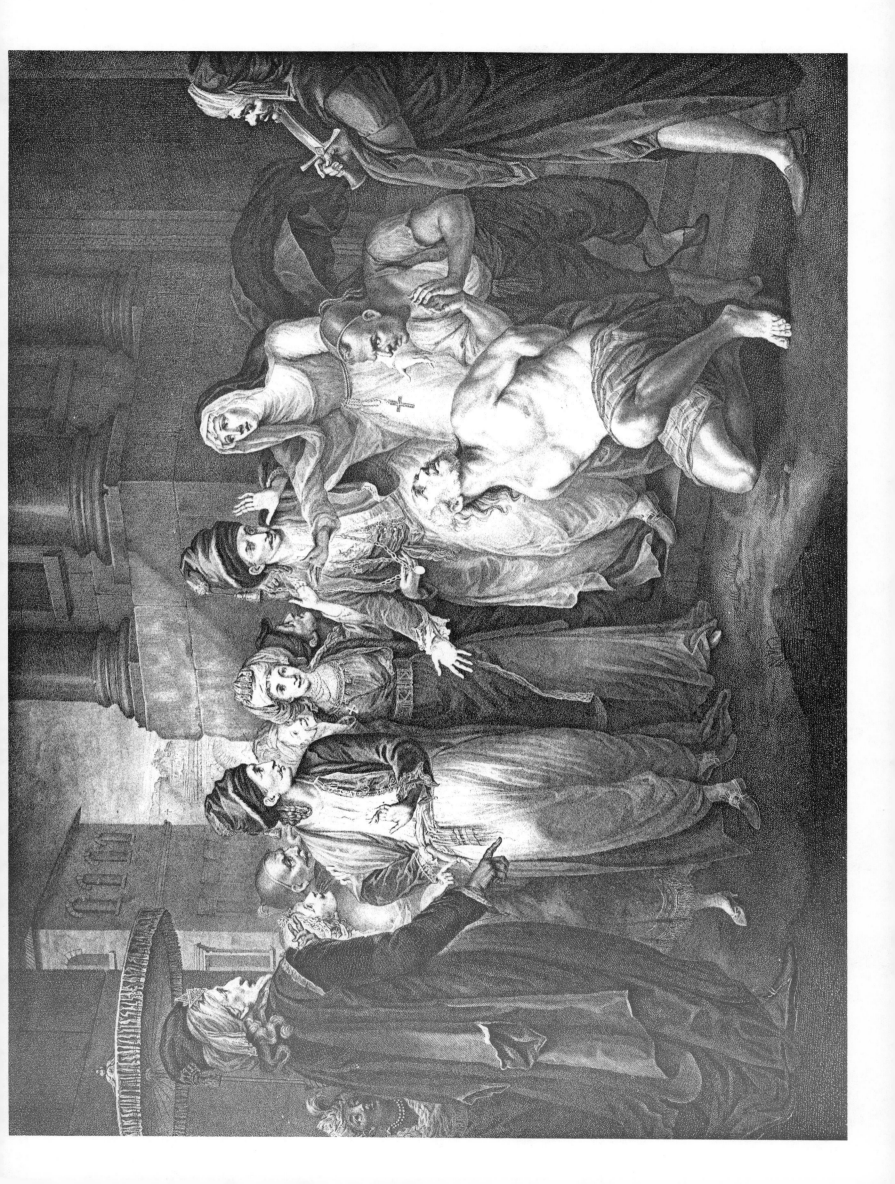

XVI.

## MUCH ADO ABOUT NOTHING.

### ACT III. SCENE I.

AN ORCHARD.

*Hero, Ursula, and Beatrice.*

Painted by the Rev. W. Peters, R.A.  Engraved by P. Simon.

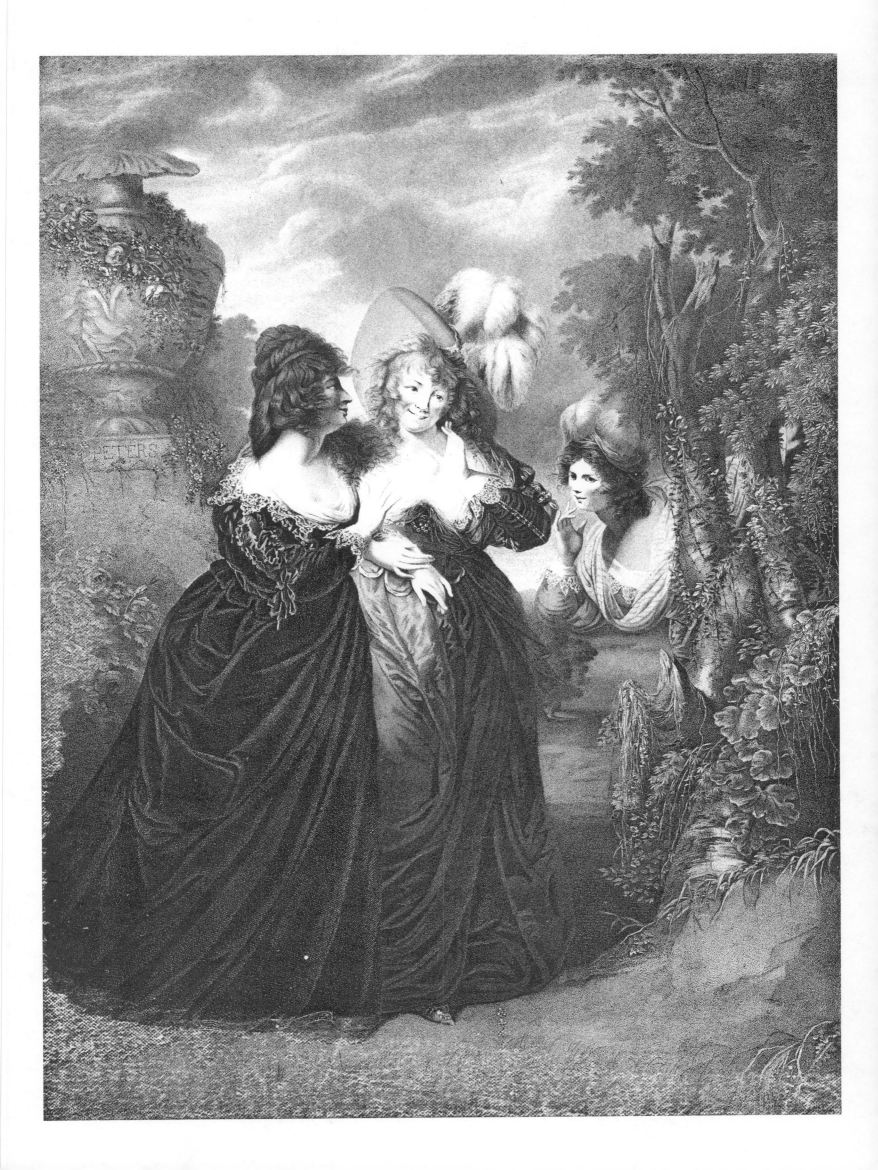

XVII.

ACT IV. SCENE I.

A CHURCH.

*Don Pedro, Don John, Leonato, Friar, Claudio, Benedick, Hero, and Beatrice.*

Painted by W. Hamilton, R. A.   Engraved by P. Simon.

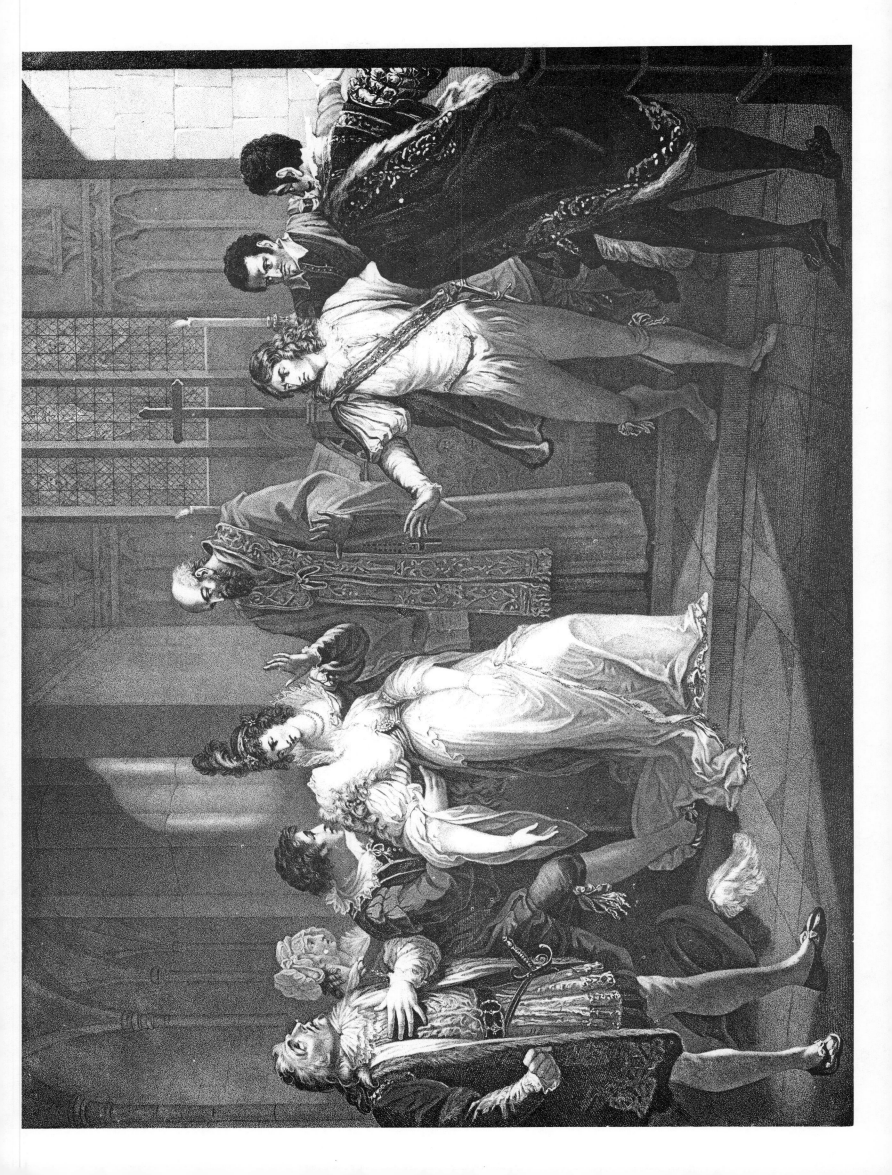

XVIII.

ACT IV. SCENE II.

A PRISON.

*Dogberry, Verges, Boracchio, Conrade, the Town Clerk, and Sexton.*

Painted by R. Smirke, R. A.     Engraved by J. Ogborne.

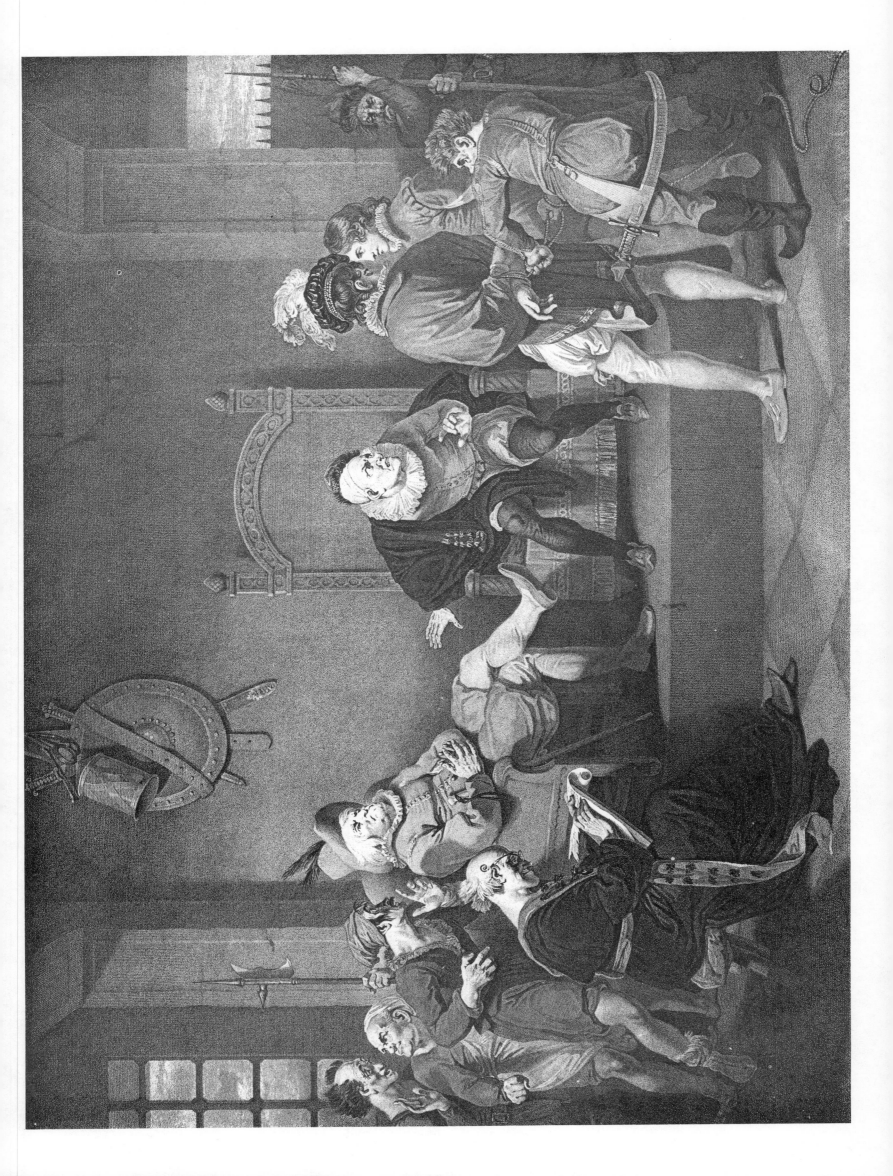

XIX.

# LOVE'S LABOUR LOST.

## ACT IV. SCENE I.

A PAVILION IN THE PARK, NEAR THE PALACE.

*Princess, Rosaline, Maria, Katherine, Lords, Attendants, and a Forester.*

Painted by W. Hamilton, R. A.   Engraved by T. Ryder.

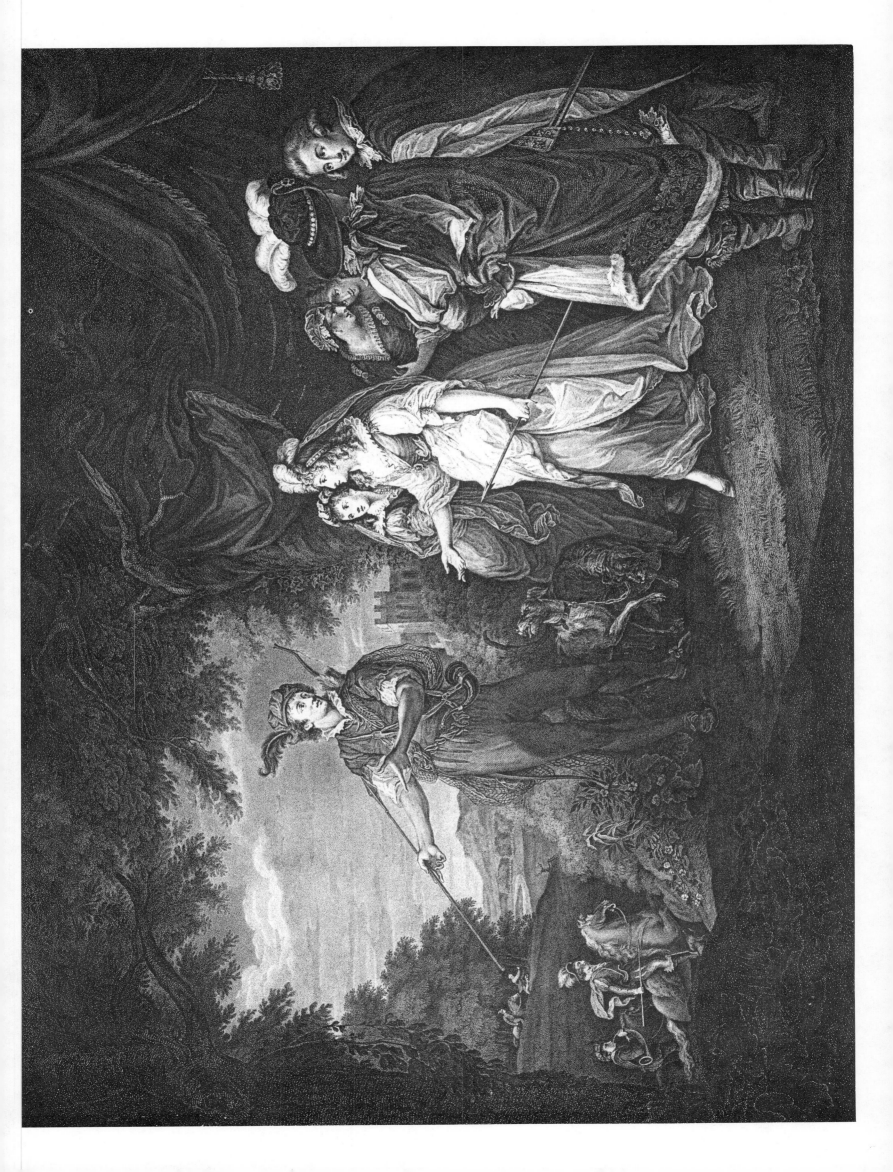

XX.

# MIDSUMMER-NIGHT'S DREAM.

## ACT IV. SCENE I.

### A WOOD.

*Titiana, Queen of the Fairies, Bottom, Fairies attending, &c. &c.*

Painted by H. Fuseli, R. A.   Engraved by P. Simon.

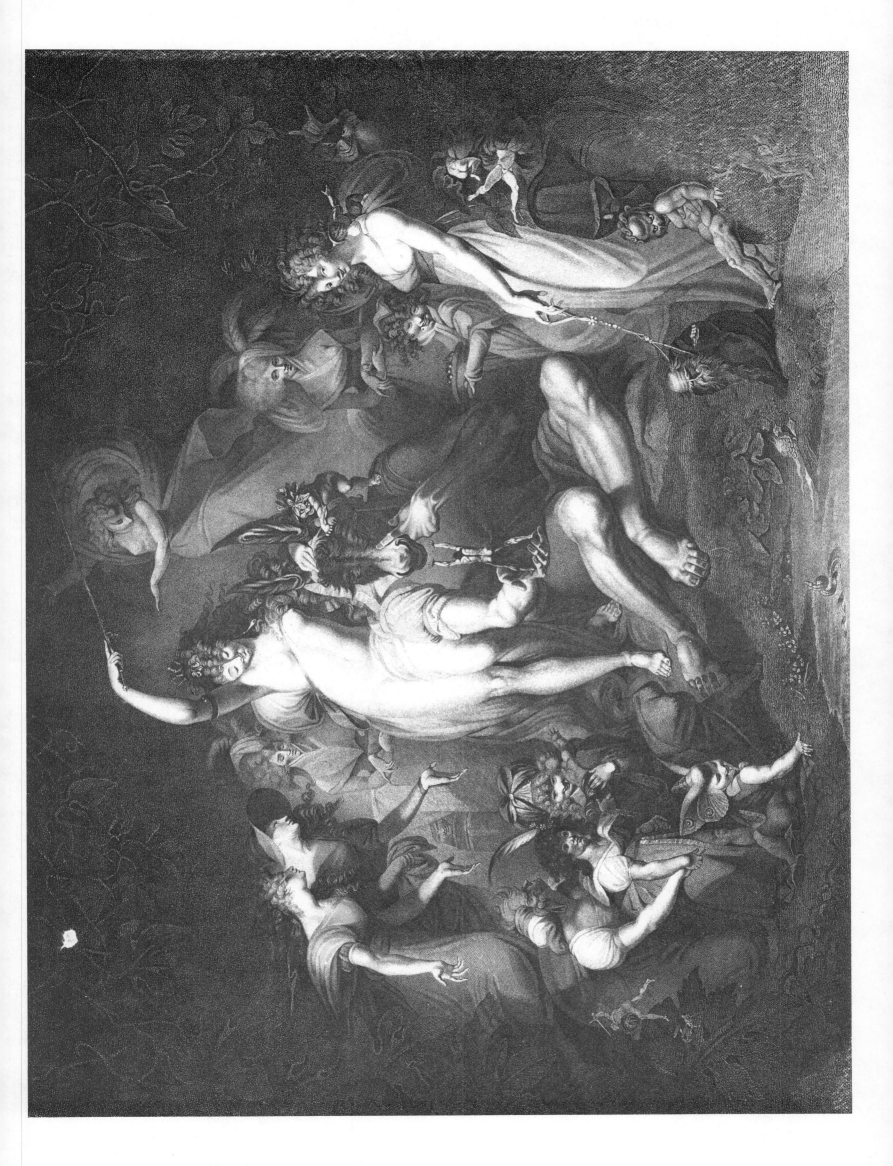

XXI.

ACT IV. SCENE I.

*Oberon, Queen of the Fairies, Puck, Bottom, Fairies attending, &c.*

Painted by H. Fuseli, R. A.   Engraved by T. Ryder.

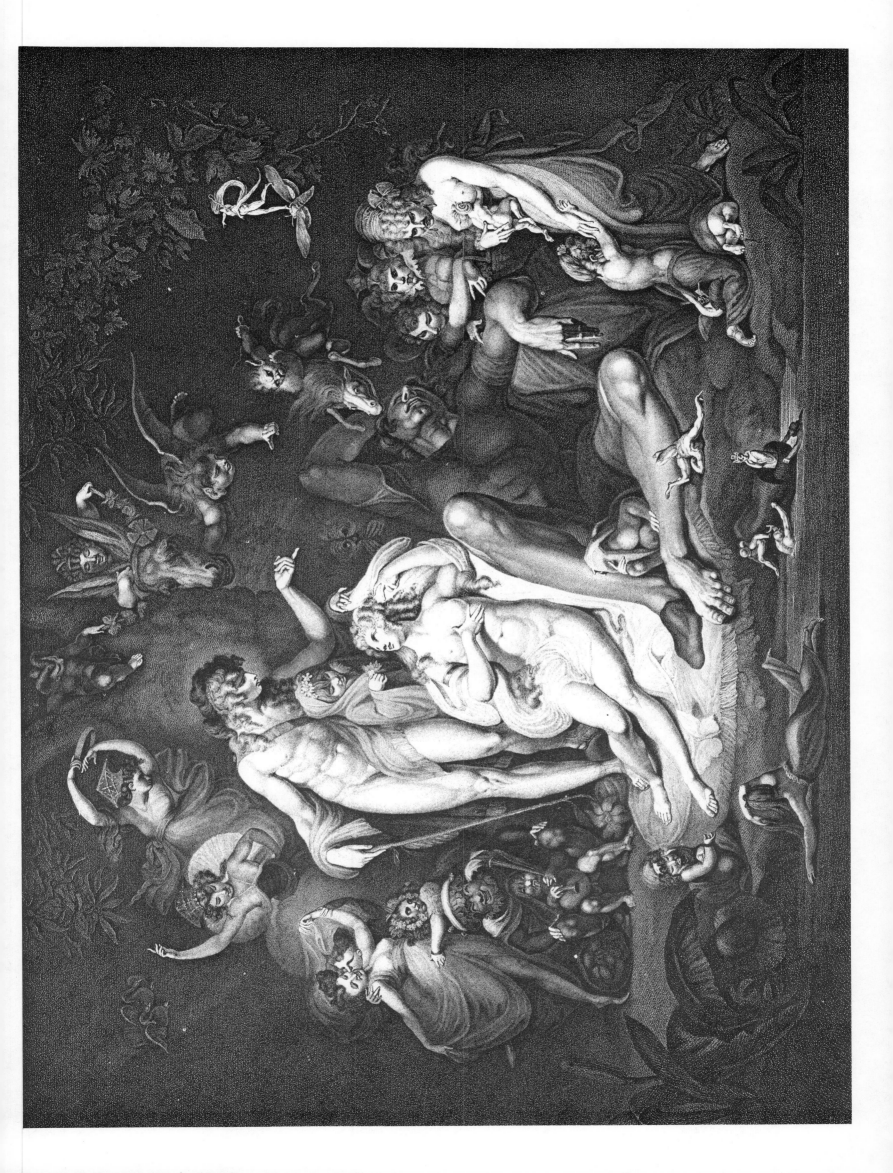

XXII.

# MERCHANT OF VENICE.

## ACT II. SCENE V.

SHYLOCK'S HOUSE.

*Shylock, Jessica, and Launcelot.*

Painted by R. Smirke, R. A.   Engraved by P. Simon.

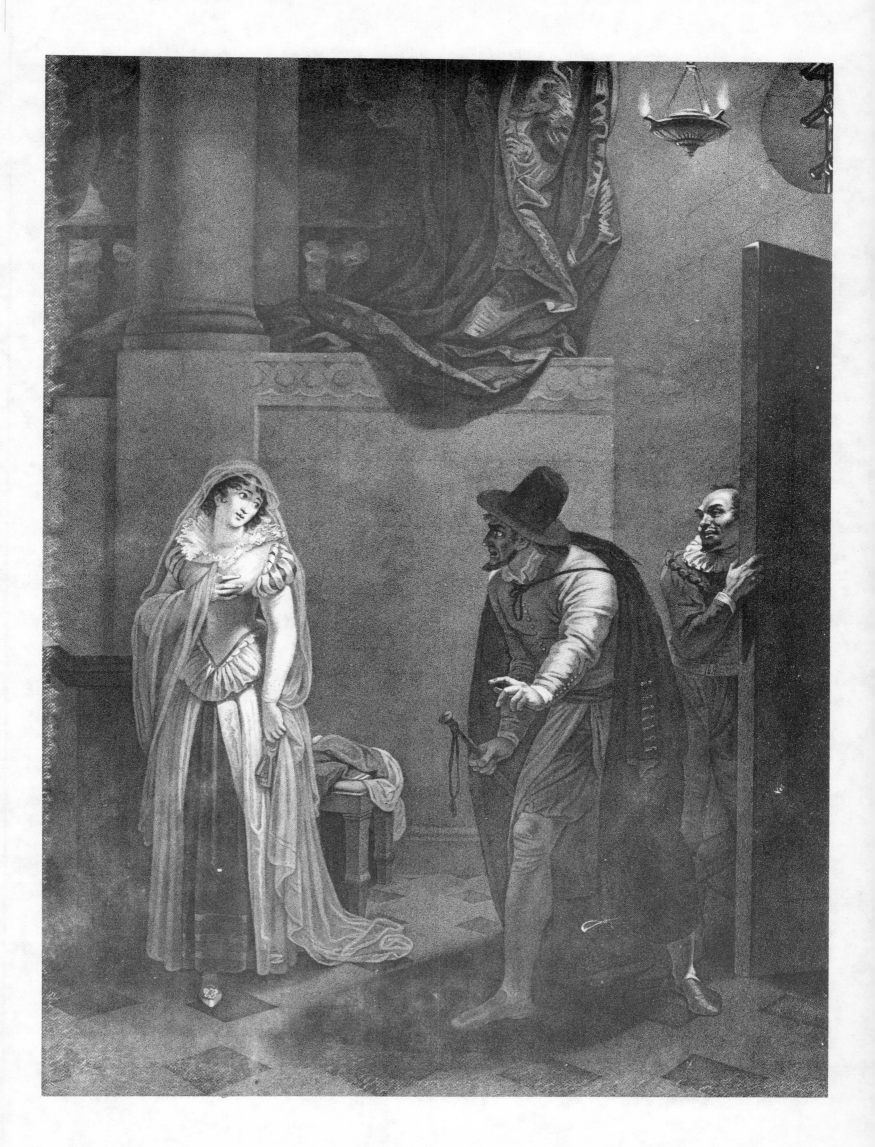

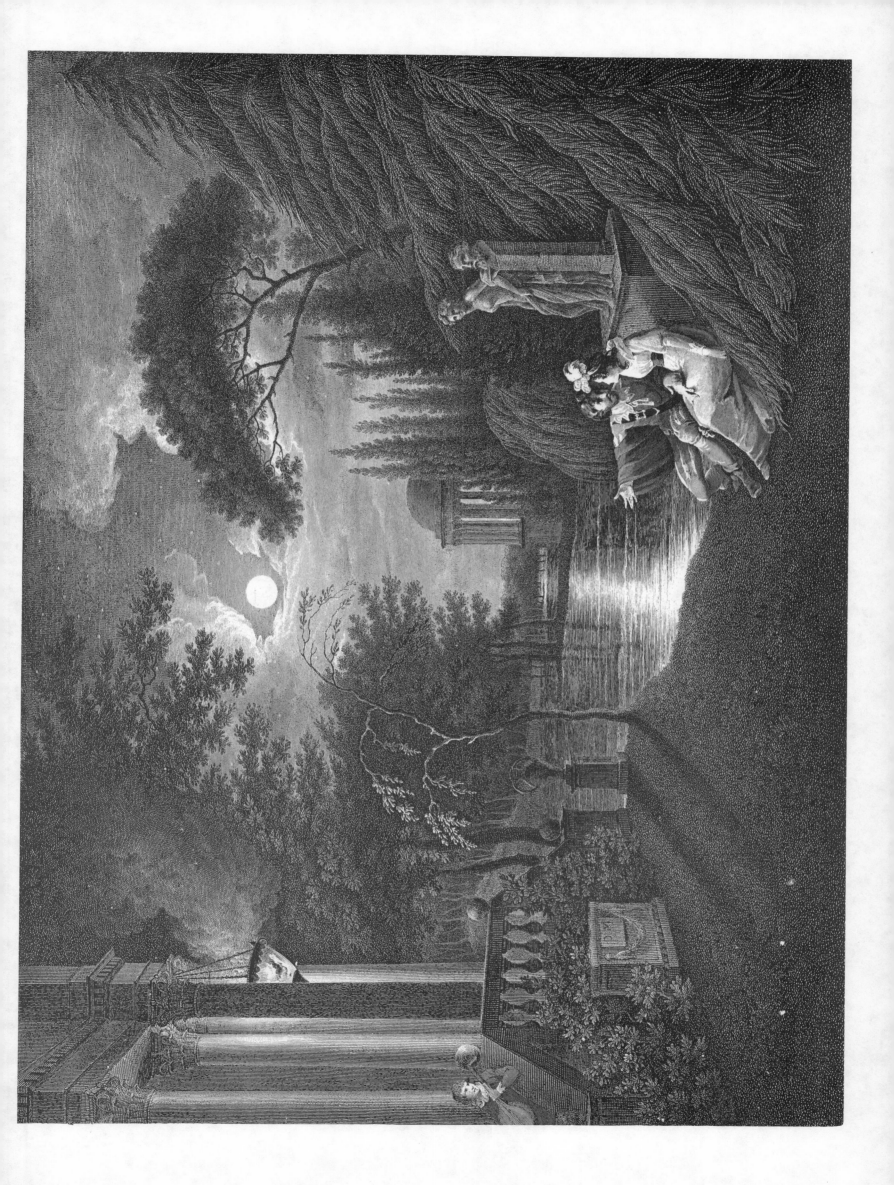

## XXIV.

## AS YOU LIKE IT.

### ACT I. SCENE II.

BEFORE THE DUKE'S PALACE.

*Rosalind, Celia, Orlando, Duke, and Attendants, &c. Charles carried off.*

Painted by J. Downman, R. A.   Engraved by W. Leney.

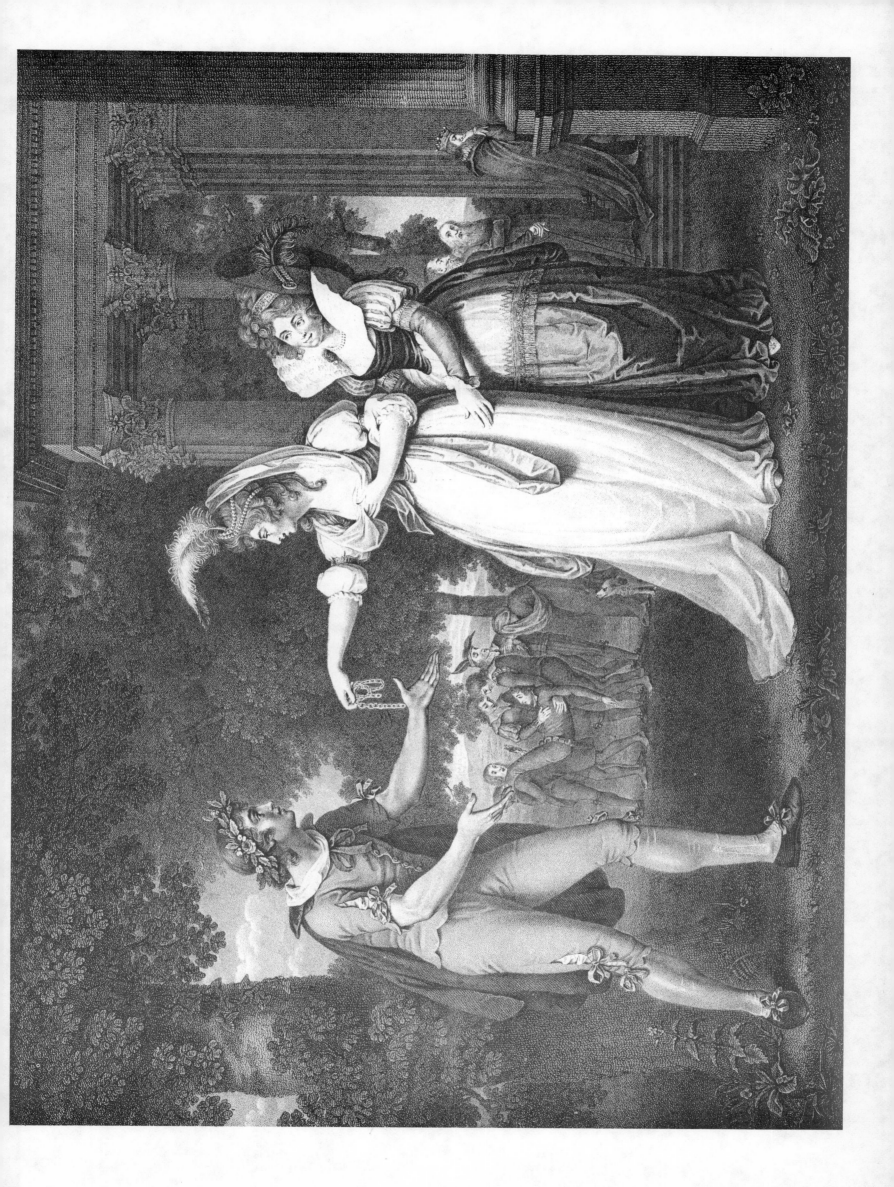

XXV.

ACT II. SCENE I.

FOREST OF ARDEN.

*Jaques and Amiens.*

Painted by W. Hodges, R. A.   Engraved by S. Middiman.

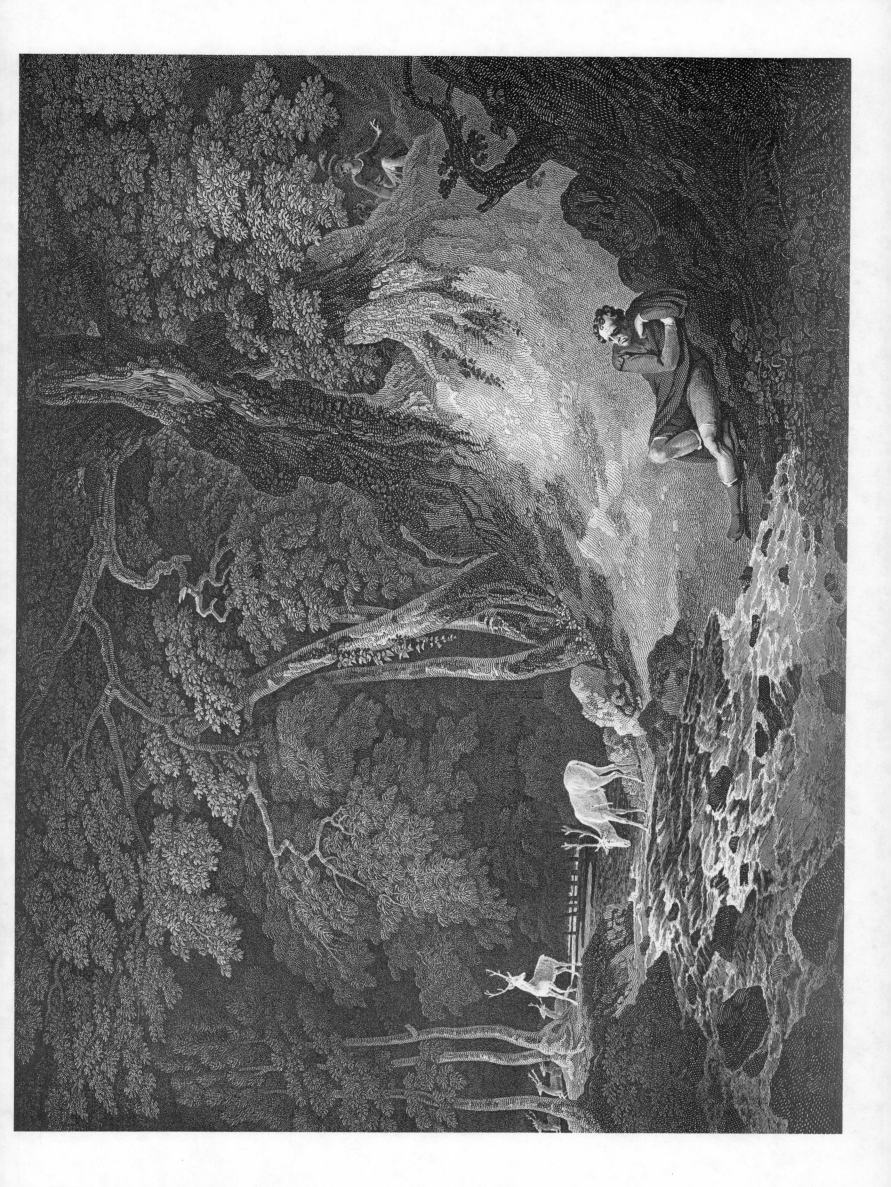

XXVI.

AS YOU LIKE IT.

ACT IV. SCENE III.

A FOREST.

*Orlando and Oliver.*

Painted by R. West.    Engraved by W. C. Wilson.

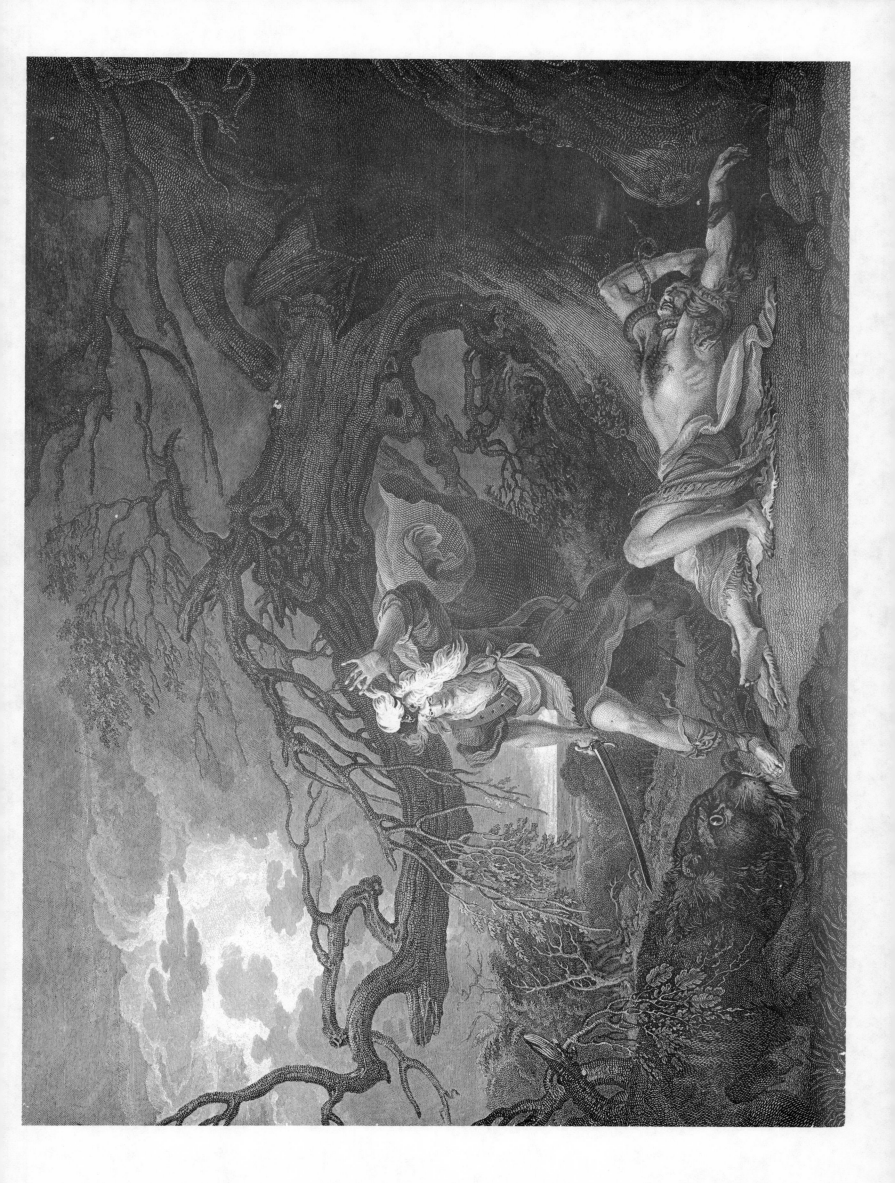

XXVII.

## ACT V. SCENE IV.

A FOREST.

*Duke Senior, Amiens, Jaques, Orlando, Oliver, Celia, Rosalind, Audry, Clown, Silvius, Phebe, Hymen, &c.*

Painted by W. Hamilton, R. A.    Engraved by P. Simon.

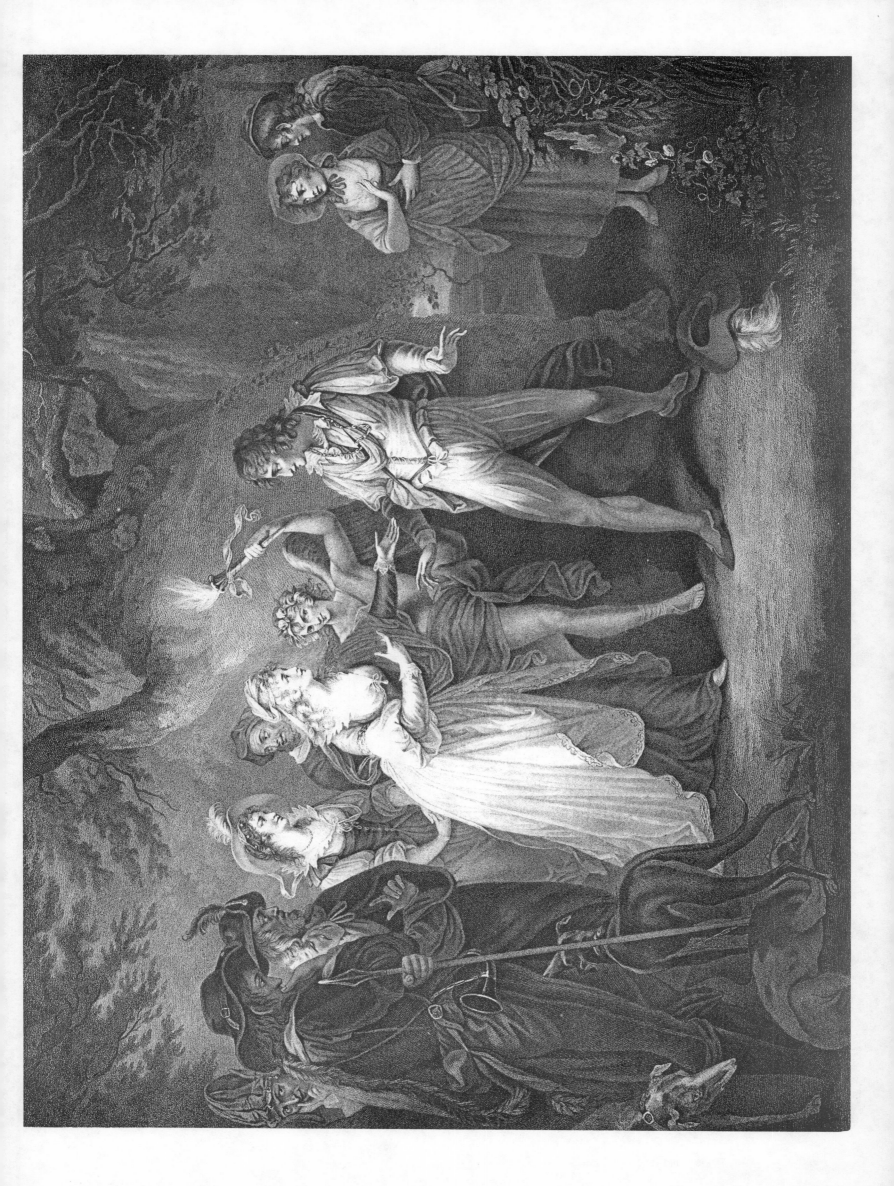

XXVIII.

TAMING OF THE SHREW.

INDUCTION.

SCENE II.

A ROOM IN THE LORD'S HOUSE.

*Sly, with Lord and Attendants; some with Apparel, Bason and*
*Ewer, and other Appurtenances.*

Painted by R. Smirke, R. A.   Engraved by R. Thew.

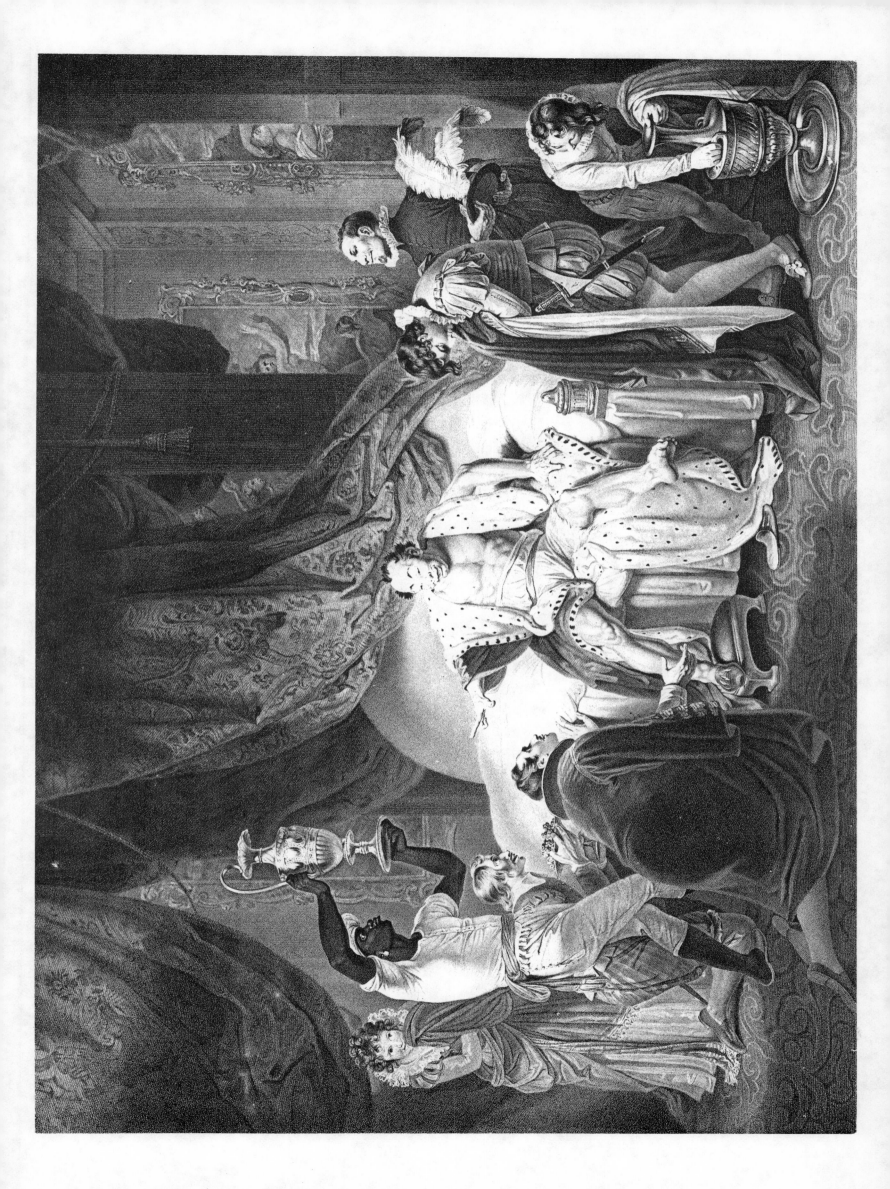

XXIX.

ACT III. SCENE II.

BAPTISTA'S HOUSE.

*Petruchio, Katherine, Bianca, Hortensia, Baptista, Grumio, and Train.*

Painted by F. Wheatley, R. A.    Engraved by P. Simon.

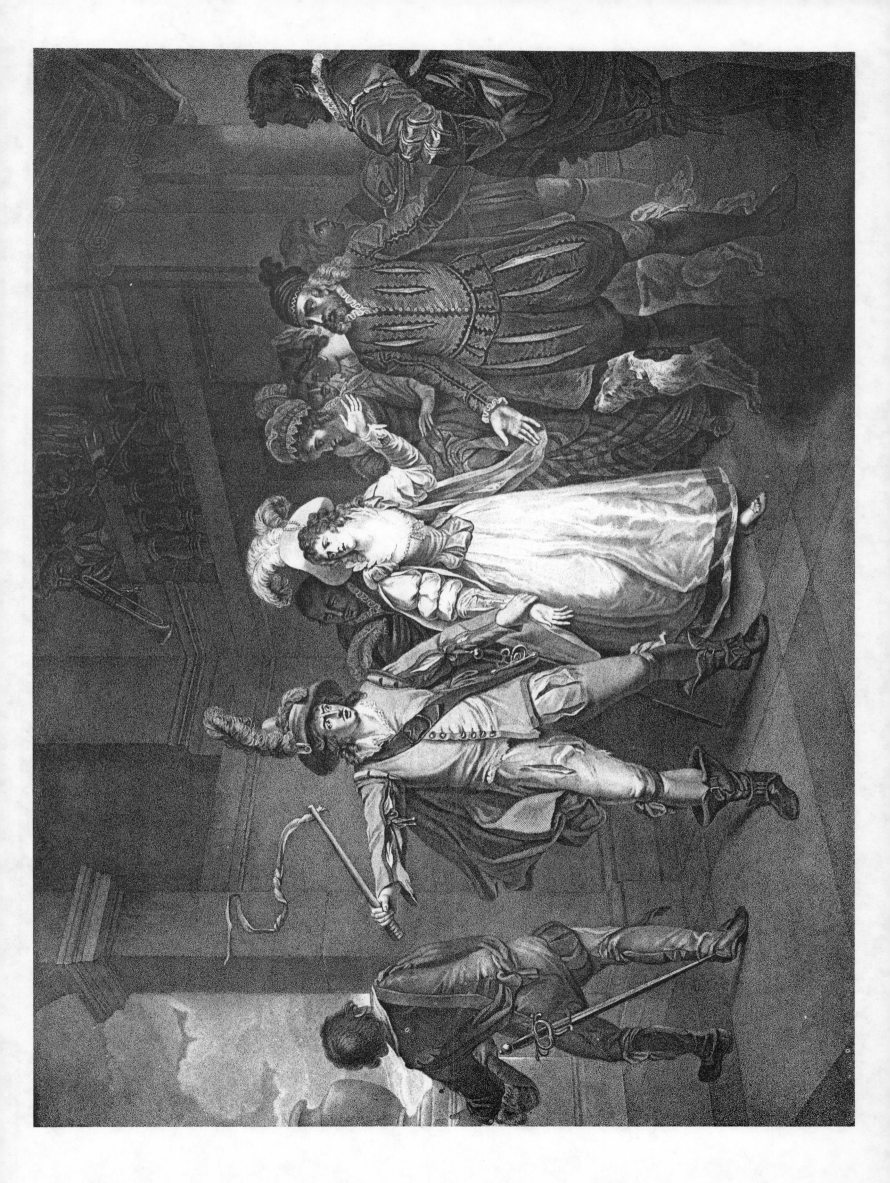

XXX.

ALL'S WELL THAT ENDS WELL.

ACT V. SCENE III.

*King, Countess, Lafeu, Lords, Attendants, &c.  Bertram guarded,*
*Diana, and Widow.*

Painted by F. Wheatley, R. A.    Engraved by G. S. and
J. G. Facius.

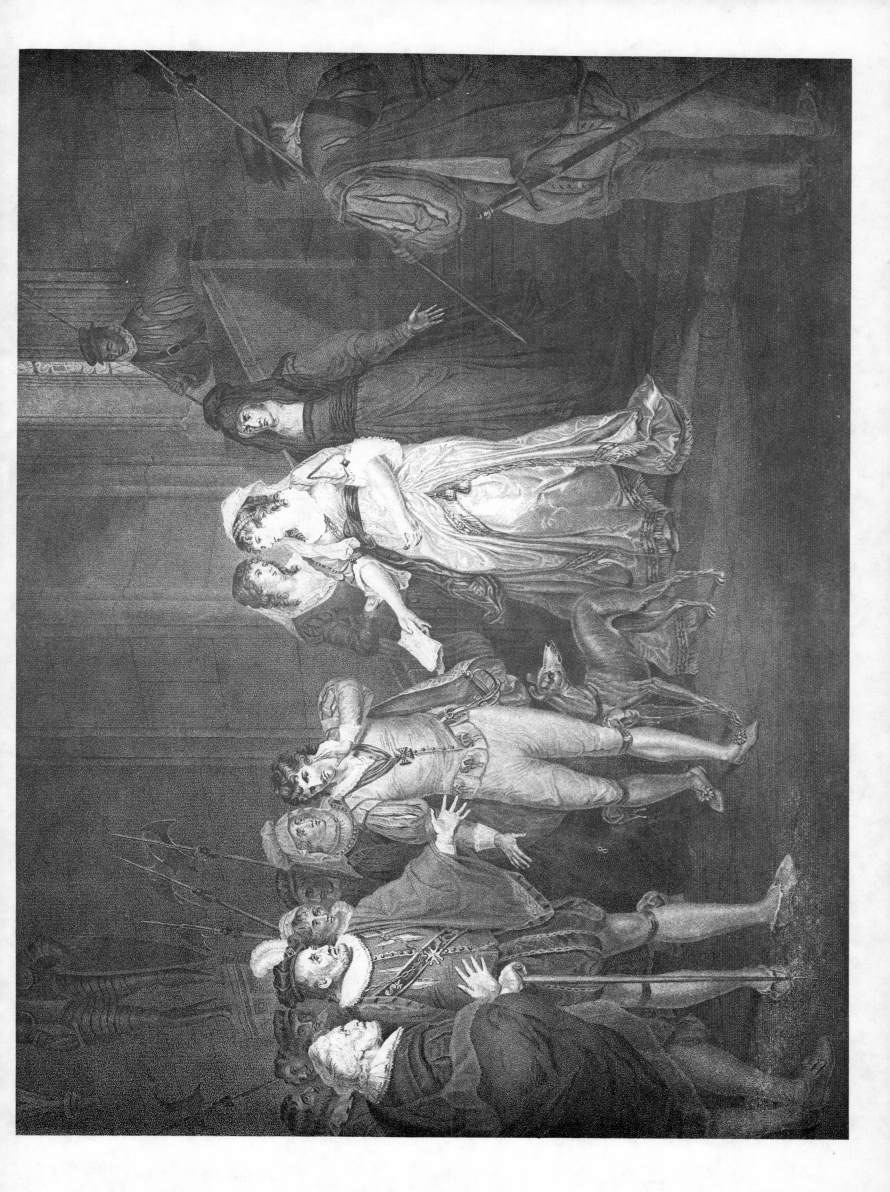

XXXI.

# TWELFTH NIGHT.

## ACT III. SCENE IV.

OLIVIA'S HOUSE.

*Olivia, Maria, and Malvolio.*

Painted by H. Ramberg, Professor of Painting at Hanover.

Engraved by T. Ryder.

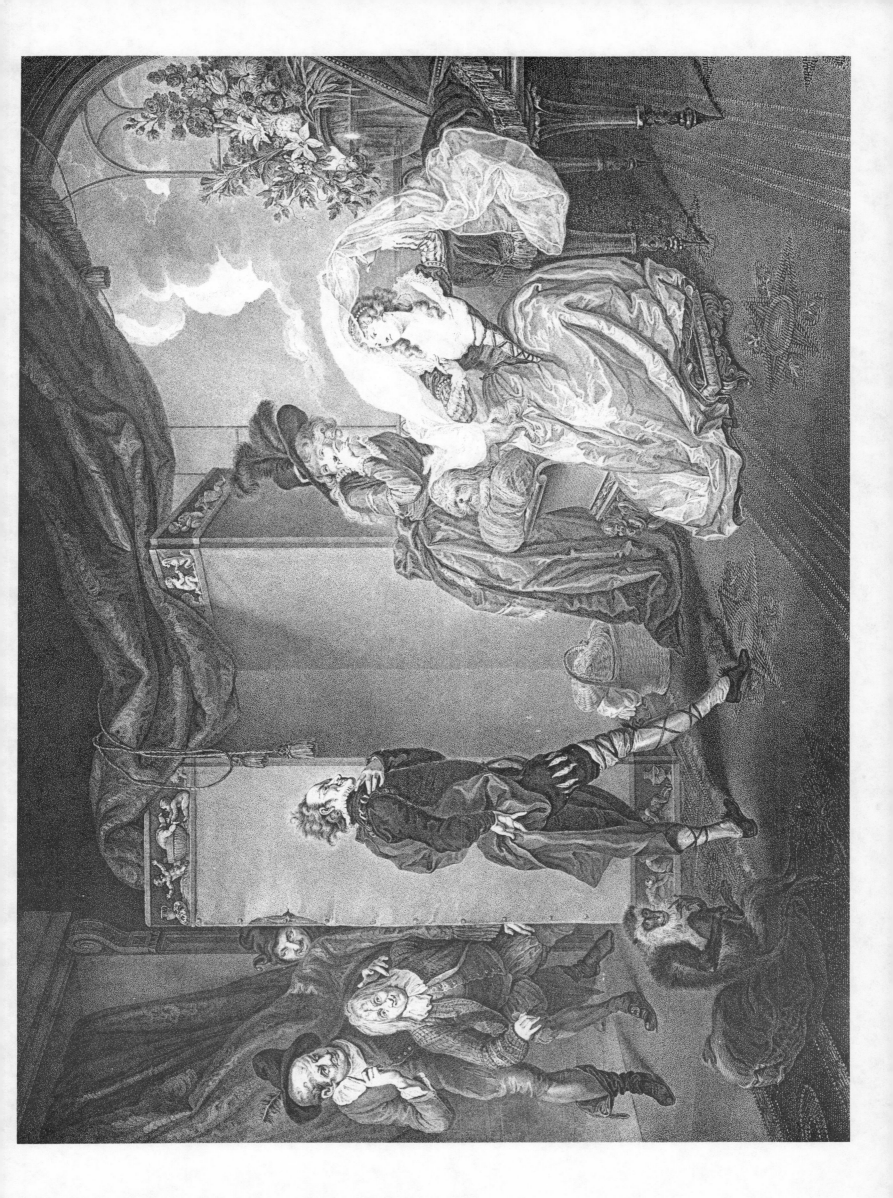

XXXII.

ACT V. SCENE I.

THE STREET.

*The Duke, Viola, Antonio, Officers, Olivia, Priest, and Attendants.*

Painted by W. Hamilton, R.A. Engraved by F. Bartolozzi, R.A.

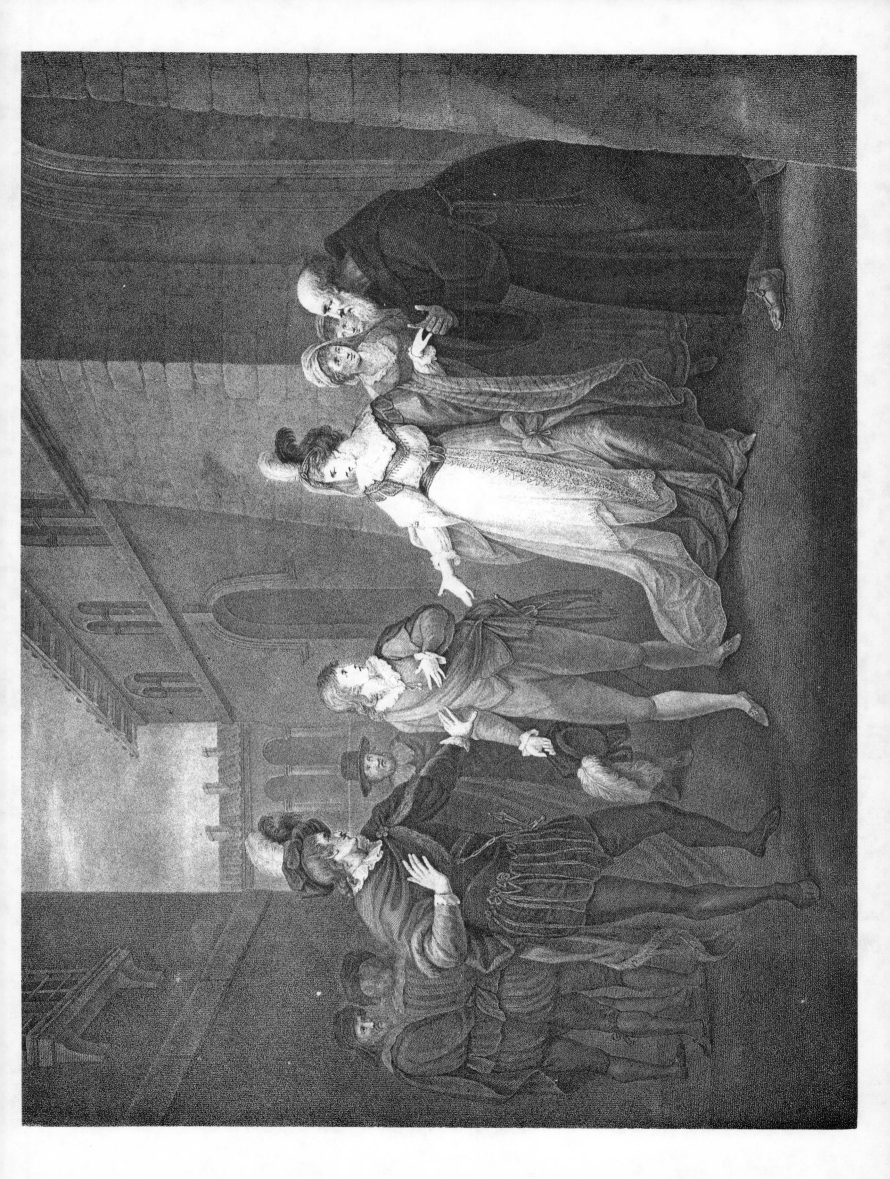

XXXIII.

# WINTER'S TALE.

## ACT II. SCENE III.

A PALACE.

*Leontes, Antigonus, Lords, Attendants, and the Infant Perdita.*

Painted by J. Opie, R. A.   Engraved by P. Simon.

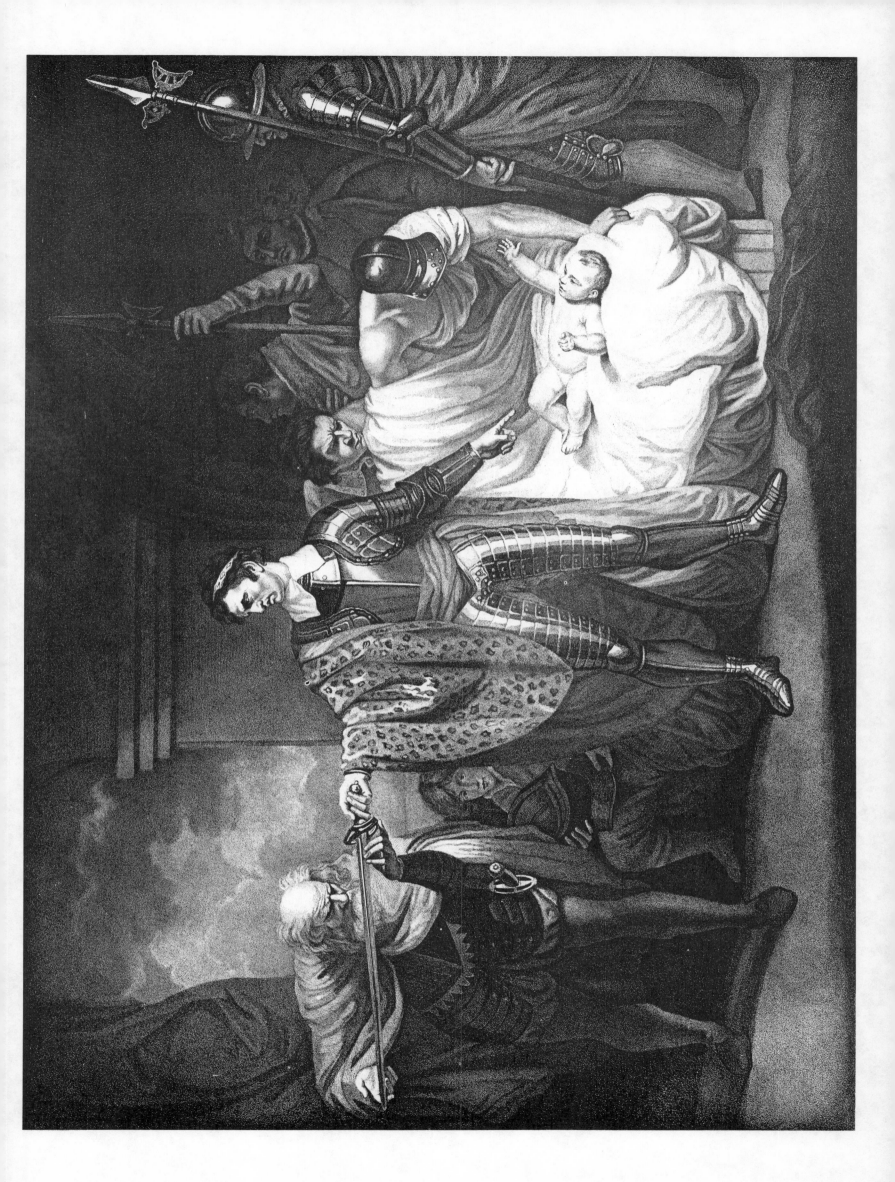

XXXIV.

ACT III. SCENE III.

A DESERT PLACE NEAR THE SEA.

*Antigonus pursued by a Bear.*

Painted by J. Wright, of Derby.   Engraved by S. Middiman.

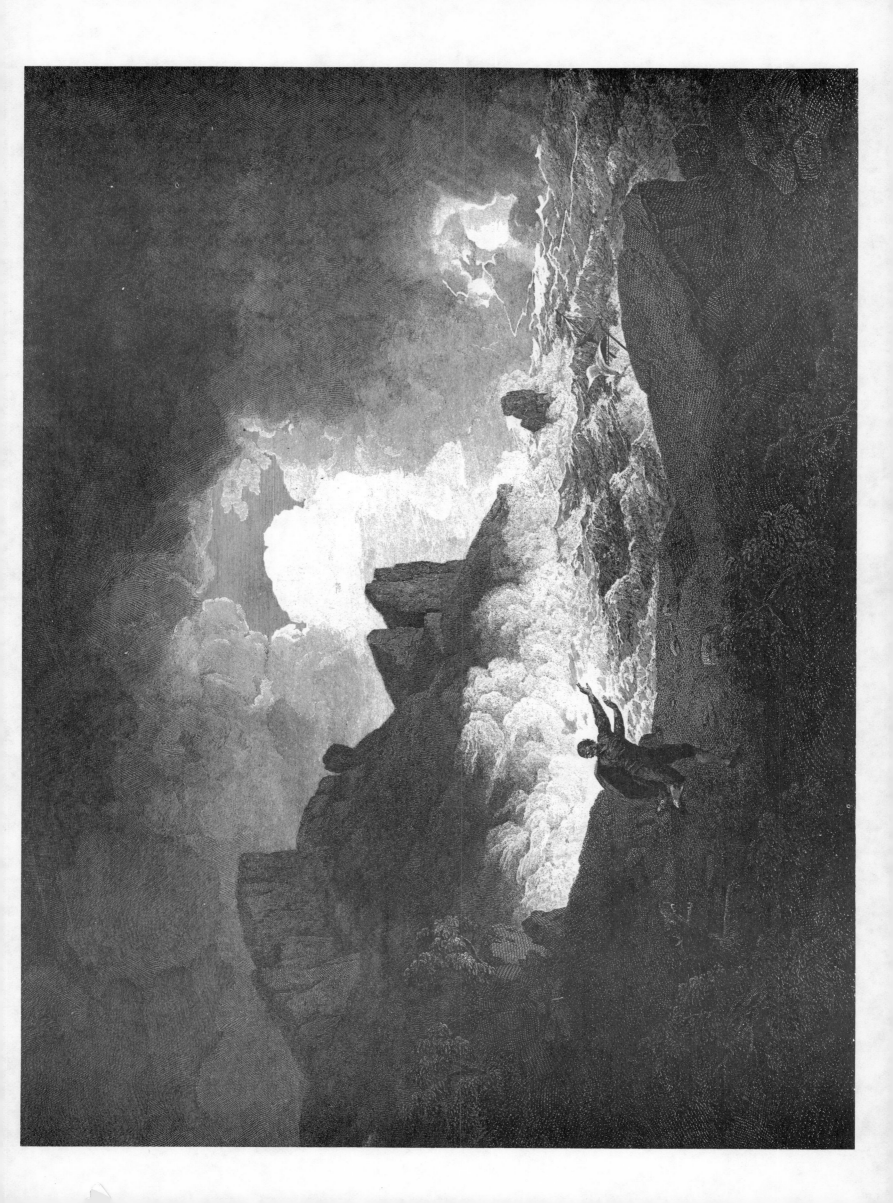

XXXV.

ACT IV. SCENE III.

A SHEPHERD'S COT.

*Florizel, Perdita, Shepherd, Clown, Mopsa, Dorcas, Servants, Polixenes, and Camillo disguised.*

Painted by F. Wheatley, R. A.   Engraved by J. Fittler.

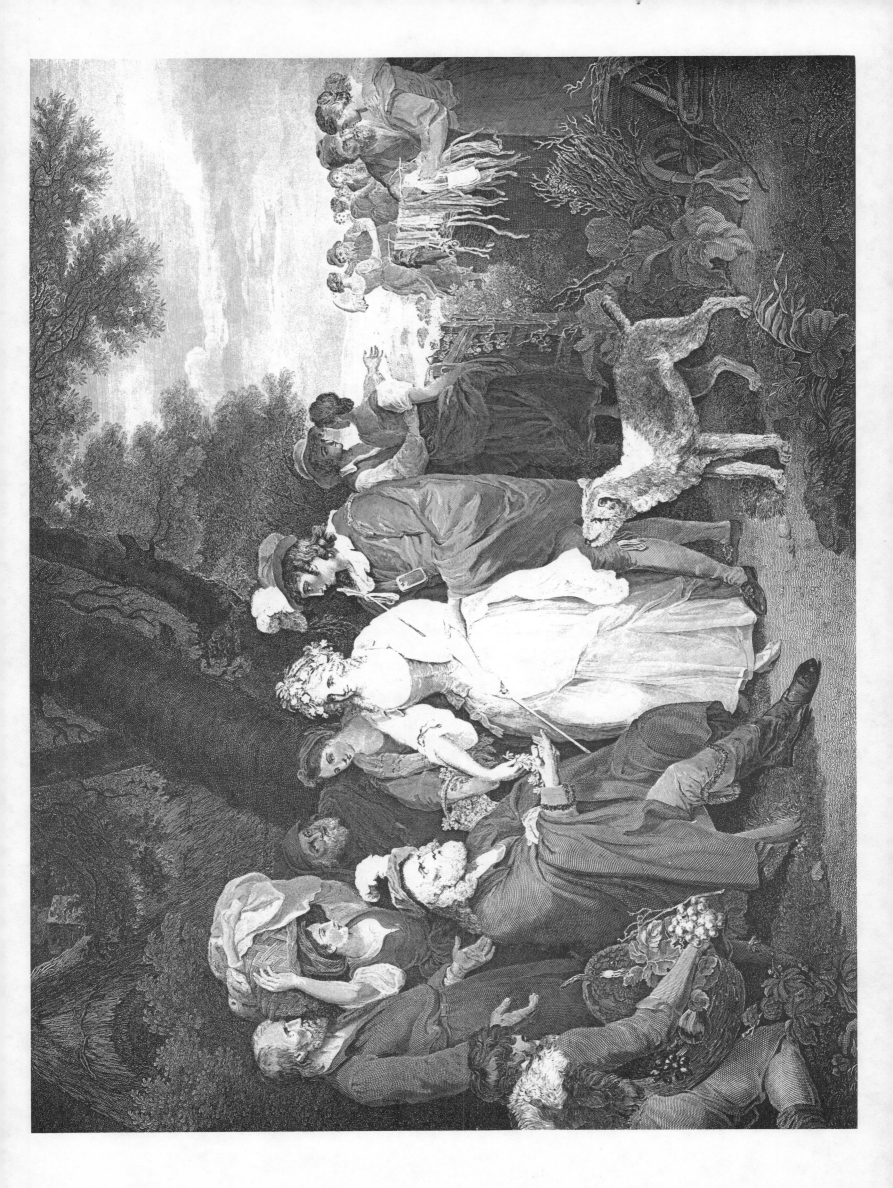

XXXVI.

ACT V. SCENE III.
PAULINA'S HOUSE.

Leontes, Polixenes, Florizel, Perdita, Camillo, Paulina, Lords, and Attendants. Hermione as a Statue.

Painted by W. Hamilton, R. A.   Engraved by R. Thew.

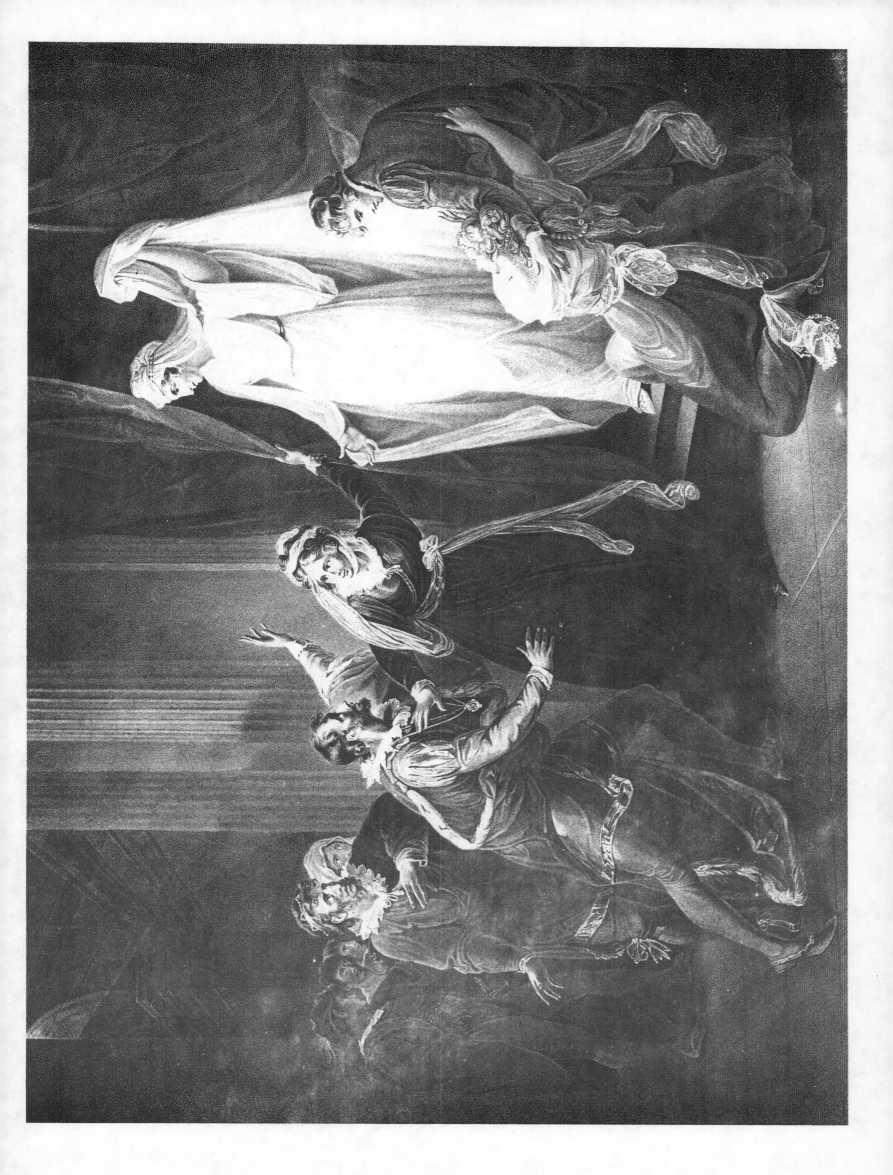

XXXVII.

MACBETH.

ACT I. SCENE III.

A HEATH.

*Macbeth, Banquo, and three Witches.*

Painted by H. Fuseli, R. A.    Engraved by J. Caldwall.

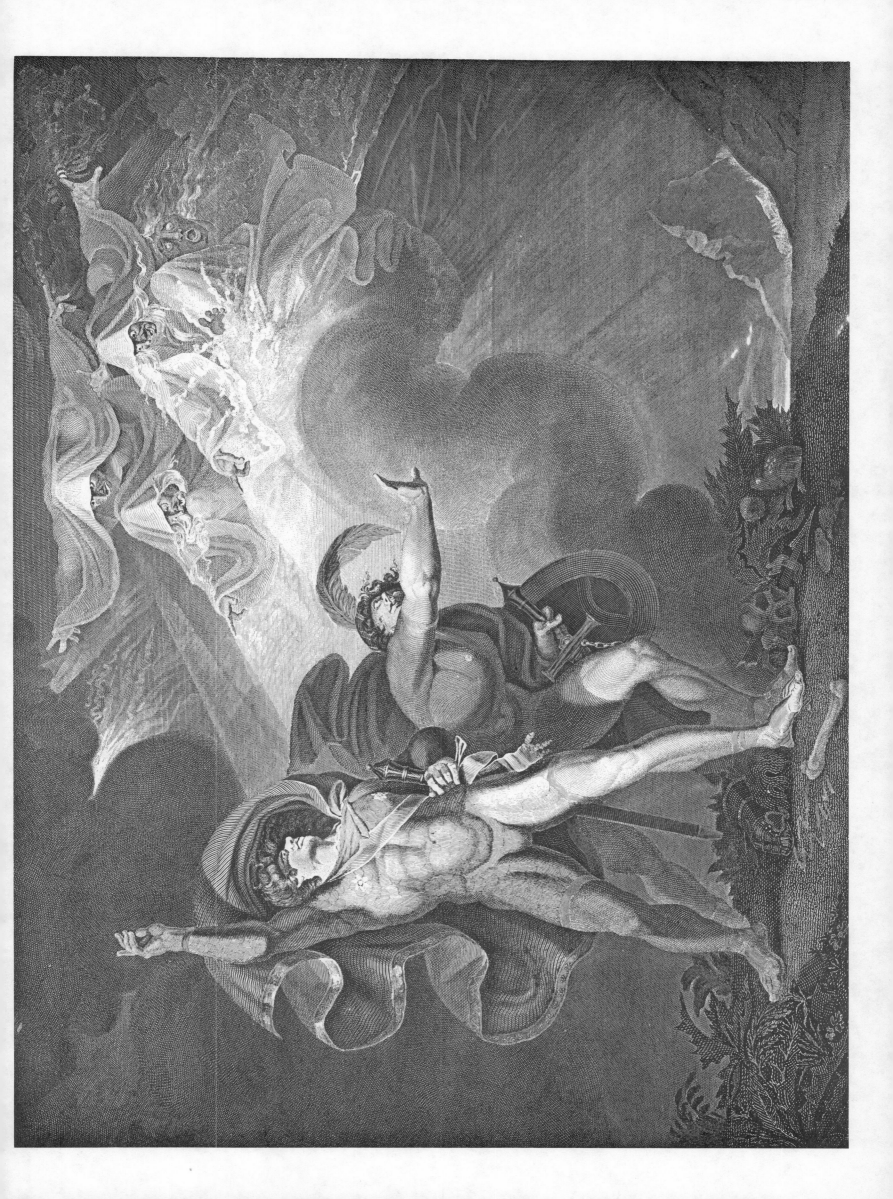

## XXXVIII.

### ACT I. SCENE V.

INVERNESS. A ROOM IN MACBETH'S CASTLE.

*Lady Macbeth with a Letter.*

Painted by R. Westall, R. A.  Engraved by J. Parker.

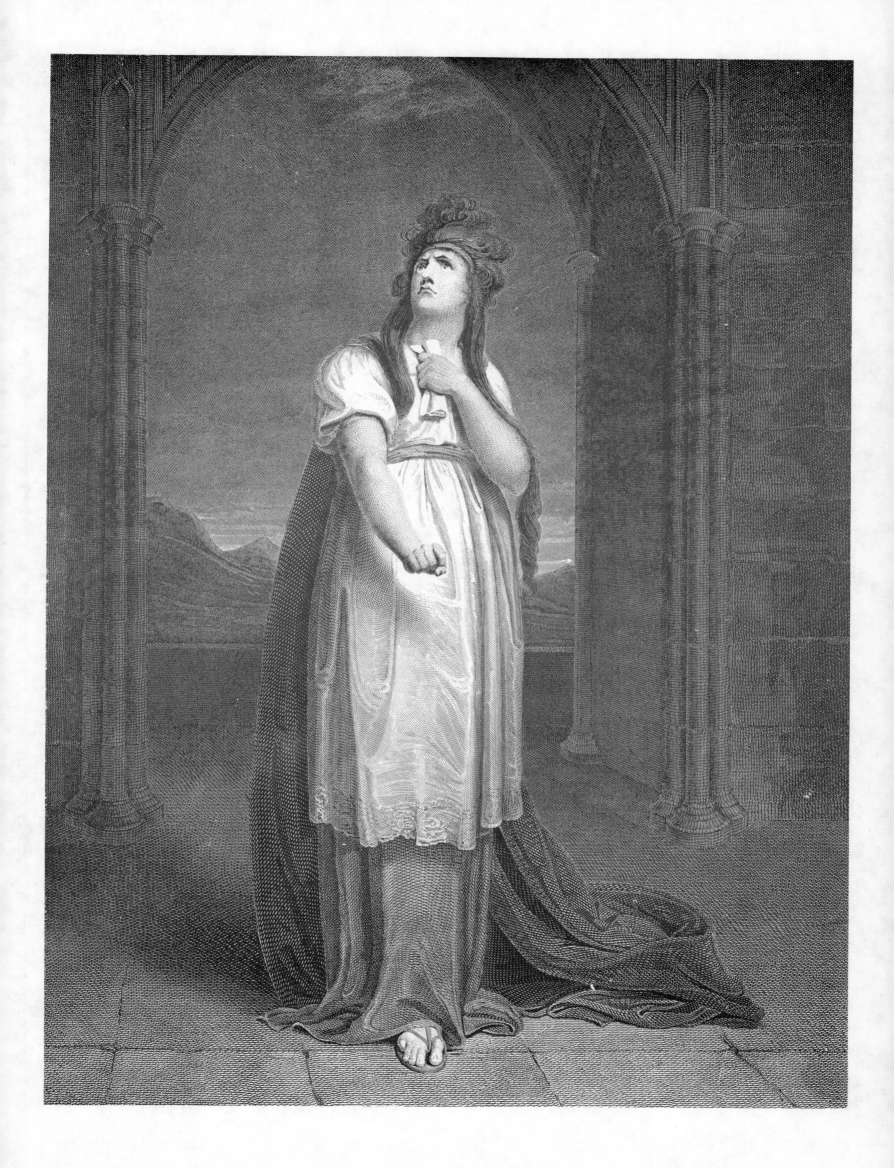

XXXIX.

ACT IV. SCENE I.

A DARK CAVE, IN THE MIDDLE A CAULDRON BOILING.

*Three Witches, Macbeth, Hecate, &c.*

Painted by Sir Joshua Reynolds, late President of the Royal
Academy. Engraved by R. Thew.

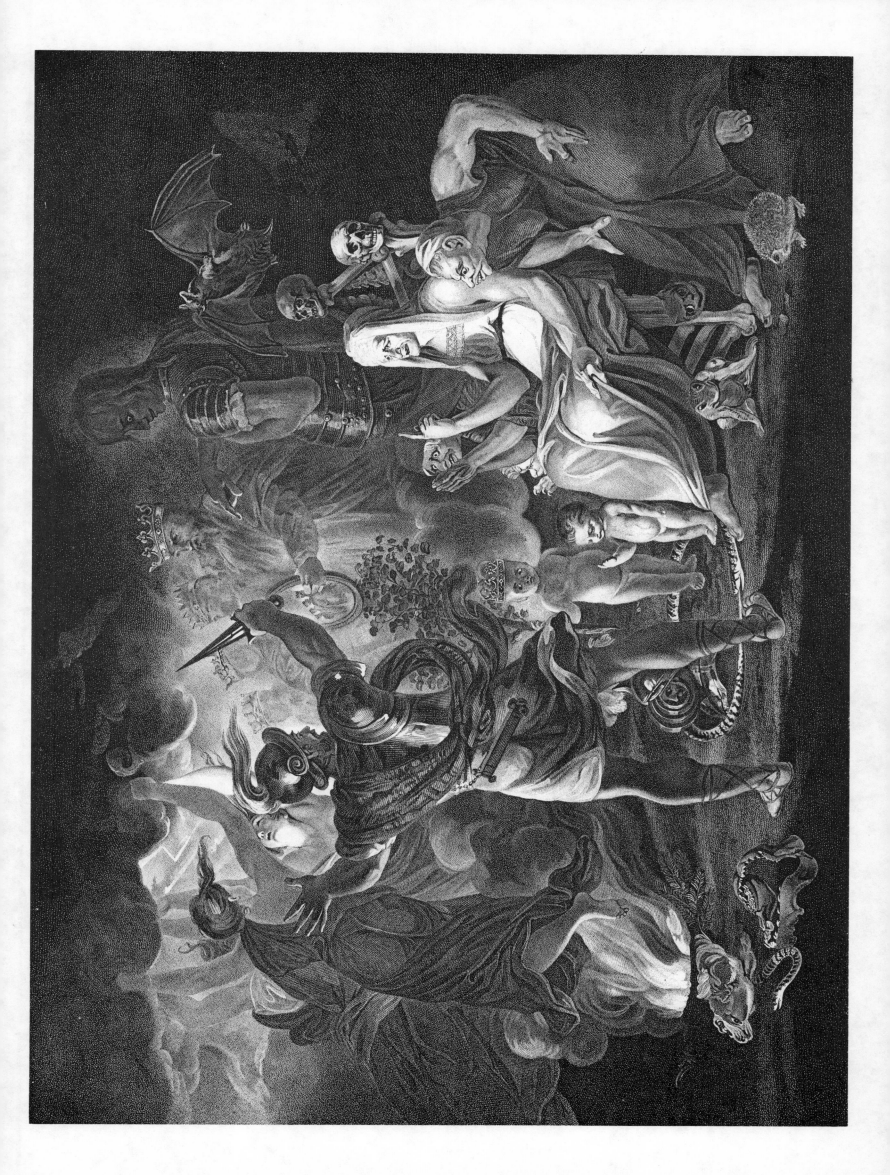

XL.

No. 1.   *Engraved by P. W. Tomkins.*

At first the infant,

Mewling and puking in the nurse's arms :

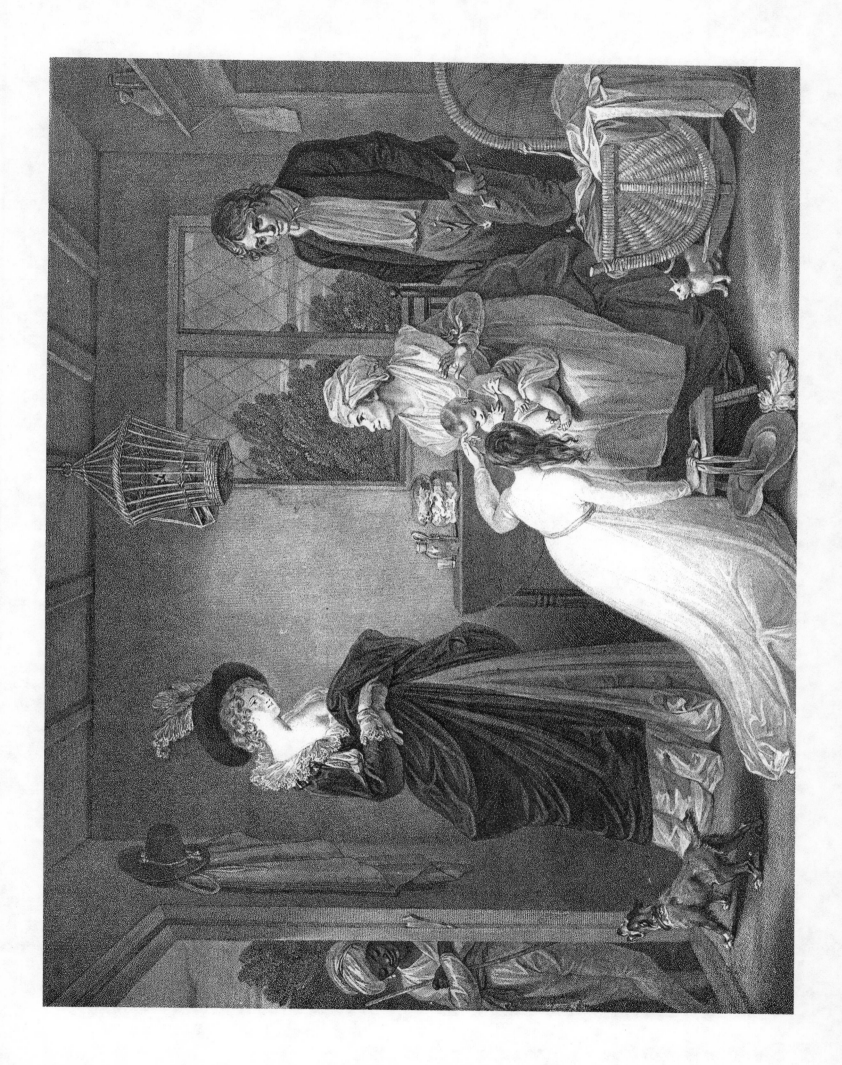

XLI.

No. 2.   *Engraved by J. Ogborne.*

And then, the whining school-boy, with his satchel,
And shining morning face, creeping like snail
Unwillingly to school:

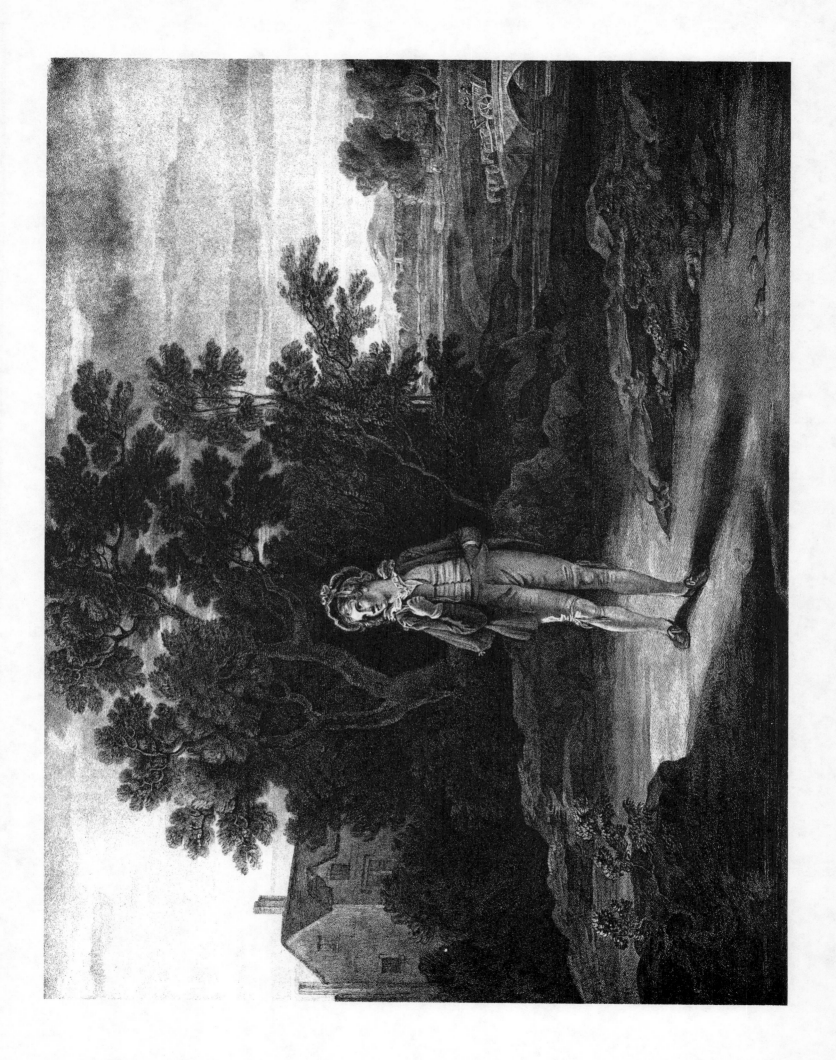

XLII.

No. 3. *Engraved by R. Thew.*

And then, the lover ;

Sighing like furnace, with a woeful ballad

Made to his mistress' eyebrow :

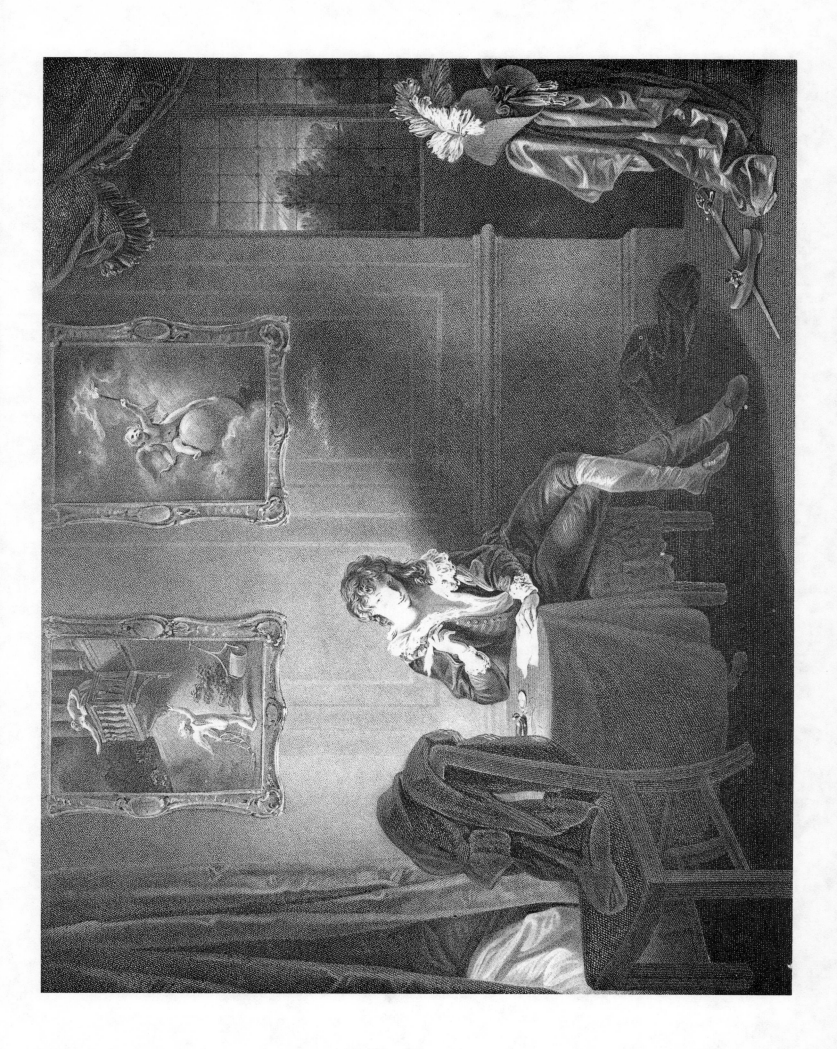

XLIII.

No. 4. *Engraved by J. Ogborne.*

Then, a soldier;
Full of strange oaths, and bearded like the pard,
Jealous in honour, sudden and quick in quarrel,
Seeking the bubble reputation
Even in the cannon's mouth;

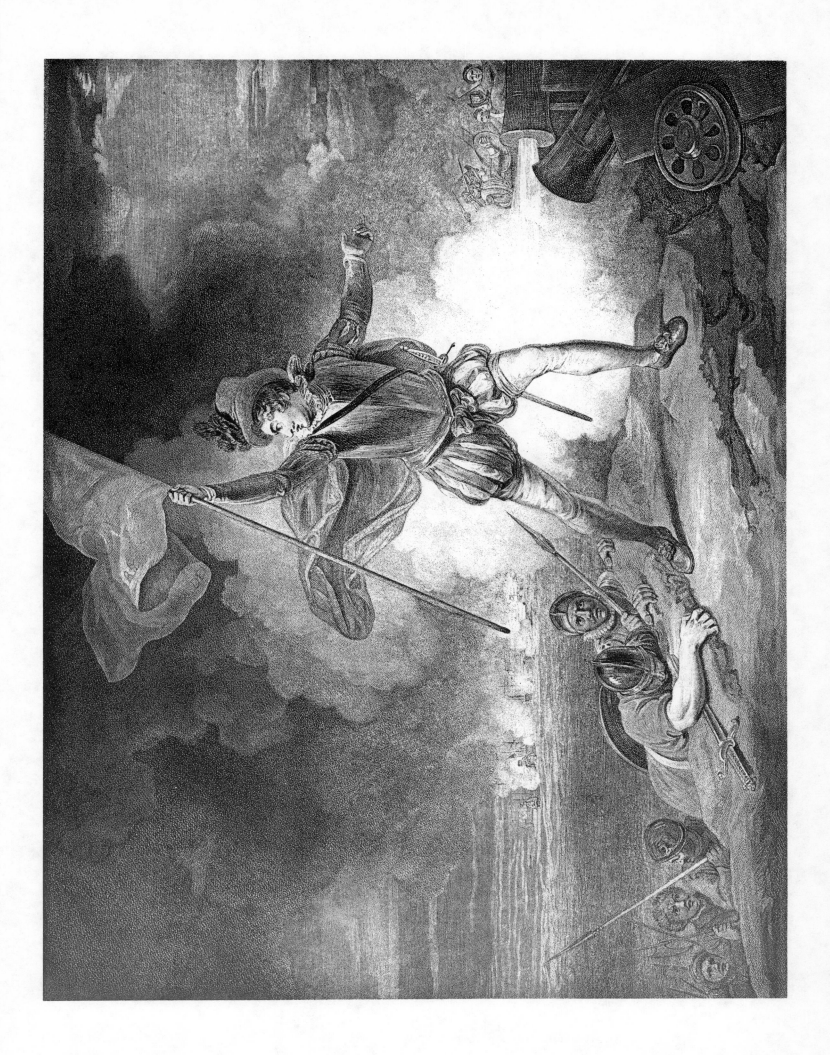

LXIV.

No. 5.  *Engraved by P. Simon.*

And then, the justice
In fair round belly, with good capon lin'd,
With eyes severe, and beard of formal cut,
Full of wise saws and modern instances,
And so he plays his part :

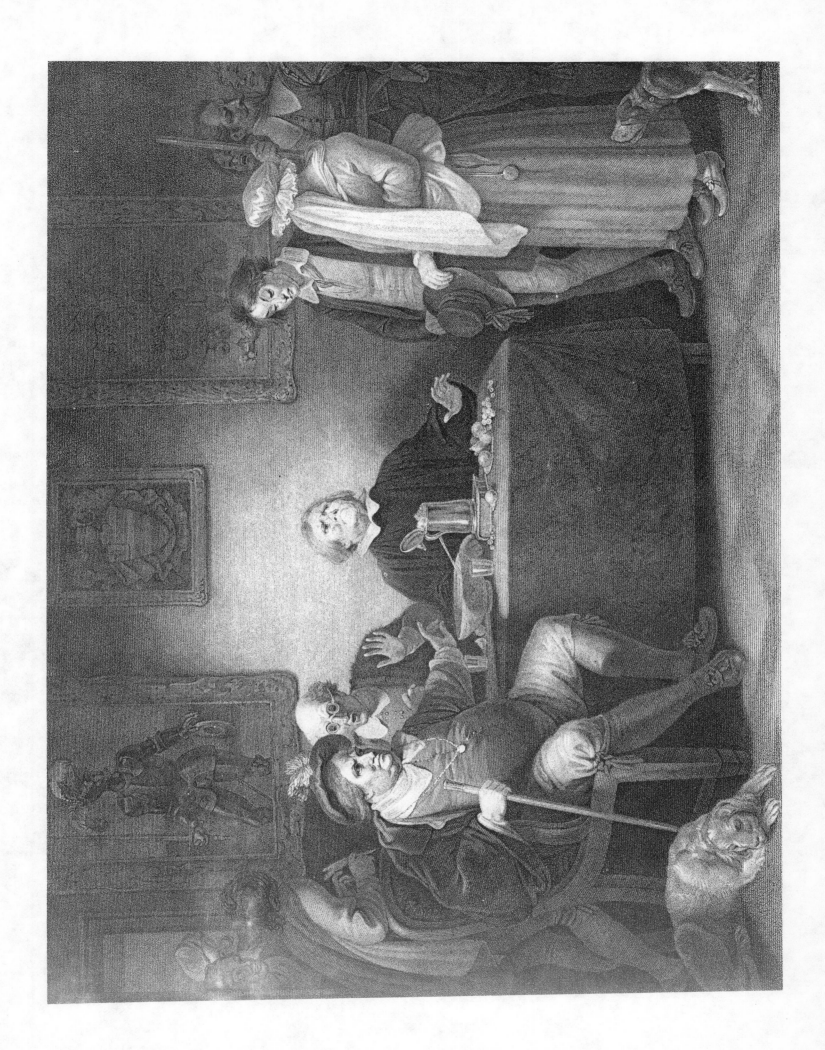

XLV.

No. 6.   *Engraved by W. Leney.*

The sixth age shifts
Into the lean and slipper'd pantaloon ;
With spectacles on nose, and pouch on side ;
His youthful hose well sav'd, a world too wide
For his shrunk shank ; and his big manly voice
Turning again toward childish treble, pipes
And whistles in his sound :

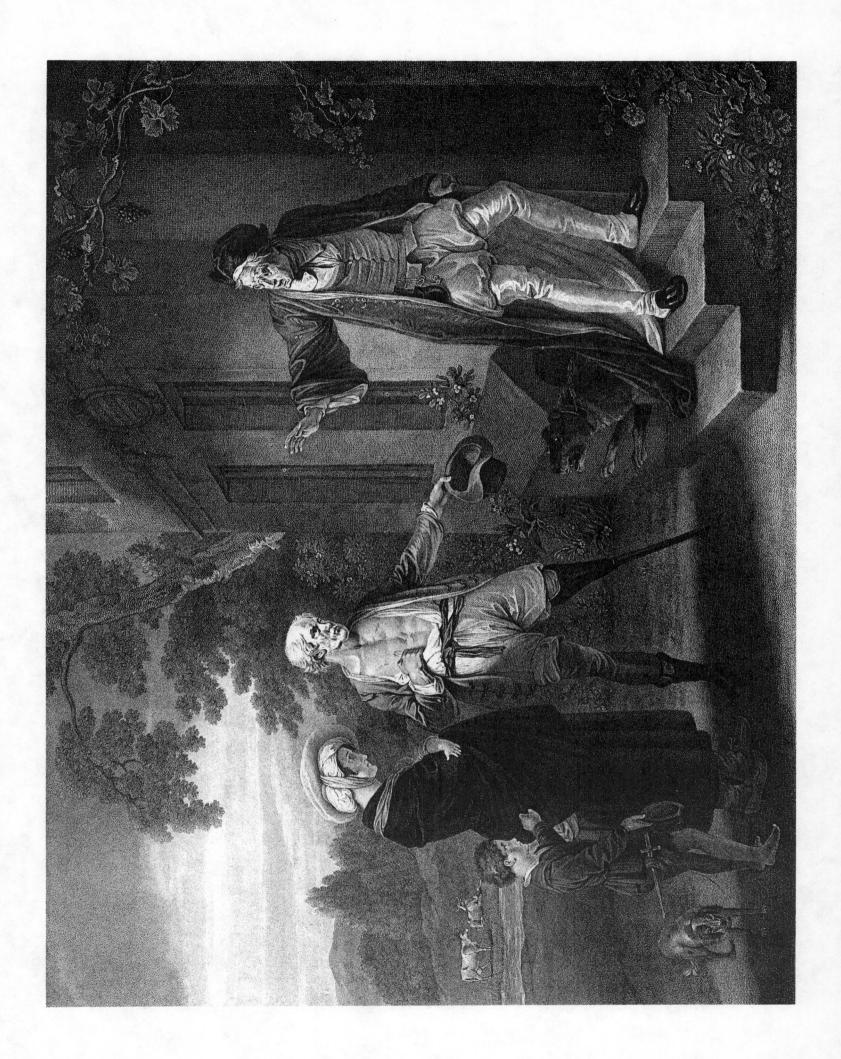

Last scene of all,

That ends this strange eventful history,
Is second childishness and mere oblivion ;
Sans teeth, sans eyes, sans taste, sans every thing.

XLVI.

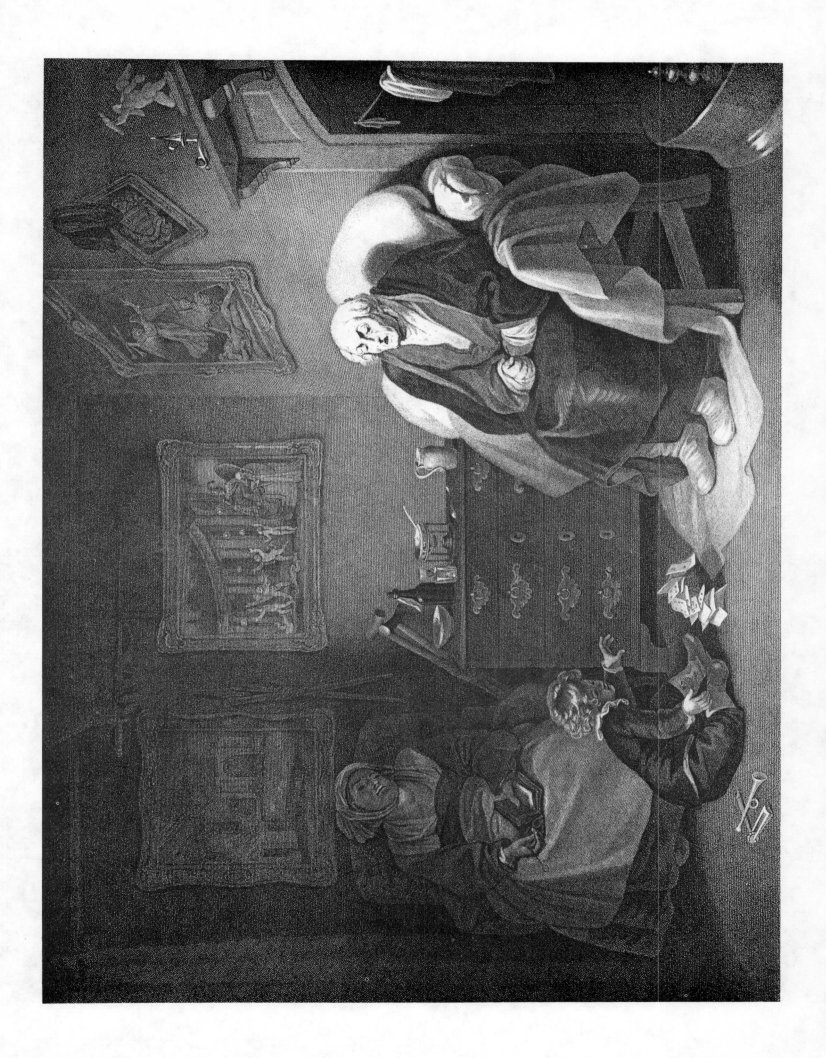

A

# COLLECTION OF PRINTS,

FROM PICTURES PAINTED FOR THE PURPOSE OF ILLUSTRATING

THE

## DRAMATIC WORKS

OF

# SHAKSPEARE,

BY THE

## ARTISTS OF GREAT-BRITAIN.

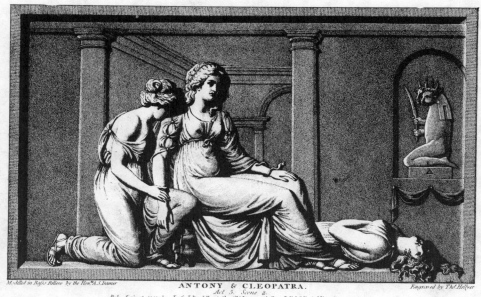

Modelled in Basso-Relievo by the Hon.ble A. S. Damer.          Engraved by Tho.s Hellyer

ANTONY & CLEOPATRA.
Act 5. Scene 2.
Pub. June 4, 1803, by J. & J. Boydell, at the Shakspeare Gallery, Pall Mall, & N.o 90. Cheapside. London

## VOLUME II.

### LONDON:

PUBLISHED BY JOHN AND JOSIAH BOYDELL,

SHAKSPEARE GALLERY, PALL-MALL, AND NO. 90, CHEAPSIDE.

PRINTED BY W. BULMER AND CO. CLEVELAND ROW, ST. JAMES'S.

MDCCCIII.

**FRONTISPIECE.**

Portrait of HER MAJESTY QUEEN CHARLOTTE.

Painted by Sir W. Beechy, R. A.    Engraved by T. Ryder.

# TO

# THE QUEEN'S

## MOST EXCELLENT MAJESTY.

———————

*It was always the ambitious Wish of my late departed Relation,*
*Mr.* ALDERMAN BOYDELL, *strongly impressed as he was with Your*
MAJESTY'S *Goodness to him, to have the Honour of laying this Volume*
*of the* SHAKSPEARE PRINTS *at Your* MAJESTY'S *Feet.—He has, for*
*that purpose, graced the Volume with Your* MAJESTY'S PORTRAIT.

*In executing the wishes of my late respected Relative, I hope your*
MAJESTY *will be graciously pleased to accept the humble Duty of*

## YOUR MAJESTY'S

*Most Devoted Subject and Servant,*

*JOSIAH BOYDELL.*

*London, March 25, 1805.*

# A LIST OF THE LARGE PLATES

## TO ILLUSTRATE THE

# SHAKSPEARE.

## VOL. II.

---

# LIST OF THE LARGE PLATES.

## XII.

### KING HENRY V.

#### ACT II.  SCENE II.

SOUTHAMPTON.

*Exeter, Bedford, and Westmoreland; the King, Scroop, Cambridge, Grey, and Attendants.*

Painted by H. Fuseli, R. A.  Engraved by R. Thew.

---

## XIII.

### FIRST PART OF KING HENRY VI.

#### ACT II.  SCENE III.

THE COUNTESS OF AUVERGNE'S CASTLE.

*Countess, Porter, Talbot, &c.*

Painted by J. Opie, R. A.  Engraved by R. Thew.

## XIV.

#### ACT II.  SCENE IV.

LONDON; THE TEMPLE GARDEN.

*Earls of Somerset, Suffolk, and Warwick; Richard Plantagenet, Vernon, and another Lawyer.*

Painted by J. Boydell.  Engraved by J. Ogborne.

## XV.

#### ACT II.  SCENE V.

A ROOM IN THE TOWER.

*Mortimer in a Chair, Jailor, and Richard Plantagenet.*

Painted by J. Northcote, R. A.  Engraved by R. Thew.

---

## XVI.

### SECOND PART OF KING HENRY VI.

#### ACT I.  SCENE IV.

*Mother Jourdain, Hume, Southwell, Bolingbroke, and Eleanor.*

Painted by J. Opie, R. A.  Engraved by C. G. Playter and R. Thew.

## XVII.

#### ACT III.  SCENE III.

CARDINAL BEAUFORT'S BEDCHAMBER.

*King Henry, Salisbury, and Warwick.  The Cardinal in Bed.*

Painted by Sir Joshua Reynolds, late President of the Royal Academy.  Engraved by Caroline Watson.

---

## XVIII.

### THIRD PART OF KING HENRY VI.

#### ACT I.  SCENE III.

A FIELD OF BATTLE BETWIXT SANDAL CASTLE AND WAKEFIELD.

*Rutland and his Tutor, Clifford and Soldiers.*

Painted by J. Northcote, R. A.  Engraved by C. G. Playter and T. Ryder.

## XIX.

### THIRD PART OF KING HENRY VI.

#### ACT II.  SCENE V.

A FIELD OF BATTLE, NEAR TOWTON, IN YORKSHIRE.

*King Henry.  Son that has killed his Father—Father that has killed his Son.*

Painted by J. Boydell.  Engraved by J. Ogborne.

## XX.

#### ACT IV.  SCENE V.

A PARK, NEAR MIDDLEHAM CASTLE, IN YORKSHIRE.

*King Edward and Huntsman; Gloster, Hastings, and Sir William Stanley in the distance.*

Painted by W. Miller.  Engraved by J. B. Michel and W. Leney.

## XXI.

#### ACT V.  SCENE VII.

THE PALACE IN LONDON.

*King Edward, the Queen, with the young Prince, Clarence, Gloster, Hastings, and Attendants.*

Painted by J. Northcote, R. A.  Engraved by J. B. Michel.

---

## XXII.

### KING RICHARD III.

#### ACT III.  SCENE I.

LONDON.

*Prince of Wales, Duke of York, his Brother, Dukes of Gloucester and Buckingham, Cardinal Bourchier, Lord Hastings, Lord Mayor and his Train.*

Painted by J. Northcote, R. A.  Engraved by R. Thew.

## XXIII.

#### ACT IV.  SCENE III.

THE TOWER.

*The Royal Children; Dighton and Forest, the Murderers.*

Painted by J. Northcote, R. A.  Engraved by F. Legat.

## XXIV.

#### ACT IV.  SCENE III.

TOWER OF LONDON.

*Burying the Royal Children.*

Painted by J. Northcote, R. A.  Engraved by W. Skelton.

---

## XXV.

### KING HENRY VIII.

#### ACT I.  SCENE IV.

YORK PLACE.

*Cardinal Wolsey, Lord Sands, Anne Bullen, King Henry, &c.*

Painted by T. Stothard, R. A.  Engraved by I. Taylor.

# TO ILLUSTRATE THE SHAKSPEARE.

### XXVI.

## KING HENRY VIII.
#### ACT III. SCENE I.
THE QUEEN'S APARTMENTS.

*Queen and her Women at Work ; Cardinals Wolsey and Campeius.*

Painted by the Rev. W. Peters, R.A. Engraved by R. Thew.

### XXVII.

#### ACT IV. SCENE II.
THE ABBEY OF LEICESTER.

*Abbot of Leicester, Wolsey, Northumberland, and Attendants.*

Painted by R. Westall, R.A. Engraved by R. Thew

### XXVIII.

#### ACT V. SCENE IV.
THE PALACE.

*The Christening of Queen Elizabeth.*

Painted by the Rev. W. Peters, R.A. Engraved by J. Collyer.

---

### XXIX.

## CORIOLANUS.
#### ACT V. SCENE III.

*Coriolanus, Aufidius, Virgilia, Volumnia, young Marcius, Valeria, and Attendants.*

Painted by G. Hamilton. Engraved by J. Caldwall.

---

### XXX.

## JULIUS CÆSAR.
#### ACT IV. SCENE III.
BRUTUS'S TENT, IN THE CAMP NEAR SARDIS.

*Brutus and the Ghost of Cæsar.*

Painted by R. Westall, R.A. Engraved by E. Scriven.

---

### XXXI.

## ANTONY AND CLEOPATRA.
#### ACT III. SCENE IX.
THE PALACE IN ALEXANDRIA.

*Antony, Cleopatra, Eros, Charmian, Iras, &c. &c.*

Painted by H. Tresham, R.A. Engraved by G.S. and J.G. Facius.

---

### XXXII.

## TIMON OF ATHENS.
#### ACT IV. SCENE III.
A WOOD.

*Timon, Alcibiades, Phrynia, and Timandra.*

Painted by J. Opie, R.A. Engraved by R. Thew.

### XXXIII.

## TITUS ANDRONICUS.
#### ACT IV. SCENE I.
TITUS'S HOUSE.

*Titus and Marcus. Young Lucius pursued by Lavinia.*

Painted and engraved by T. Kirk.

---

### XXXIV.

## TROILUS AND CRESSIDA.
#### ACT II. SCENE II.
TROY.

*Cassandra raving.*

Painted by G. Romney. Engraved by F. Legat.

### XXXV.

#### ACT V. SCENE II.
CALCHAS' TENT.

*Diomed and Cressida, Troilus, Ulysses, and Thersites.*

Painted by Angelica Kauffman, R.A. Engraved by L. Schiavonetti.

---

### XXXVI.

## CYMBELINE.
#### ACT I. SCENE II.

*Imogen, Posthumus, Queen, Cymbeline, &c.*

Painted by W. Hamilton, R.A. Engraved by T. Burke.

### XXXVII.

#### ACT III. SCENE IV.
NEAR MILFORD HAVEN.

*Pisanio and Imogen.*

Painted by J. Hoppner, R.A. Engraved by R. Thew.

---

### XXXVIII.

## KING LEAR.
#### ACT I. SCENE I.
LEAR'S PALACE.

*Lear, Cornwall, Albany, Goneril, Regan, Cordelia, King of France, Duke of Burgundy, Kent, Attendants, &c.*

Painted by H. Fuseli, R.A. Engraved by R. Earlom.

### XXXIX.

#### ACT III. SCENE IV.
PART OF A HEATH, WITH A HOVEL.

*Lear, Kent, Fool, Edgar, disguised as a Madman, and Gloster, with a Torch.*

Painted by B. West, President of the Royal Academy. Engraved by W. Sharpe.

# LIST OF THE LARGE PLATES, &c.

## XL.

### KING LEAR.
#### ACT V. SCENE III.
##### A CAMP NEAR DOVER.

*Lear, with Cordelia dead; Edgar, Albany, and Kent. Regan, Goneril, and Edmund, dead.*

Painted by J. Barry, R. A.   Engraved by F. Legat.

---

## XLI.

### ROMEO AND JULIET.
#### ACT I. SCENE V.
##### A HALL IN CAPULET'S HOUSE.

*Romeo, Juliet, Nurse, &c. with the Guests and the Maskers.*

Painted by W. Miller.   Engraved by G. S. and J. G. Facius.

## XLII.

#### ACT IV. SCENE V.
##### JULIET ON HER BED.

*Friar Lawrence, Capulet, Lady Capulet, Paris, Friar, Nurse, Musicians, &c.*

Painted by J. Opie, R. A.   Engraved by G. S. and J. G. Facius.

## XLIII.

#### ACT V. SCENE III.
##### A MONUMENT BELONGING TO THE CAPULETS.

*Romeo and Paris dead; Juliet and Friar Lawrence.*

Painted by J. Northcote, R. A.   Engraved by P. Simon.

---

## XLIV.

### HAMLET.
#### ACT I. SCENE IV.
##### A PLATFORM BEFORE THE CASTLE OF ELSINEUR.

*Hamlet, Horatio, Marcellus, and the Ghost.*

Painted by H. Fuseli, R. A.   Engraved by R. Thew.

## XLV.

#### ACT IV. SCENE V.
##### ELSINEUR.

*King, Queen, Laertes, Ophelia, &c.*

Painted by B. West, President of the Royal Academy. Engraved by F. Legat.

## XLVI.

### OTHELLO.
#### ACT II. SCENE I.
##### A PLATFORM.

*Desdemona, Othello, Iago, Cassio, Roderigo, Emilia, &c.*

Painted by T. Stothard, R. A.   Engraved by T. Ryder.

## XLVII.

#### ACT V. SCENE II.
##### A BEDCHAMBER.

*Othello, Desdemona in Bed, asleep.*

Painted by J. Graham.   Engraved by W. Leney.

---

## XLVIII.

### SHAKSPEARE NURSED BY TRAGEDY AND COMEDY.

Painted by G. Romney.   Engraved by B. Smith.

## XLIX.

### CYMBELINE.
#### ACT III. SCENE VI.
*Imogen in Boy's Clothes.*

Painted by R. Westall, R. A.   Engraved by —— Gaugain.

## L.

### OTHELLO.
#### ACT V. SCENE II.
*Desdemona asleep.*

Painted by J. Boydell.   Engraved by W. Leney.

The above Three Plates were not engraved from the large Pictures, but may be added to Vol. II.

---

The First Volume, including the Portrait of the King, the Vignette, and Seven Ages, will consist of Forty-eight Subjects.

The Second Volume, including the Portrait of the Queen, Vignette, and the above Three Subjects, will consist of Fifty-two, in all One Hundred.

THE END.

# I.

## KING JOHN.

### ACT IV.  SCENE I.

A ROOM IN THE CASTLE OF NORTHAMPTON.

*Arthur, Hubert, and Attendants.*

Painted by J. Northcote, R. A.   Engraved by R. Thew.

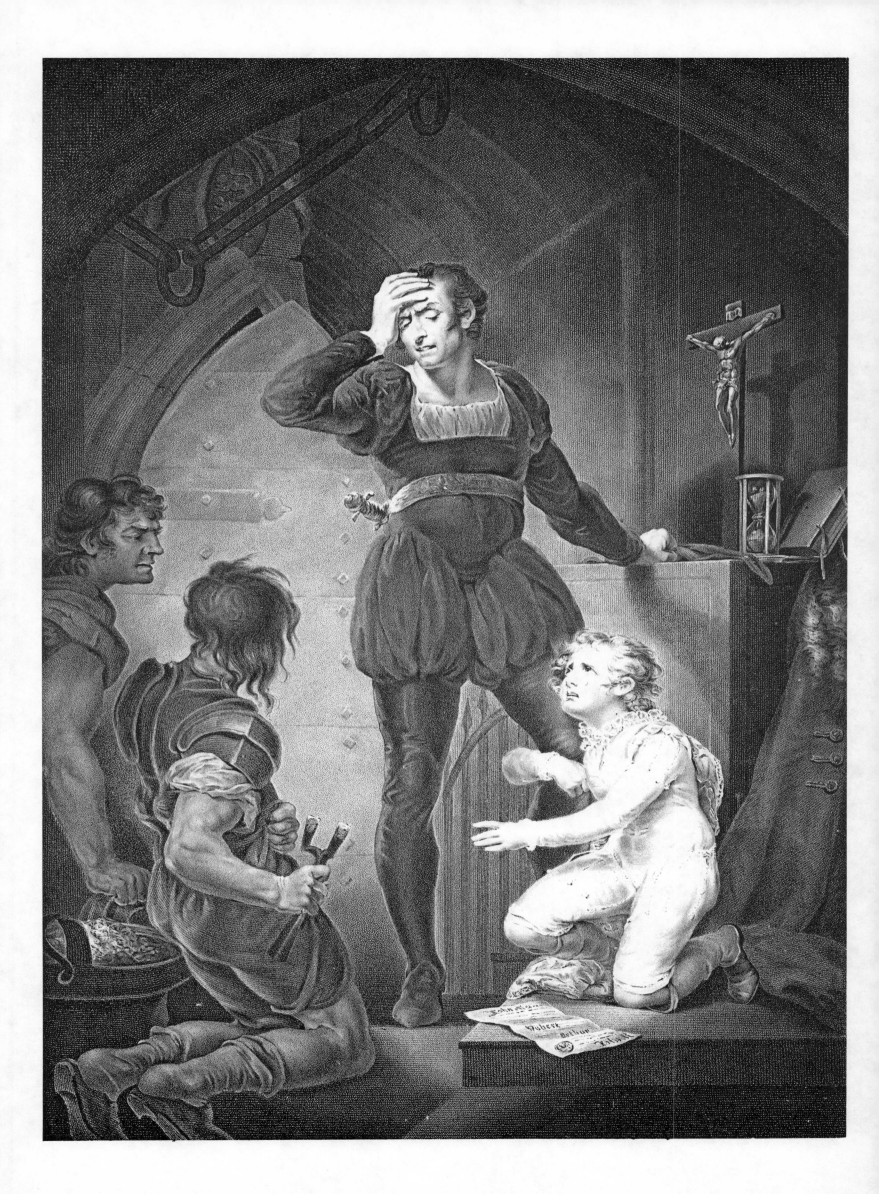

II.

# KING RICHARD II.

## ACT IV. SCENE I.

PARLIAMENT HOUSE.

*K. Richard, Bolingbroke, York, Aumerle, Northumberland, Percy, Fitzwater, Surrey, Bishop of Carlisle, Abbot of Westminster, Herald, &c. and Bagot.*

Painted by M. Browne.   Engraved by B. Smith.

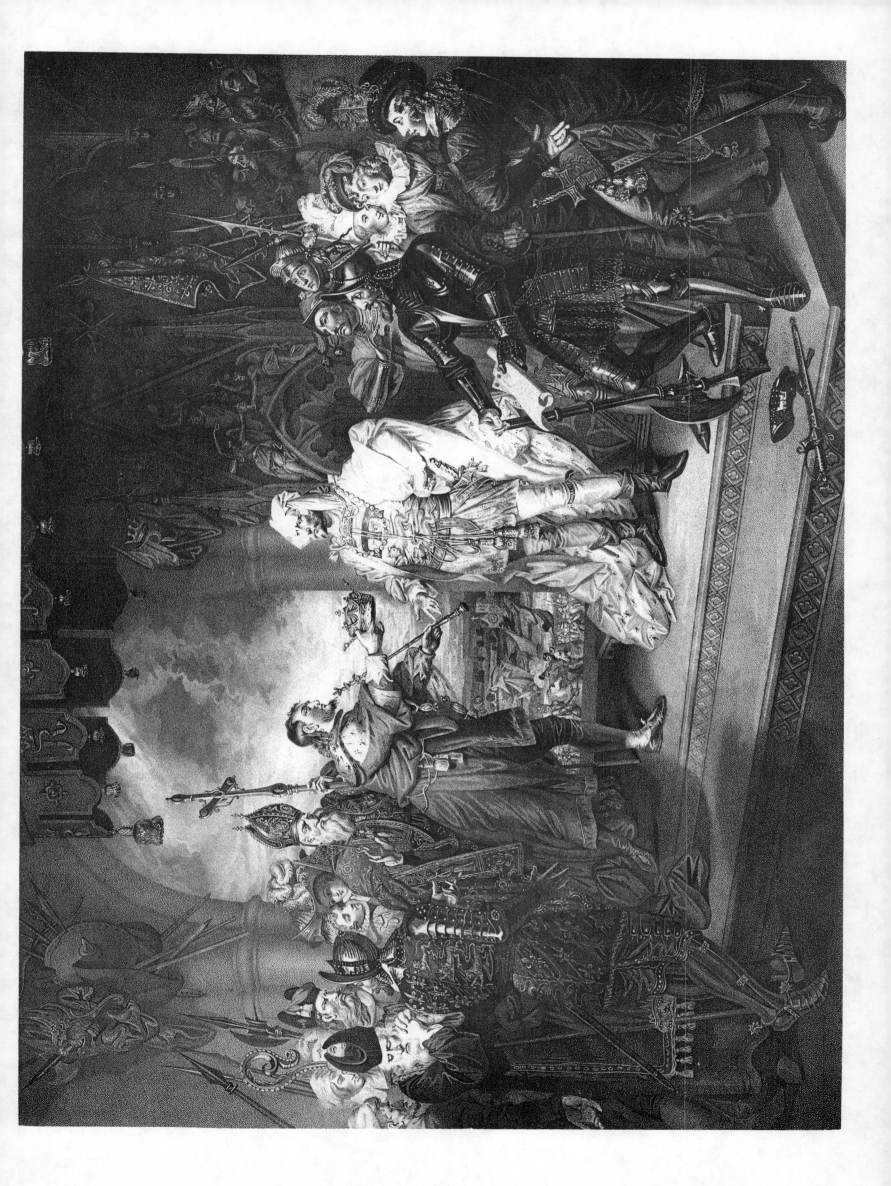

## III.

### ACT V. SCENE II.

*The Entrance of King Richard and Bolingbroke into London, as*
*described by the Duke of York.*

*York.*　　The Duke, great Bolingbroke ;
Mounted upon a hot and fiery steed,
With slow but stately pace, kept on his course,
While all tongues cry'd—God save thee, Bolingbroke !

Painted by J. Northcote, R. A.　　Engraved by R. Thew.

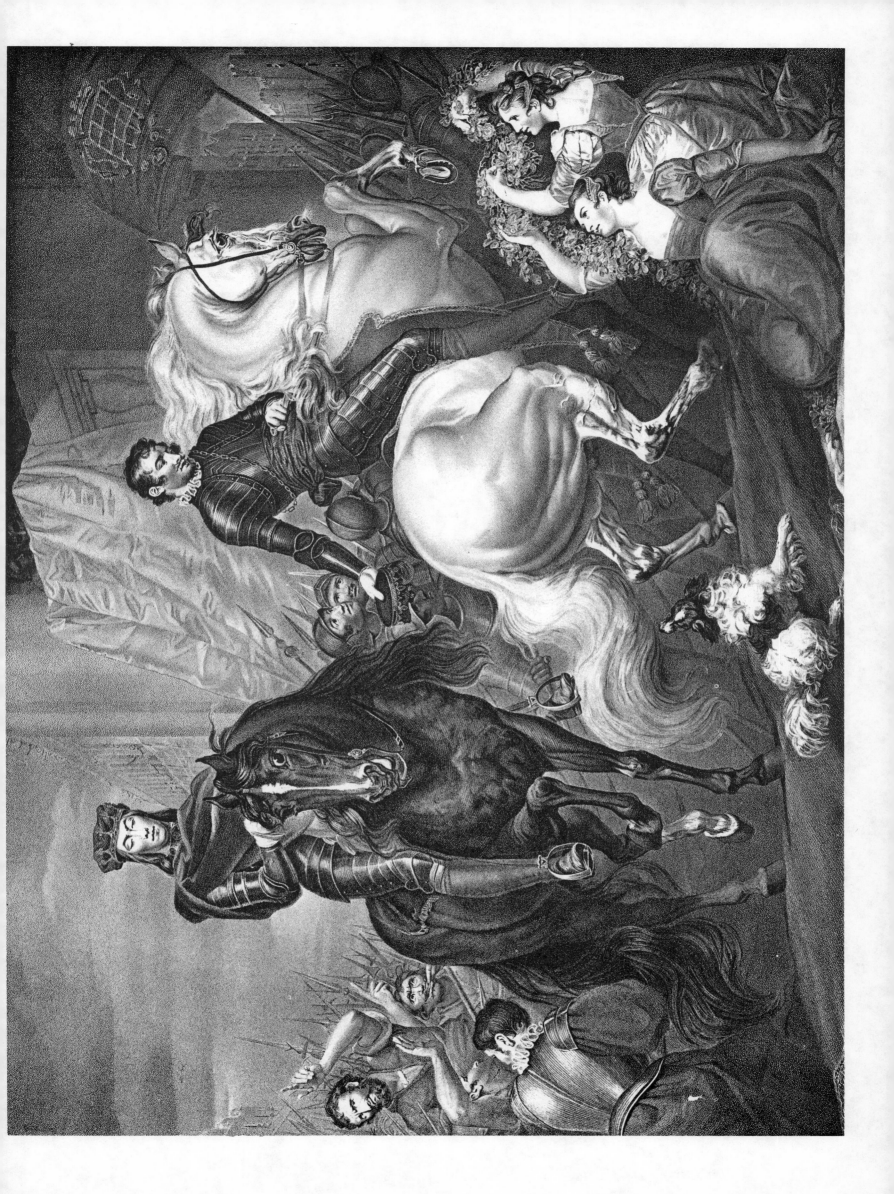

IV.

# FIRST PART OF KING HENRY IV.

## ACT II. SCENE II.

THE ROAD TO GADSHILL.

*Prince Henry, Poins, Peto, Falstaff, Gadshill, Bardolph.*

Painted by R. Smirke, R. A.  and J. Farington, R. A.

Engraved by S. Middiman.

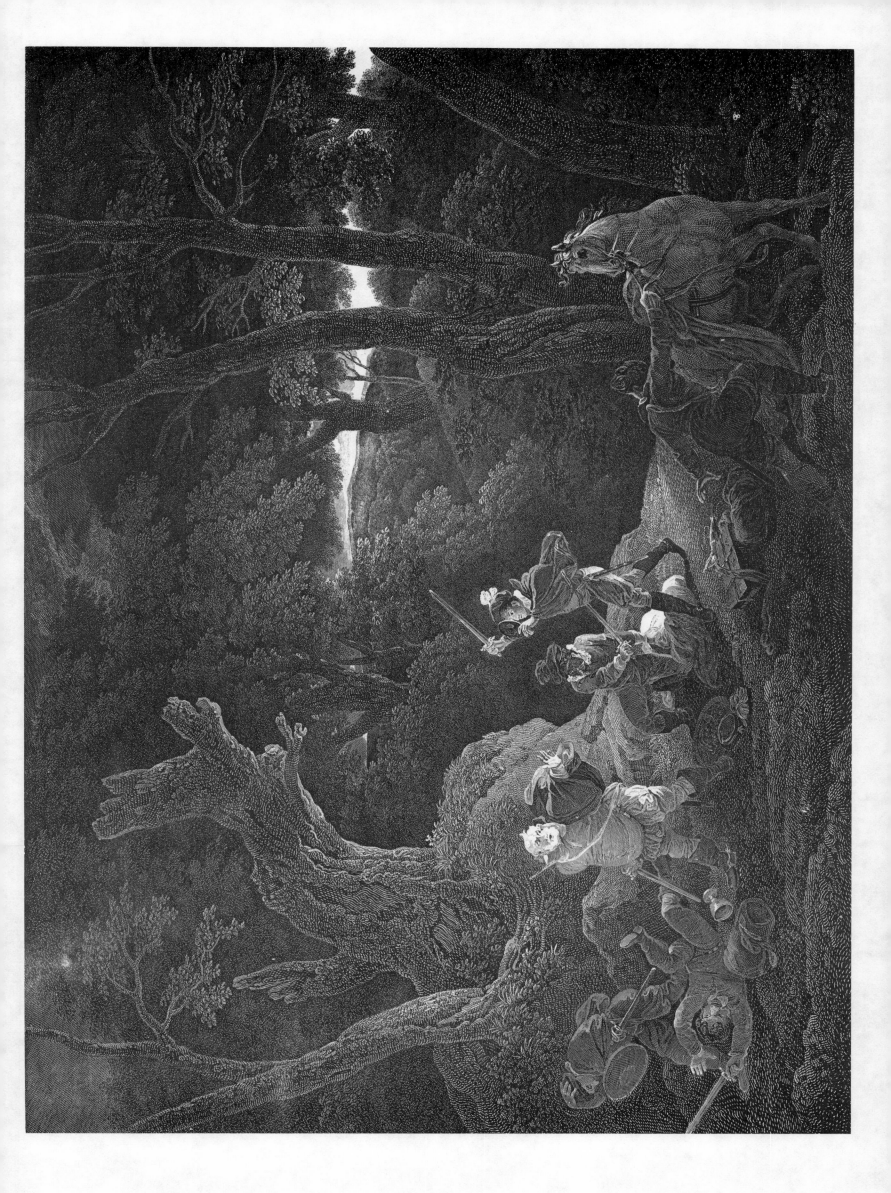

V.

# FIRST PART OF KING HENRY IV.

## ACT II.  SCENE IV.

THE BOAR'S-HEAD TAVERN, EASTCHEAP.

*Prince Henry, Falstaff, Poins, &c.*

Painted by R. Smirke, R. A.    Engraved by R. Thew.

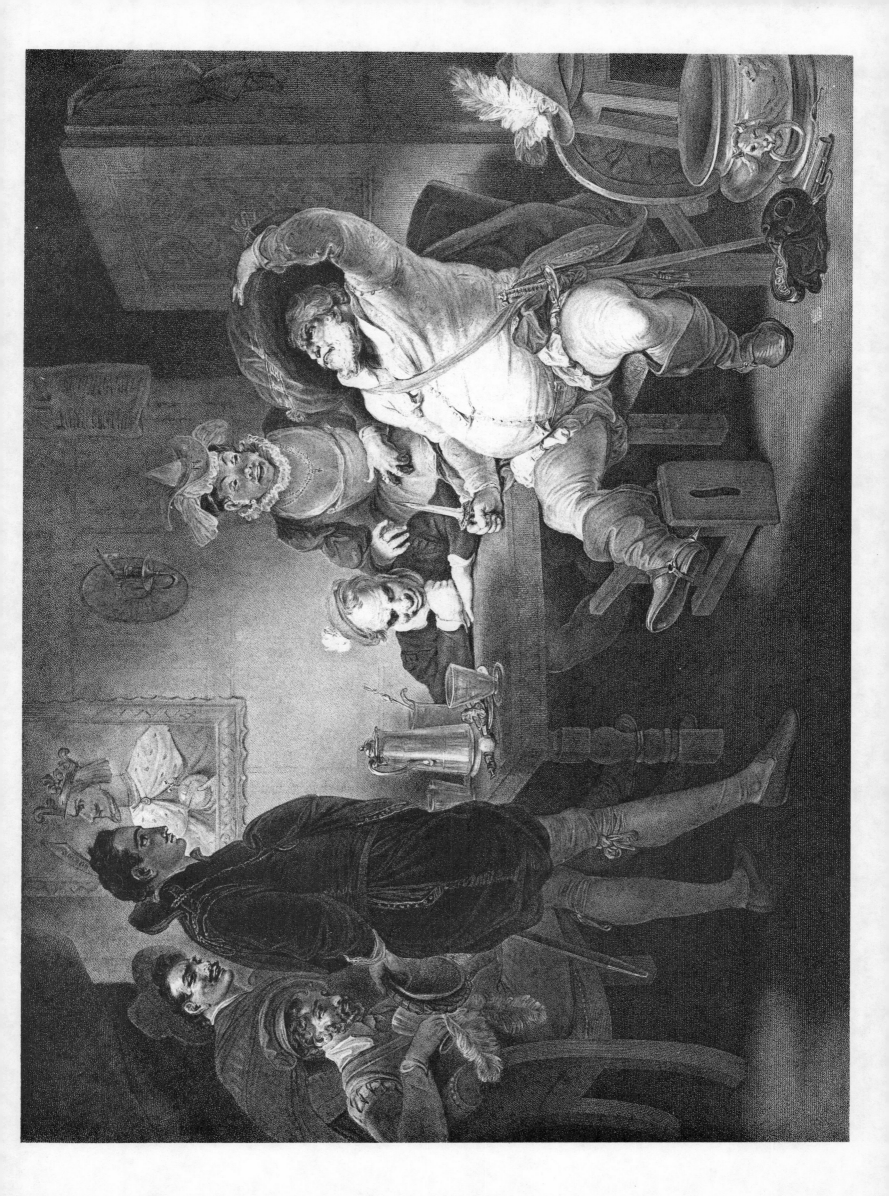

# VI.

## ACT III.  SCENE I.

THE ARCHDEACON OF BANGOR'S HOUSE, IN WALES.

*Hotspur, Worcester, Mortimer, and Owen Glendower.*

Painted by R. Westall, R. A.   Engraved by P. Simon.

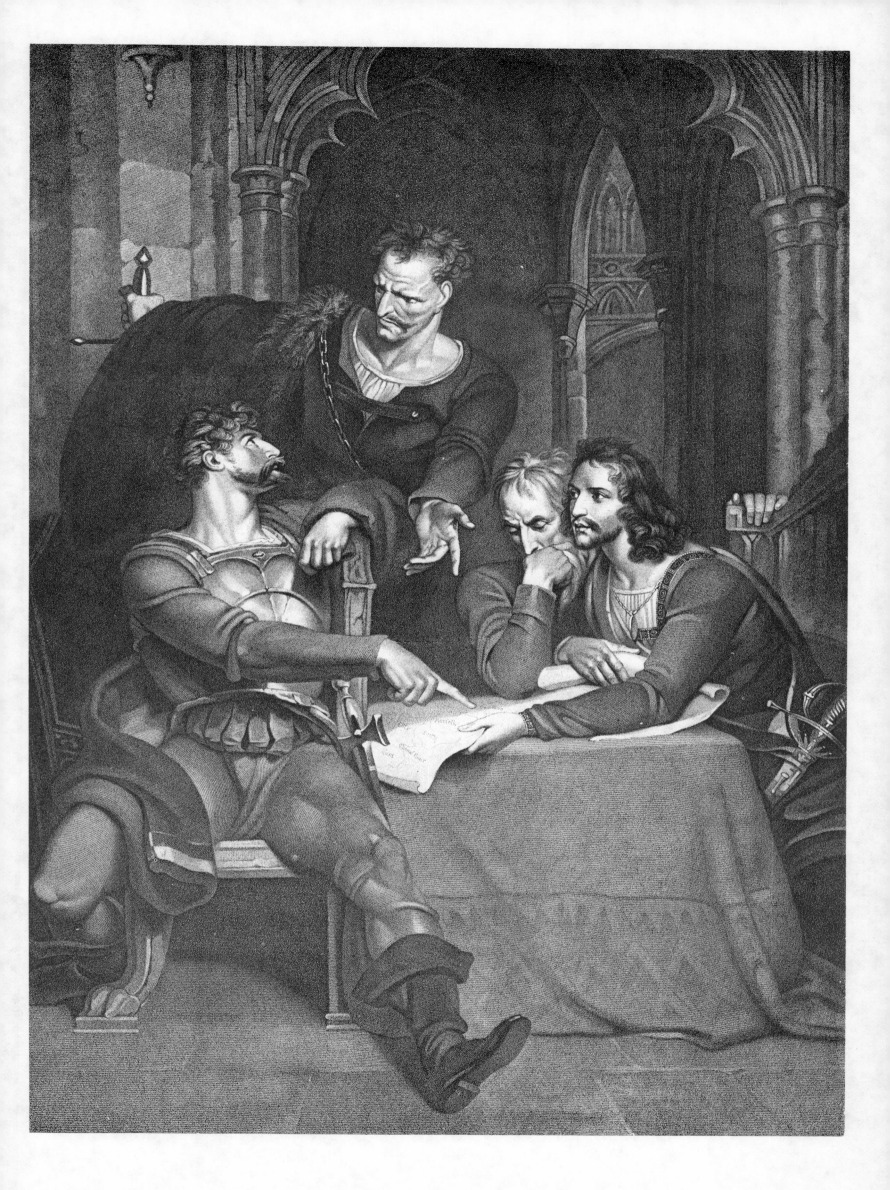

# VII.

## ACT V.  SCENE IV.

PLAIN NEAR SHREWSBURY.

*Prince Henry, Hotspur, and Falstaff.*

Painted by J. F. Rigaud, R. A.   Engraved by T. Ryder.

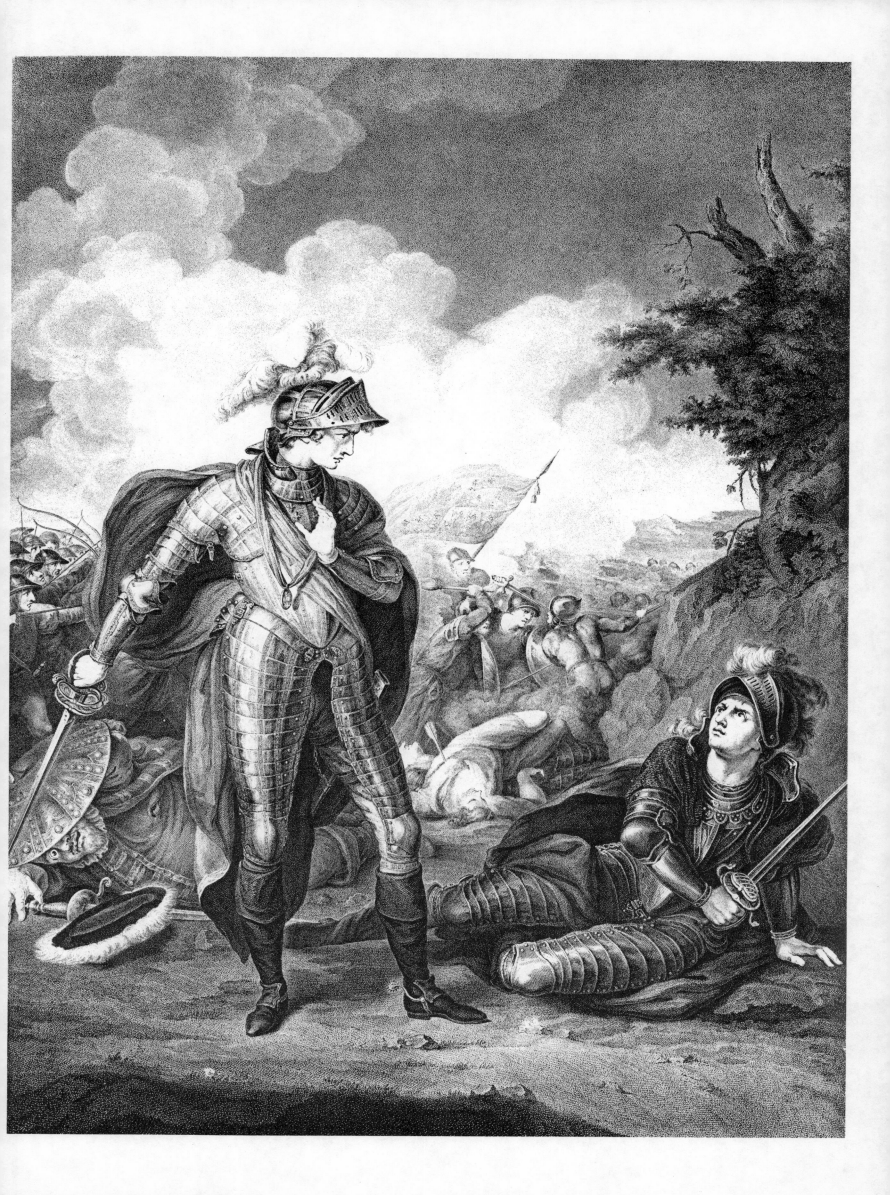

# VIII.

# SECOND PART OF KING HENRY IV.

## ACT II.  SCENE IV.

*Doll Tearsheet, Falstaff, Henry, and Poins.*

Painted by H. Fuseli, R. A.   Engraved by W. Leney.

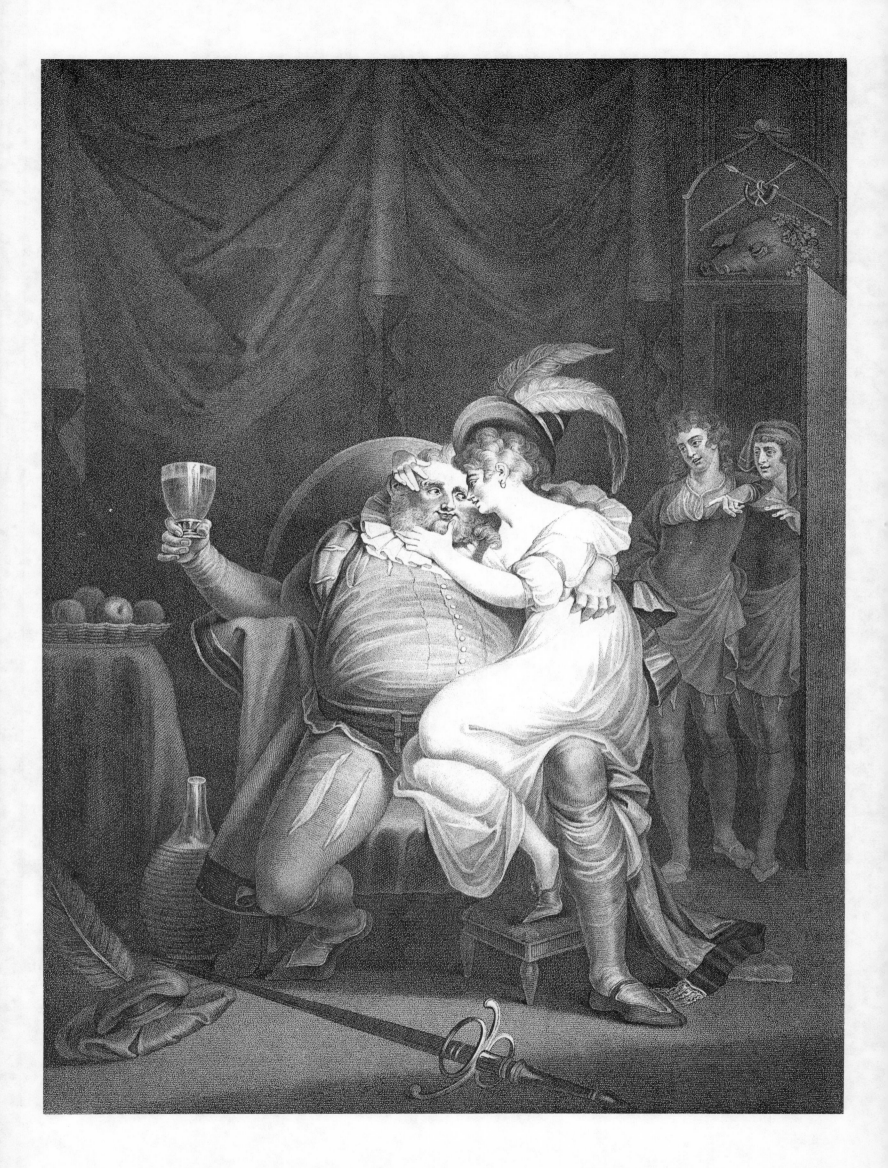

IX.

## ACT III. SCENE II.

JUSTICE SHALLOW'S SEAT, IN GLOUCESTERSHIRE.

*Shallow, Silence, Falstaff, Bardolph, Boy, Mouldy, Shadow, Wart,*
*Feeble, and Bull-calf.*

Painted by J. Durno.    Engraved by T. Ryder.

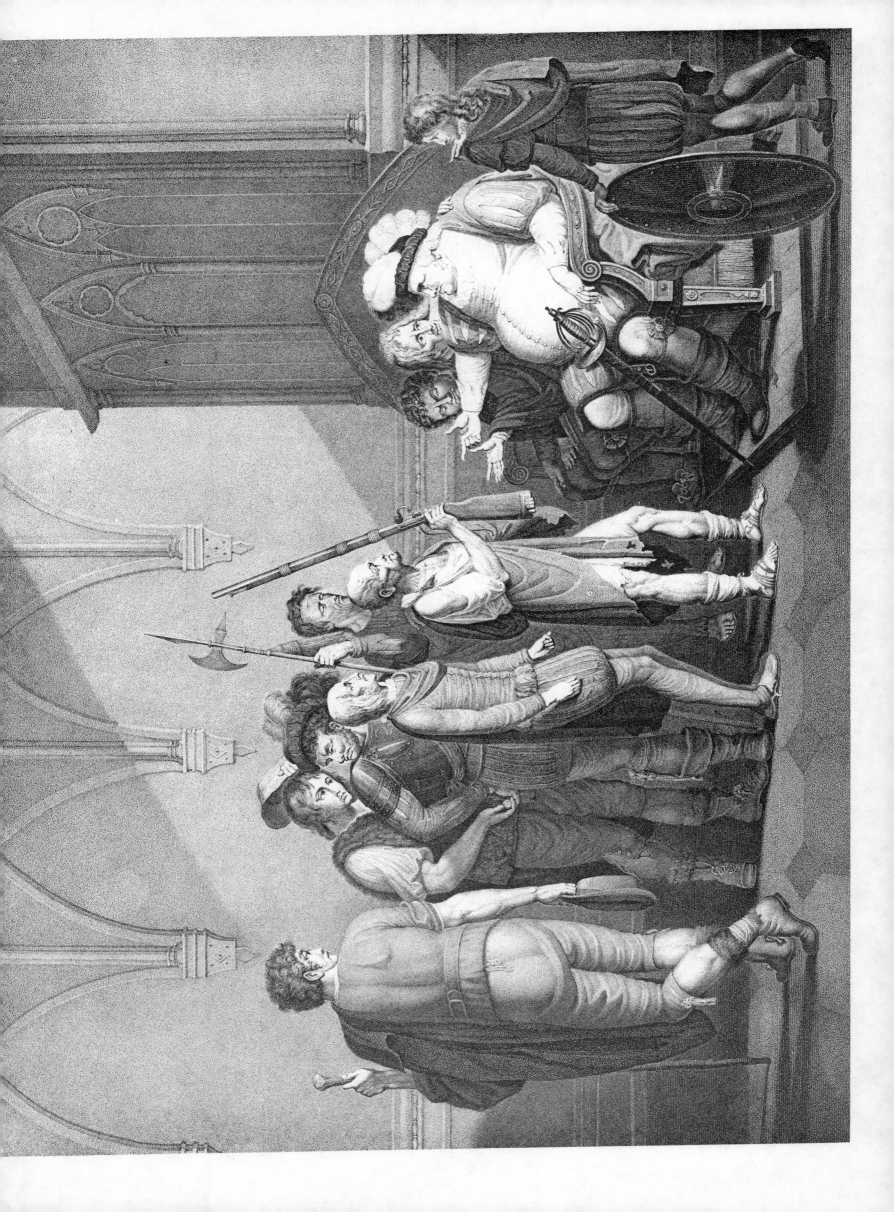

# X.

## ACT IV.  SCENE IV.

THE PALACE AT WESTMINSTER.

*King Henry asleep ; Prince of Wales.*
Painted by J. Boydell.   Engraved by R. Thew.

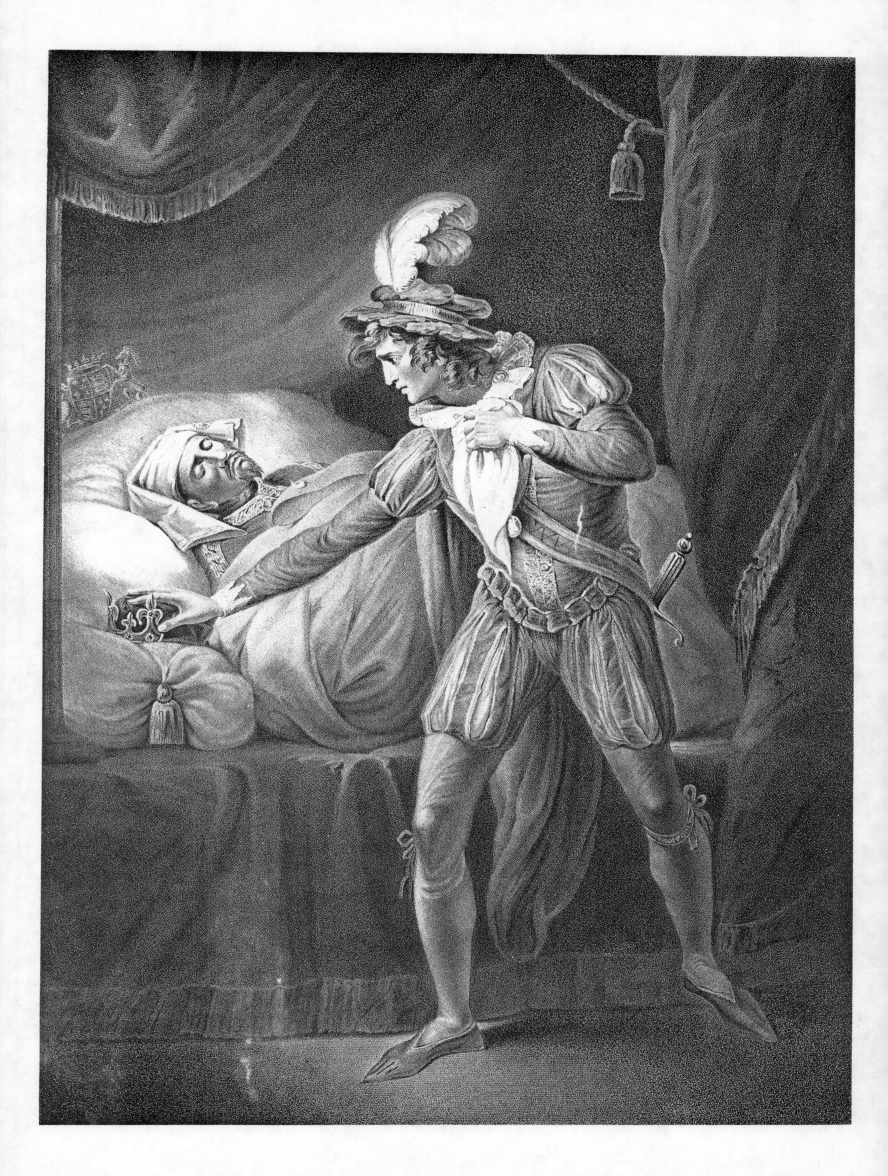

# XI.

## ACT IV.  SCENE IV.

*King Henry and the Prince of Wales.*

Painted by J. Boydell.   Engraved by R. Thew.

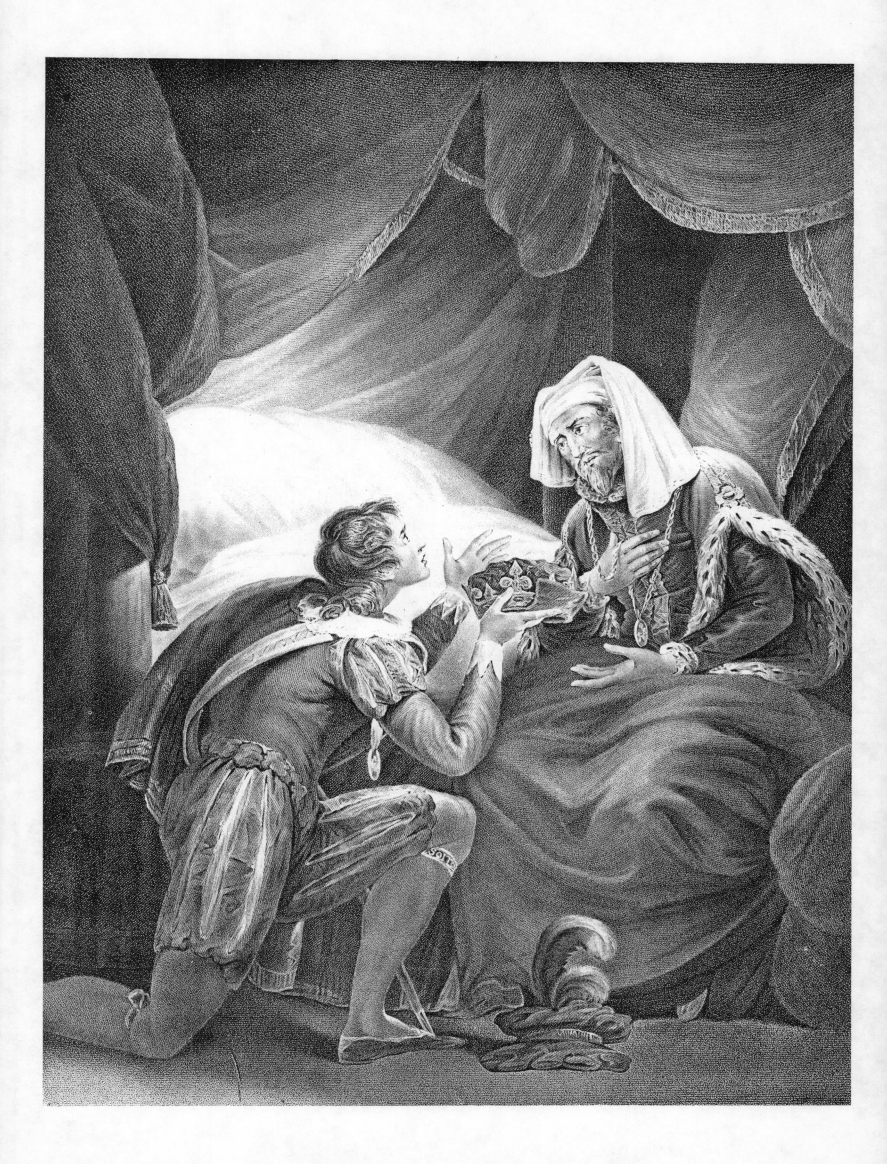

XII.

# KING HENRY V.

## ACT II. SCENE II.

SOUTHAMPTON.

*Exeter, Bedford, and Westmoreland; the King, Scroop, Cam-*
*bridge, Grey, and Attendants.*

Painted by H. Fuseli, R. A.    Engraved by R. Thew.

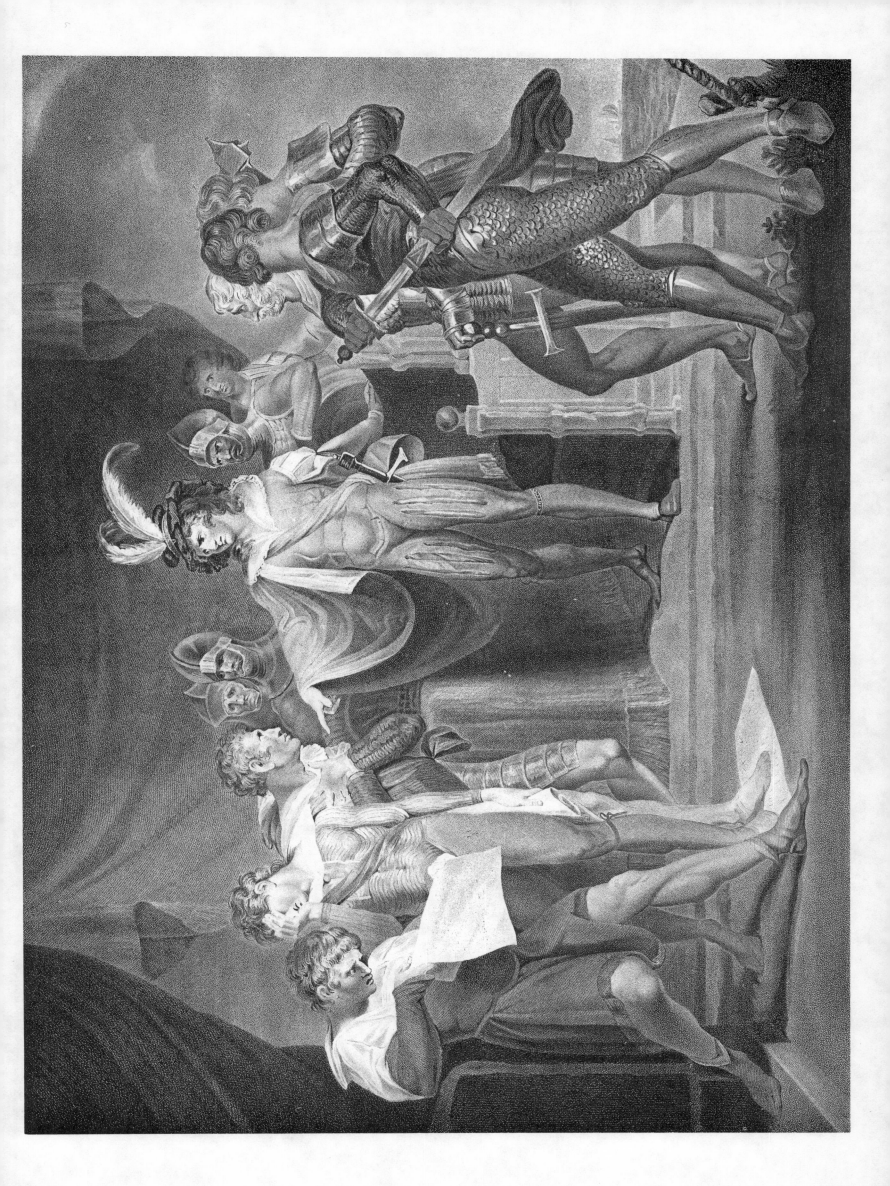

XIII.

FIRST PART OF KING HENRY VI.

ACT II. SCENE III.

THE COUNTESS OF AUVERGNE'S CASTLE.

*Countess, Porter, Talbot, &c.*

Painted by J. Opie, R. A.   Engraved by R. Thew.

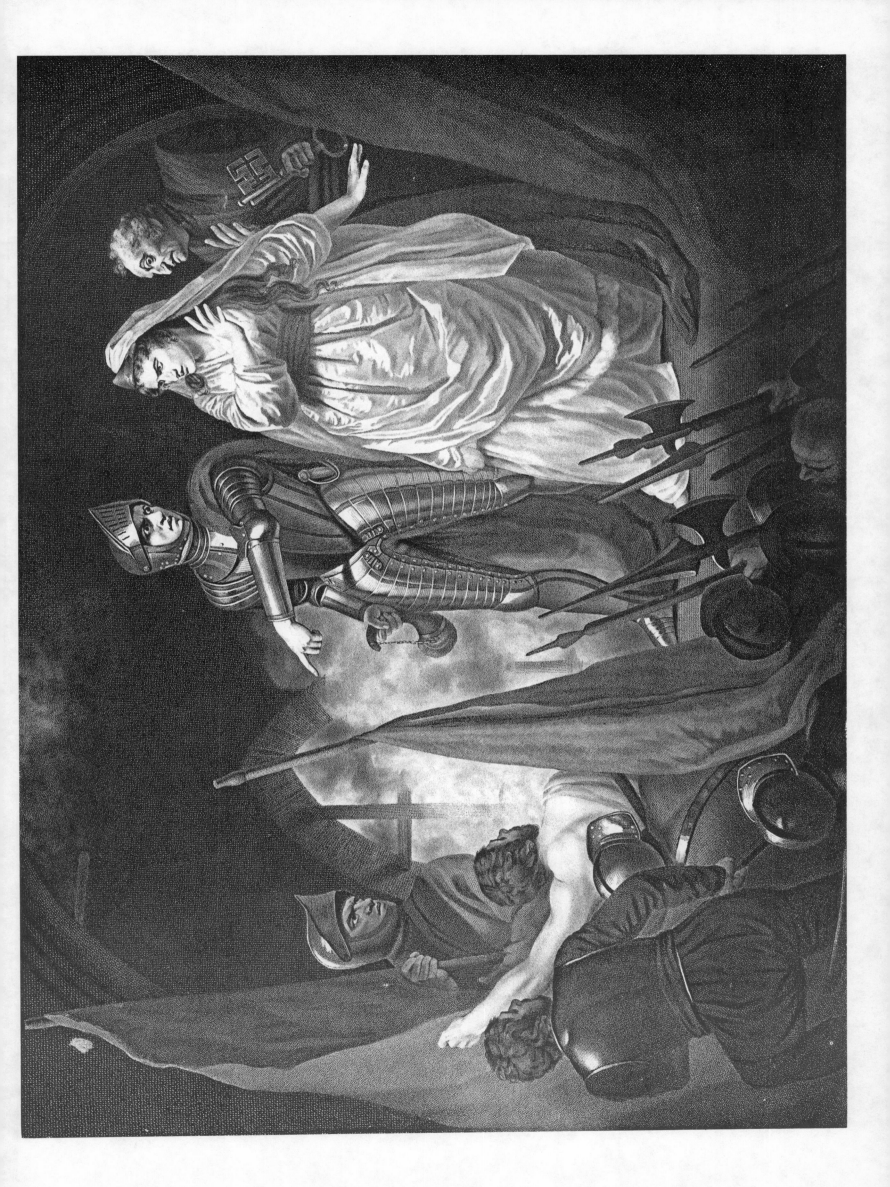

XIV.

## ACT II.  SCENE IV.

LONDON;  THE TEMPLE GARDEN.

*Earls of Somerset, Suffolk, and Warwick ;  Richard Plantagenet,*
*Vernon, and another Lawyer.*

Painted by J. Boydell.    Engraved by J. Ogborne.

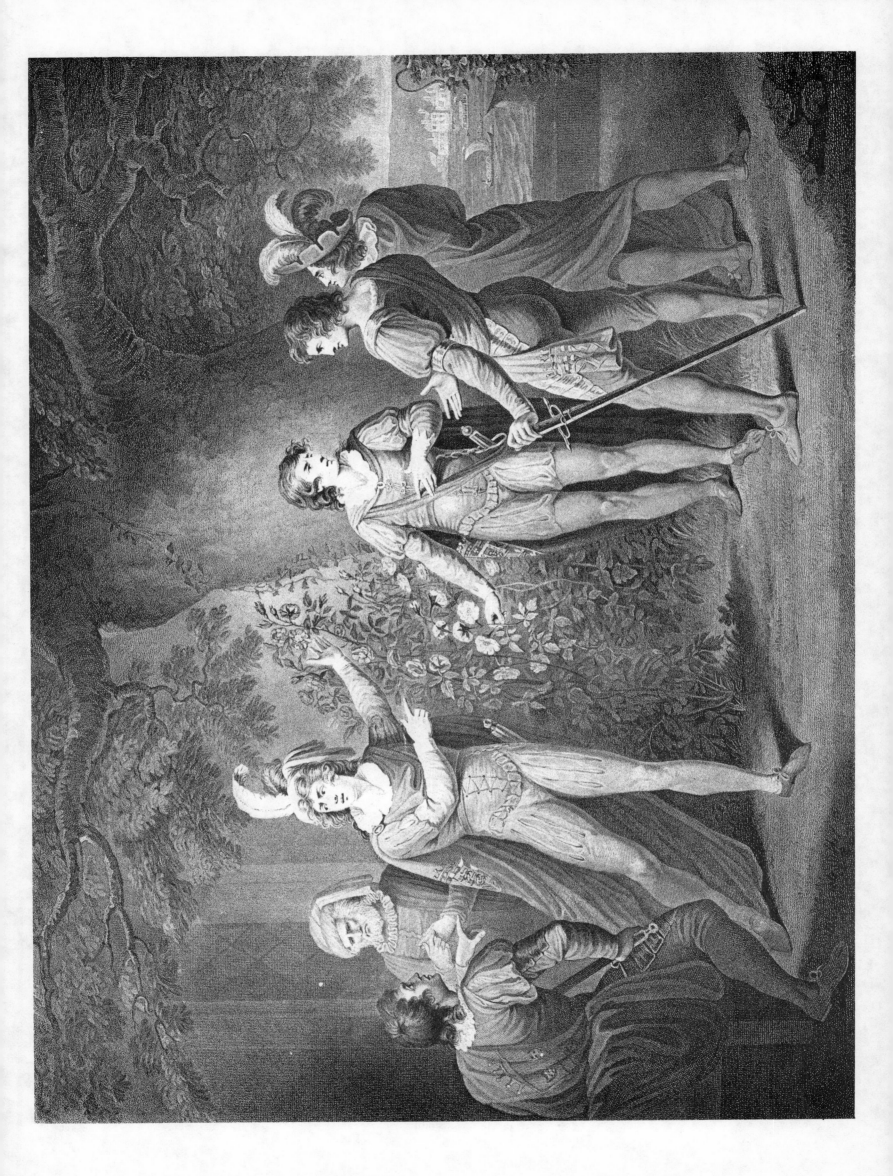

# XV.

## ACT II.  SCENE V.

A ROOM IN THE TOWER.

*Mortimer in a Chair, Jailor, and Richard Plantagenet.*

Painted by **J.** Northcote, R. A.  Engraved by R. Thew.

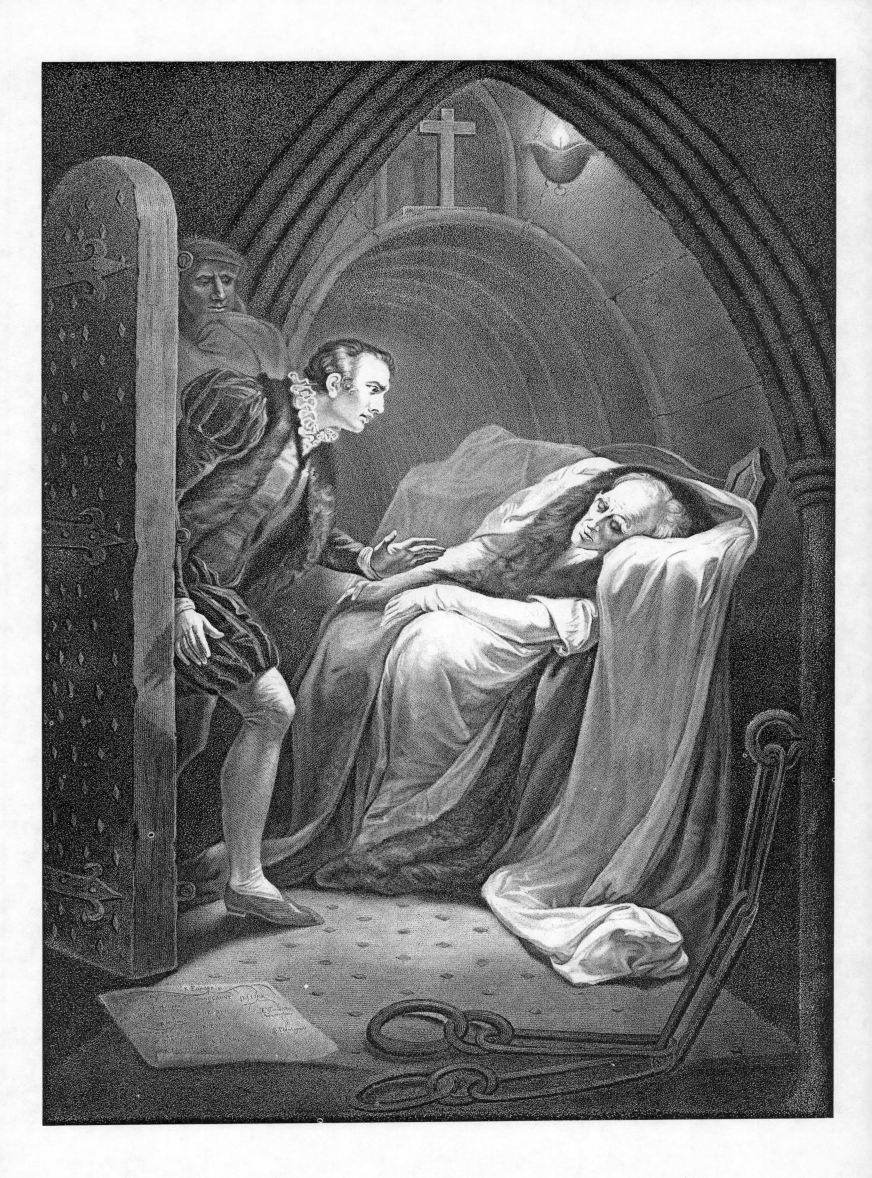

# XVI.

## SECOND PART OF KING HENRY VI.

### ACT I.   SCENE IV.

*Mother Jourdain, Hume, Southwell, Bolingbroke, and Eleanor.*

Painted by J. Opie, R. A.   Engraved by C. G. Playter and
R. Thew.

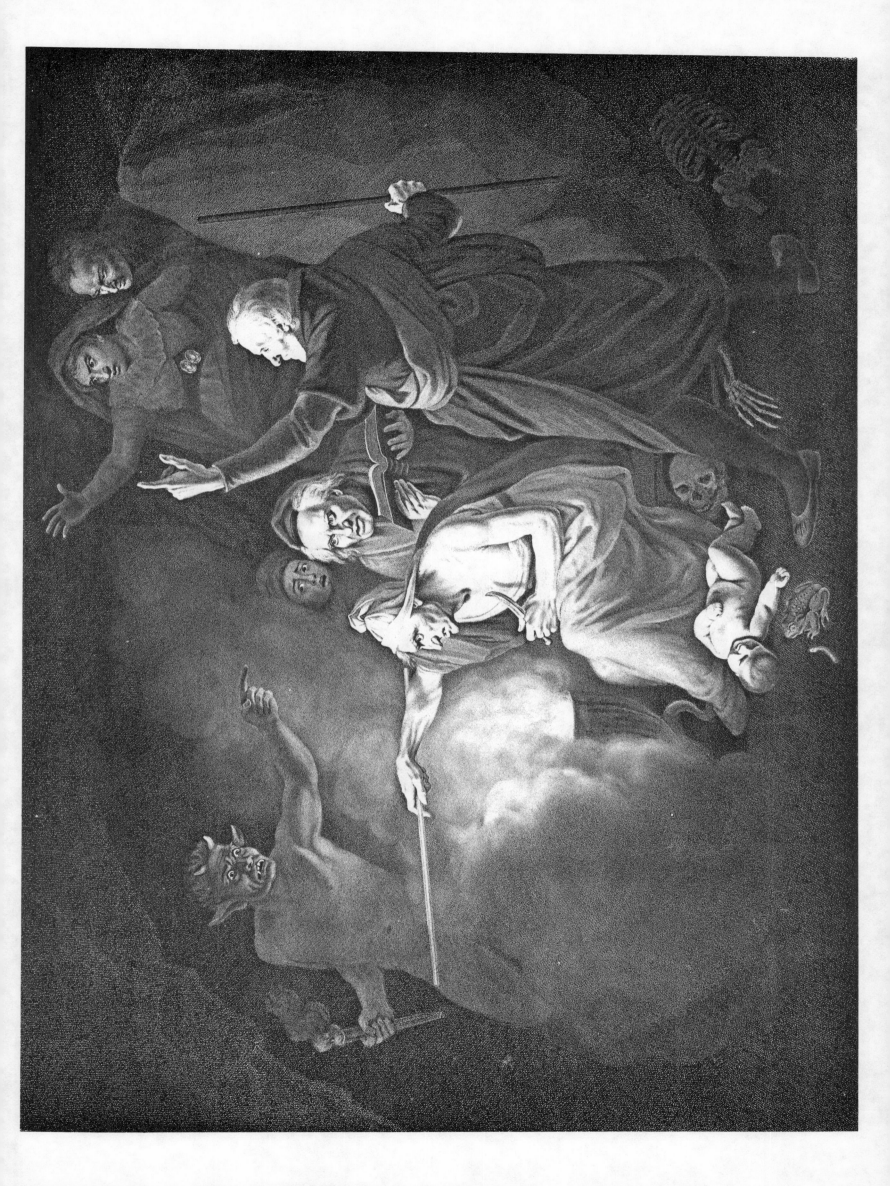

# XVII.

## ACT III.  SCENE III.

CARDINAL BEAUFORT'S BEDCHAMBER.

*King Henry, Salisbury, and Warwick.   The Cardinal in Bed.*

Painted by Sir Joshua Reynolds, late President of the Royal
Academy.   Engraved by Caroline Watson.

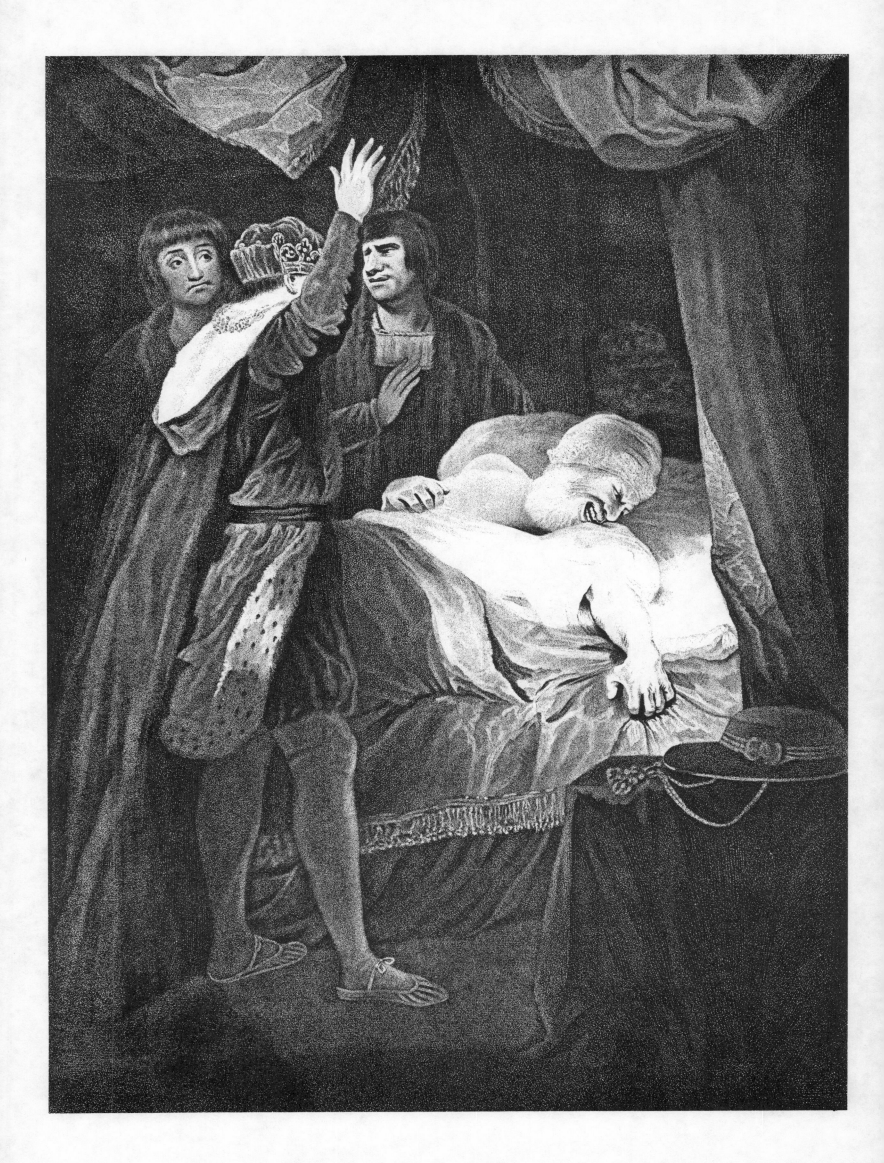

# XVIII.

## THIRD PART OF KING HENRY VI.

### ACT I.  SCENE III.

A FIELD OF BATTLE BETWIXT SANDAL CASTLE AND WAKEFIELD.

*Rutland and his Tutor, Clifford and Soldiers.*

Painted by J. Northcote, R. A.   Engraved by C. G. Playter
and T. Ryder.

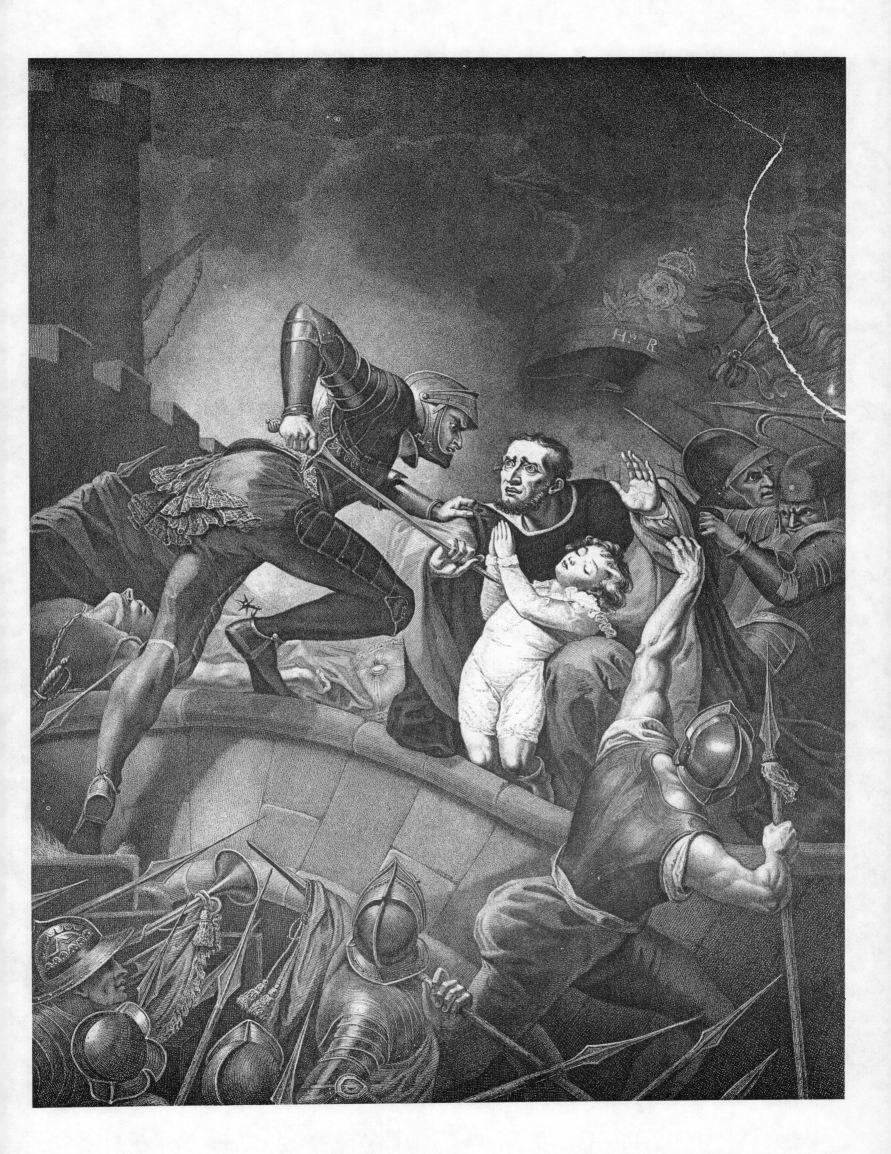

# XIX.

## THIRD PART OF KING HENRY VI.

### ACT II.  SCENE V.

A FIELD OF BATTLE, NEAR TOWTON, IN YORKSHIRE.

*King Henry.  Son that has killed his Father—Father that has killed his Son.*

Painted by J. Boydell.    Engraved by J. Ogborne.

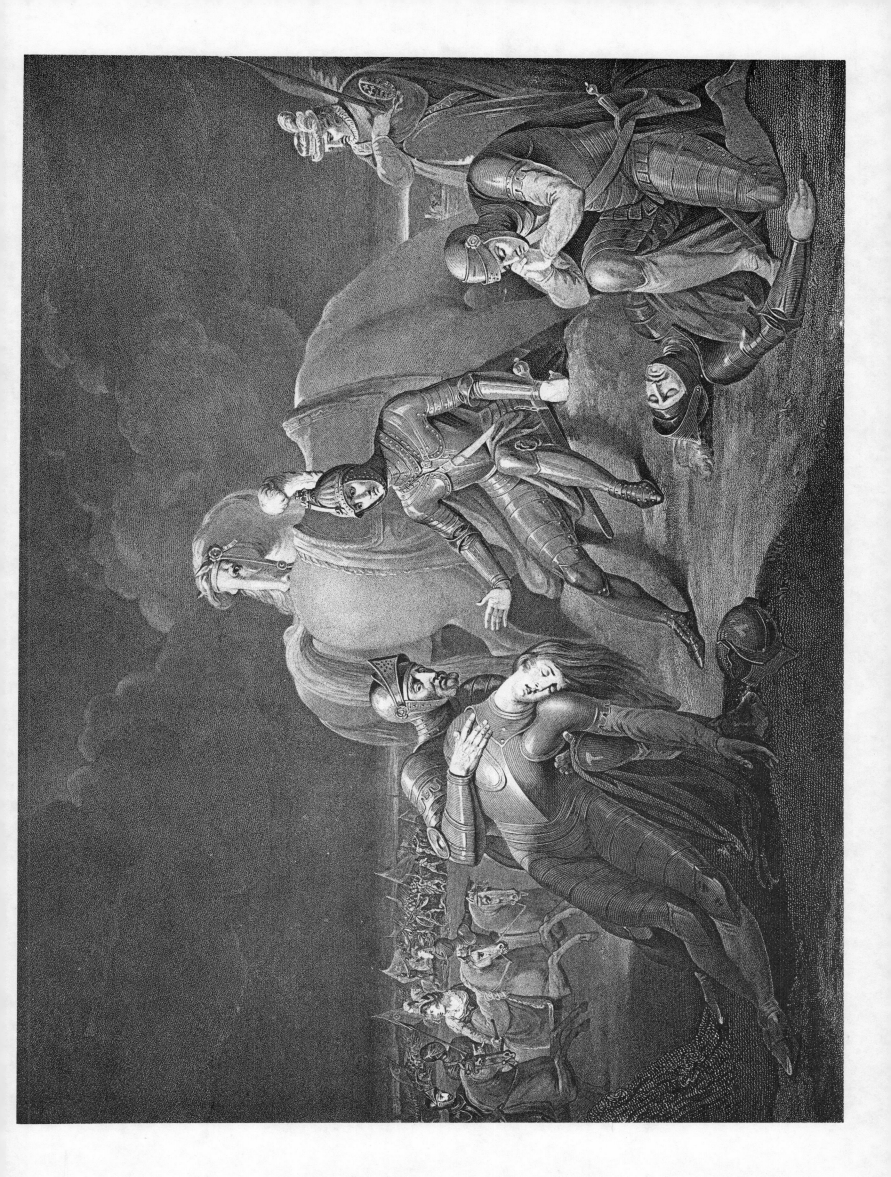

XX.

ACT IV. SCENE V.

A PARK, NEAR MIDDLEHAM CASTLE, IN YORKSHIRE.

*King Edward and Huntsman; Gloster, Hastings; and Sir William Stanley in the distance.*

Painted by W. Miller.   Engraved by J. B. Michel and W. Leney.

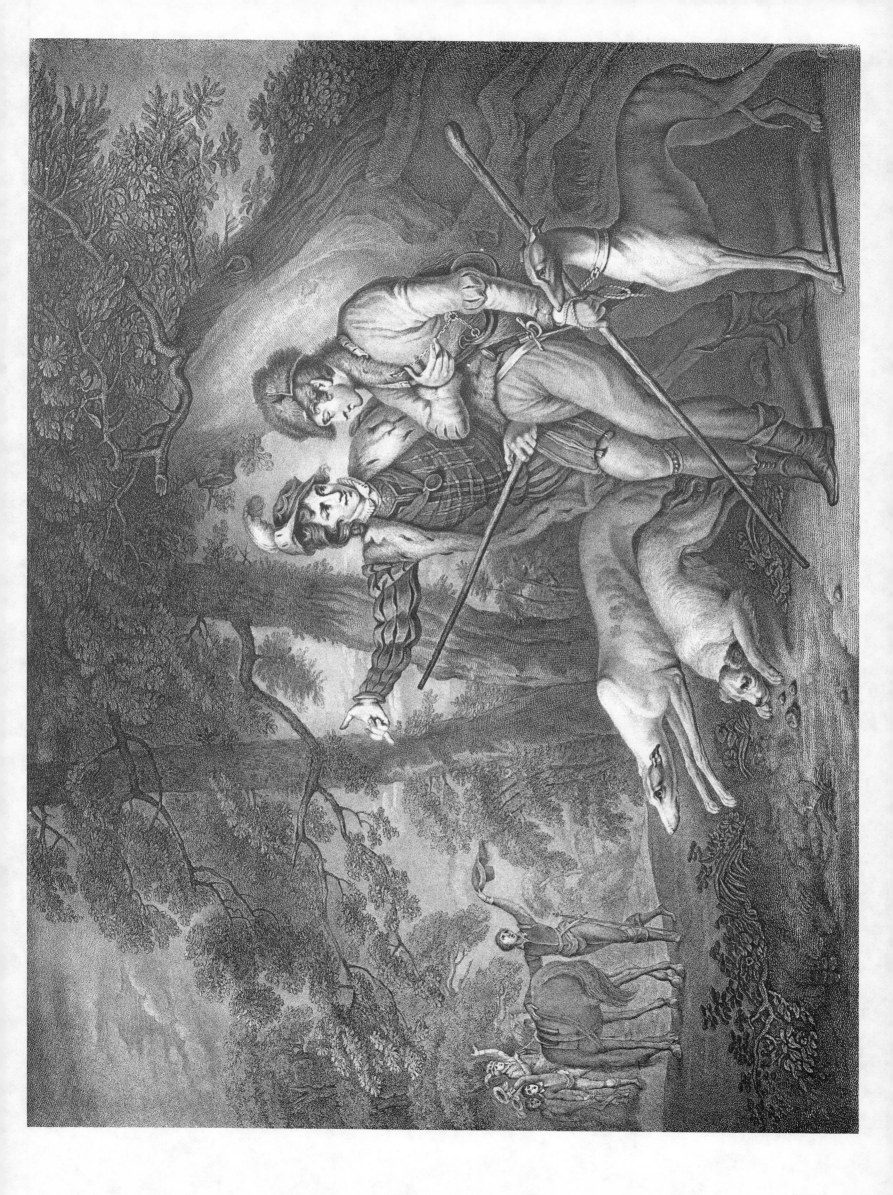

# XXI.

## ACT V.  SCENE VII.

THE PALACE IN LONDON.

*King Edward, the Queen, with the young Prince, Clarence, Gloster,*
*Hastings, and Attendants.*

Painted by J. Northcote, R. A.   Engraved by J. B. Michel.

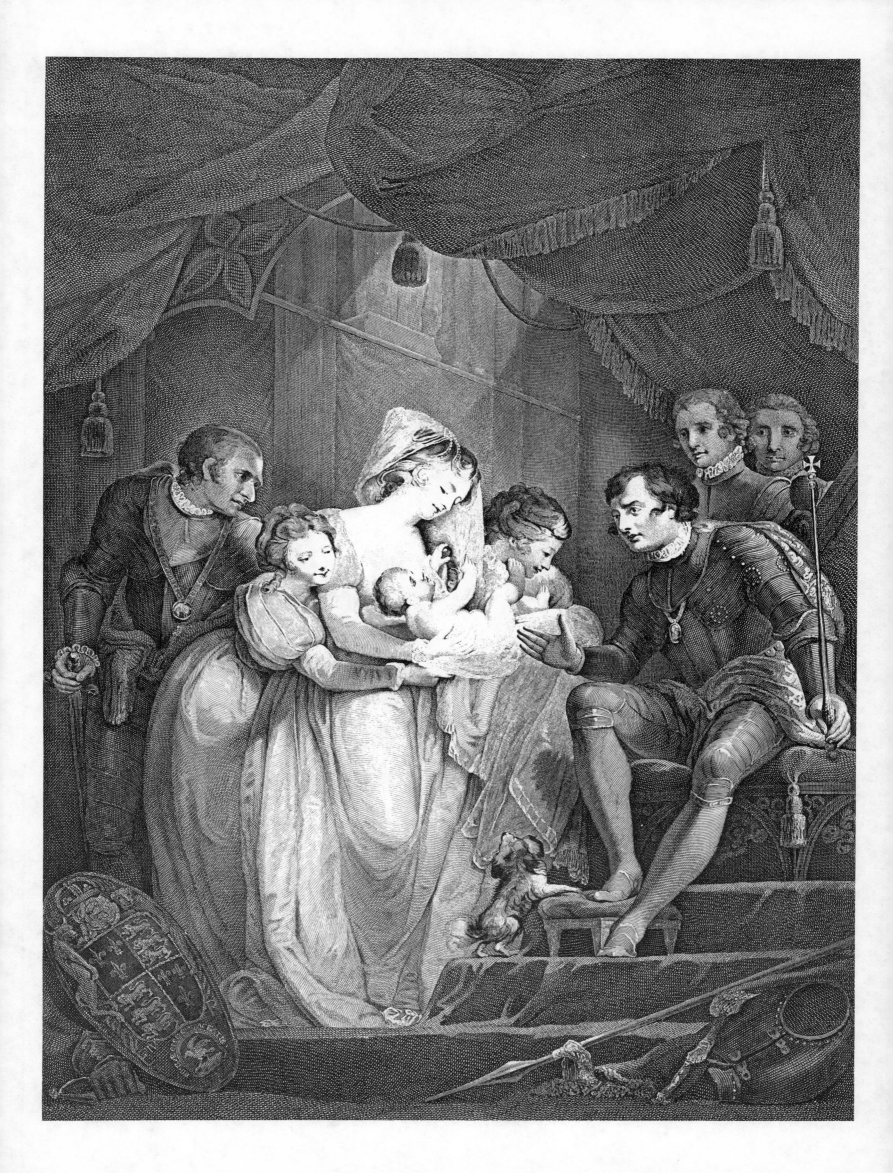

XXII.

KING RICHARD III.

ACT III. SCENE I.

LONDON.

*Prince of Wales, Duke of York, his Brother, Dukes of Gloucester and Buckingham, Cardinal Bourchier, Lord Hastings, Lord Mayor and his Train.*

Painted by J. Northcote, R. A.   Engraved by R. Thew.

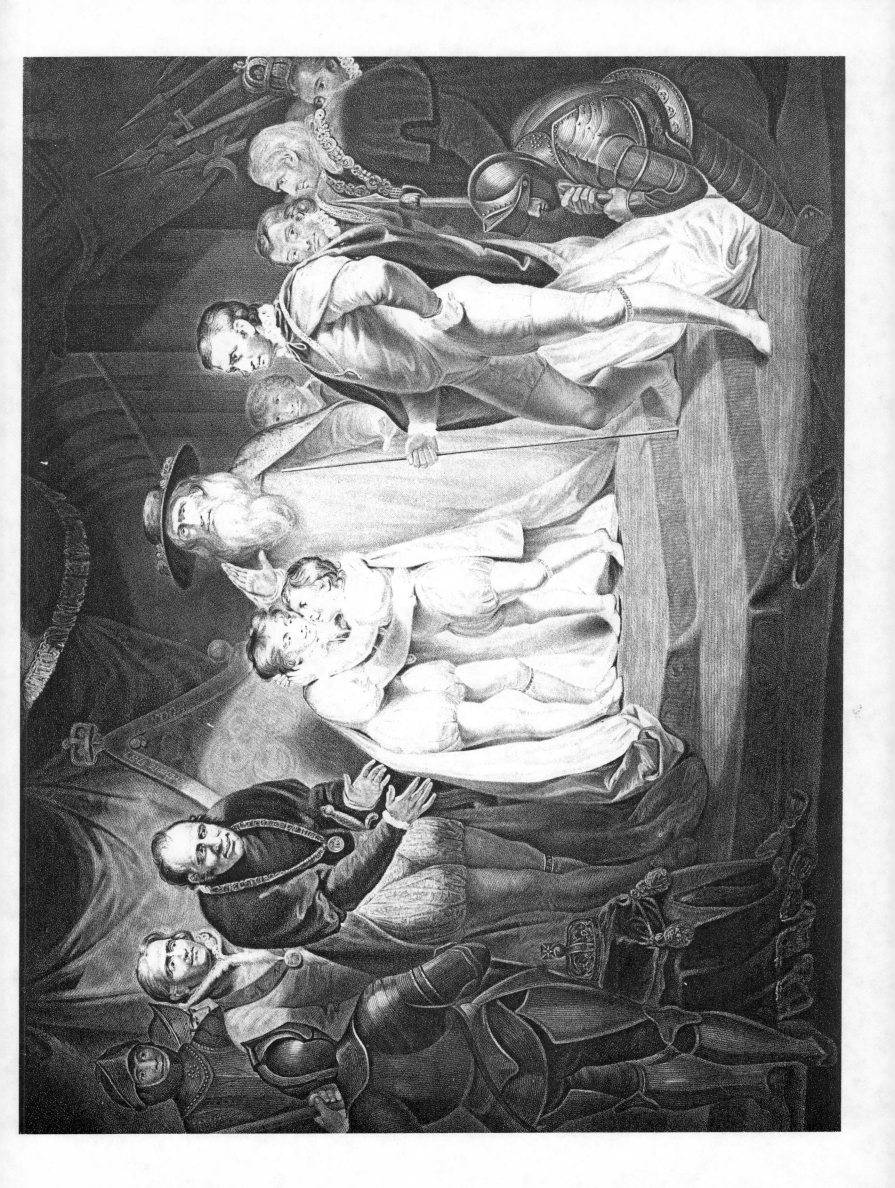

# XXIII.

## ACT IV.　SCENE III.

THE TOWER.

*The Royal Children ; Dighton and Forest, the Murderers.*
Painted by J. Northcote, R. A.　Engraved by F. Legat.

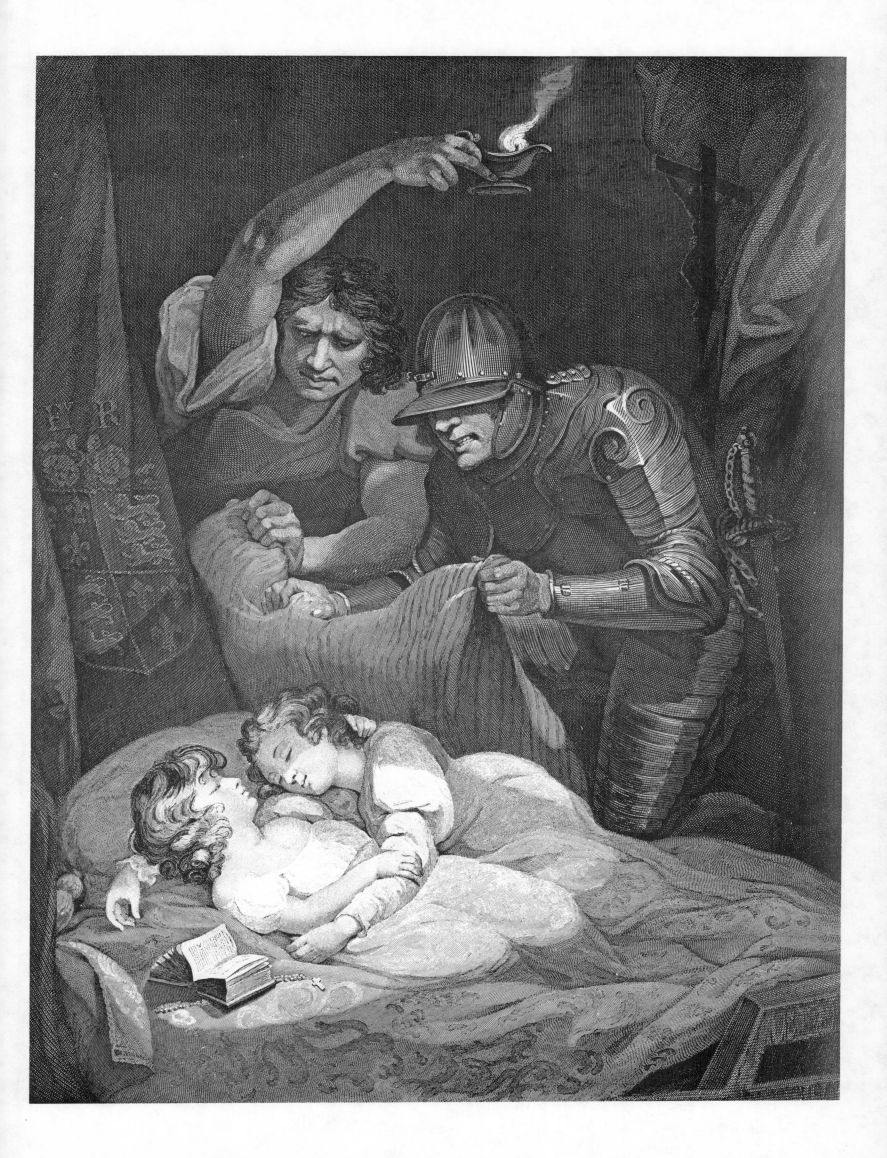

## XXIV.

### ACT IV.  SCENE III.

TOWER OF LONDON.

*Burying the Royal Children.*

Painted by J. Northcote, R. A.    Engraved by W. Skelton.

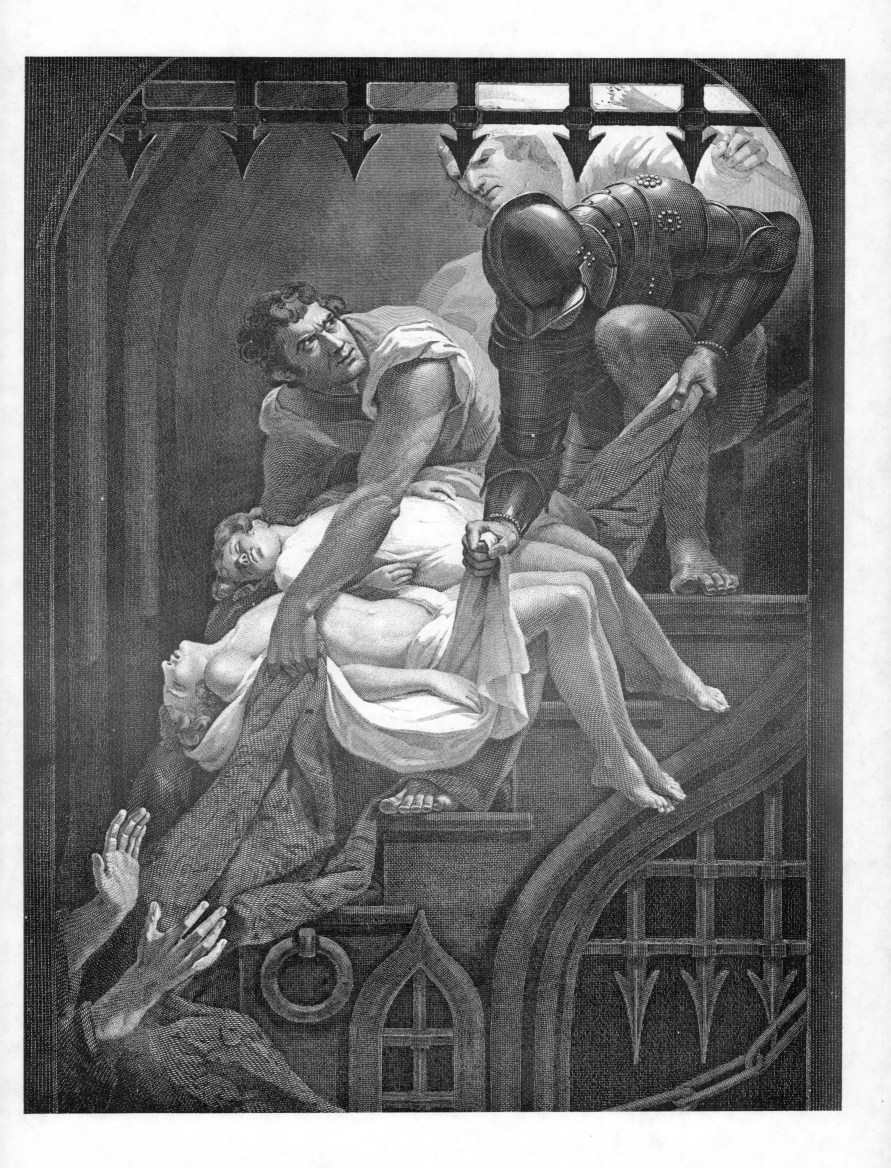

**XXV.**

## KING HENRY VIII.

### ACT I. SCENE IV.

YORK PLACE.

*Cardinal Wolsey, Lord Sands, Anne Bullen, King Henry, &c.*

Painted by T. Stothard, R. A.   Engraved by I. Taylor.

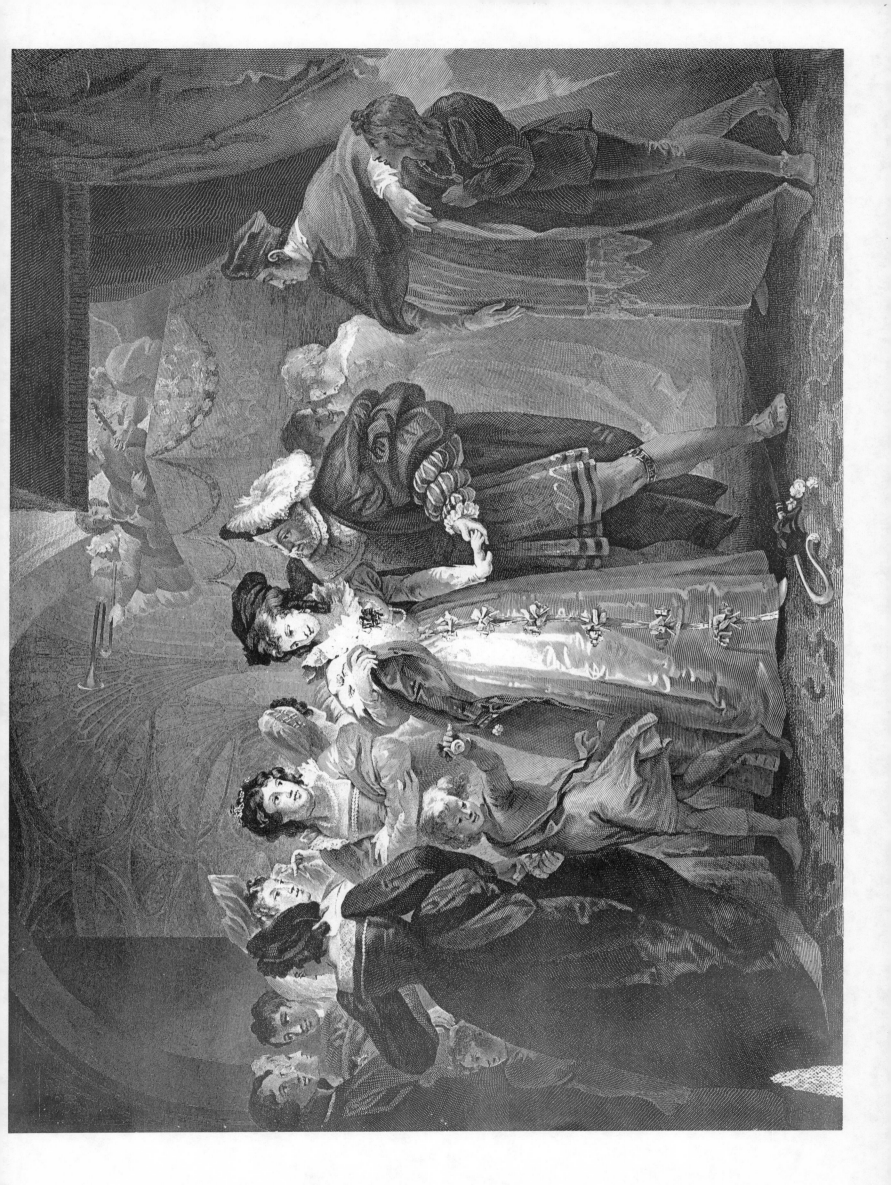

XXVI.

KING HENRY VIII.

ACT III. SCENE I.

THE QUEEN'S APARTMENTS.

*Queen and her Women at Work; Cardinals Wolsey and Campeius.*

Painted by the Rev. W. Peters, R. A.  Engraved by R. Thew.

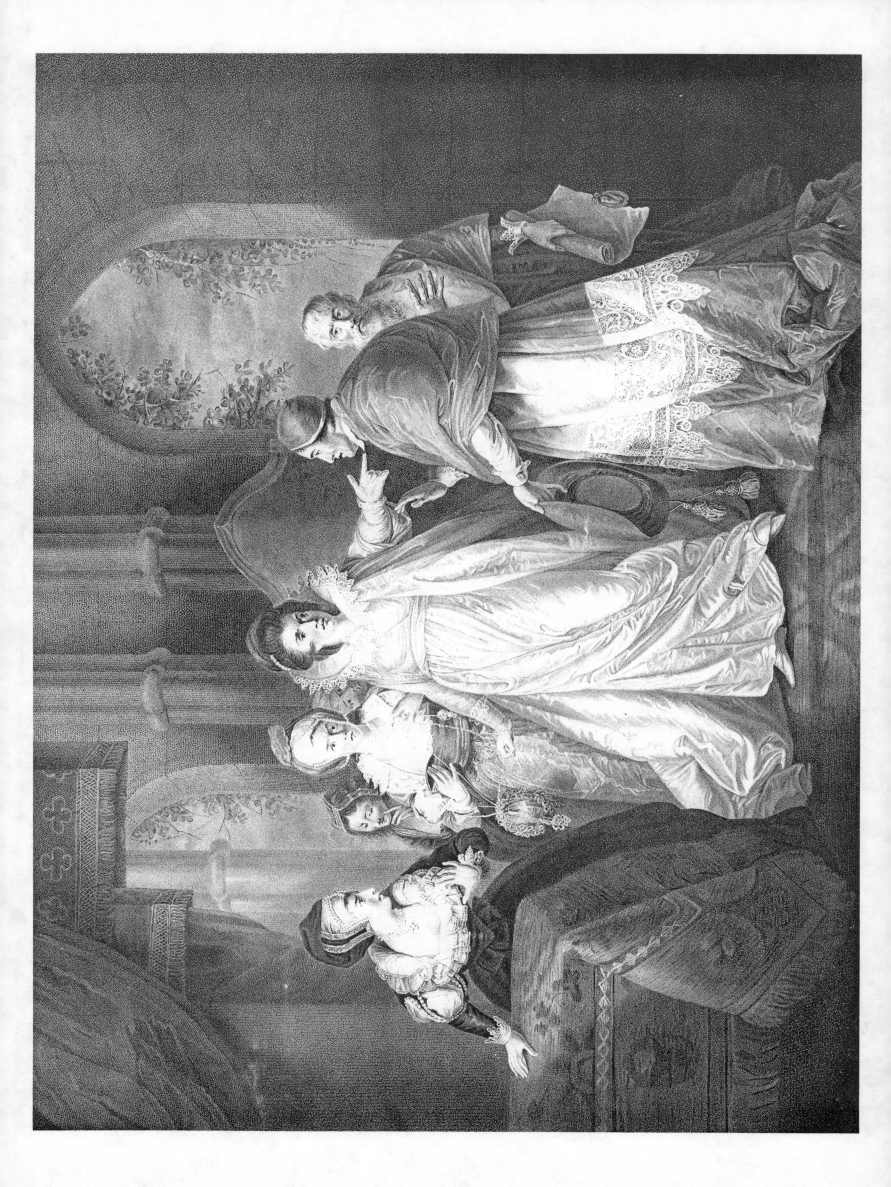

XXVII.

ACT IV.  SCENE II.

THE ABBEY OF LEICESTER.

*Abbot of Leicester, Wolsey, Northumberland, and Attendants.*

Painted by R. Westall, R. A.   Engraved by R. Thew

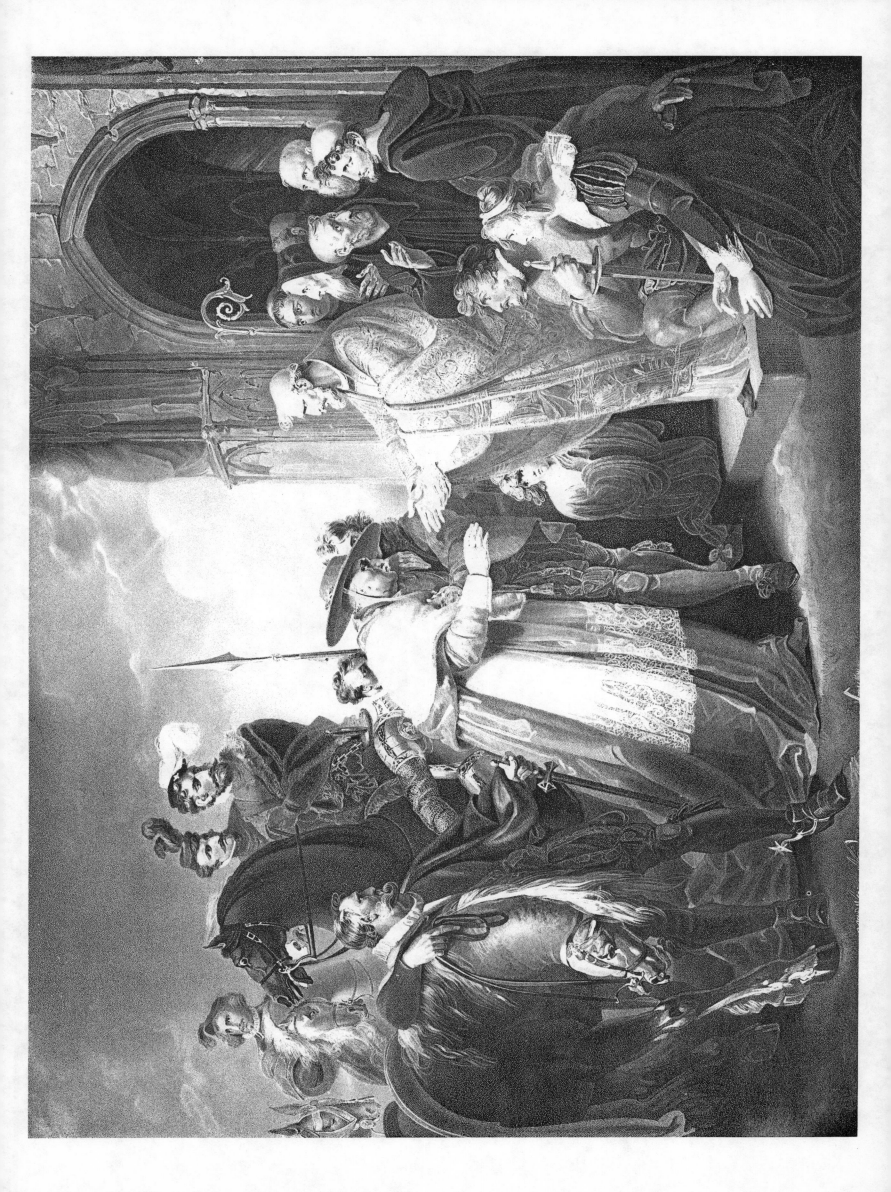

XXVIII.

ACT V.  SCENE IV.

THE PALACE.

*The Christening of Queen Elizabeth.*

Painted by the Rev. W. Peters, R. A.  Engraved by J. Collyer.

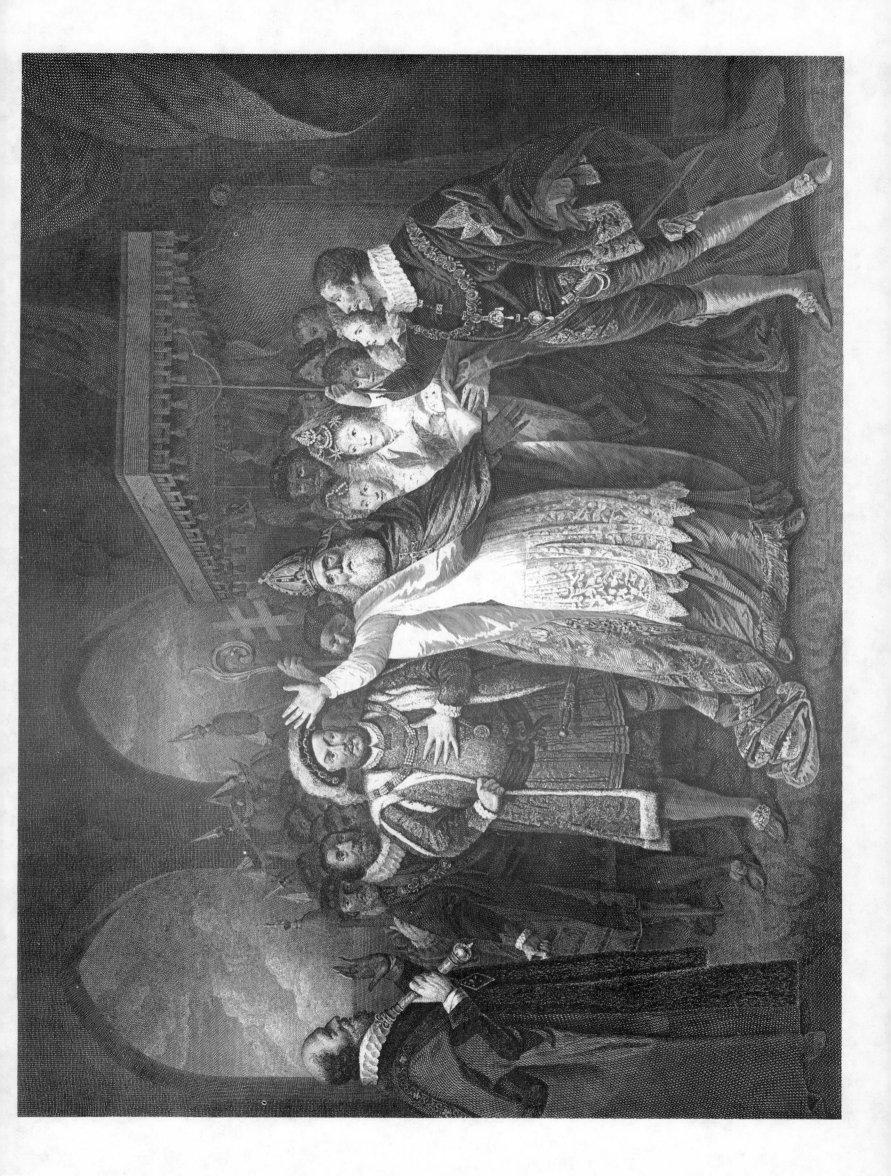

XXIX.

CORIOLANUS.

ACT V. SCENE III.

*Coriolanus, Aufidius, Virgilia, Volumnia, young Marcius, Valeria,
and Attendants.*

Painted by G. Hamilton.    Engraved by J. Caldwall.

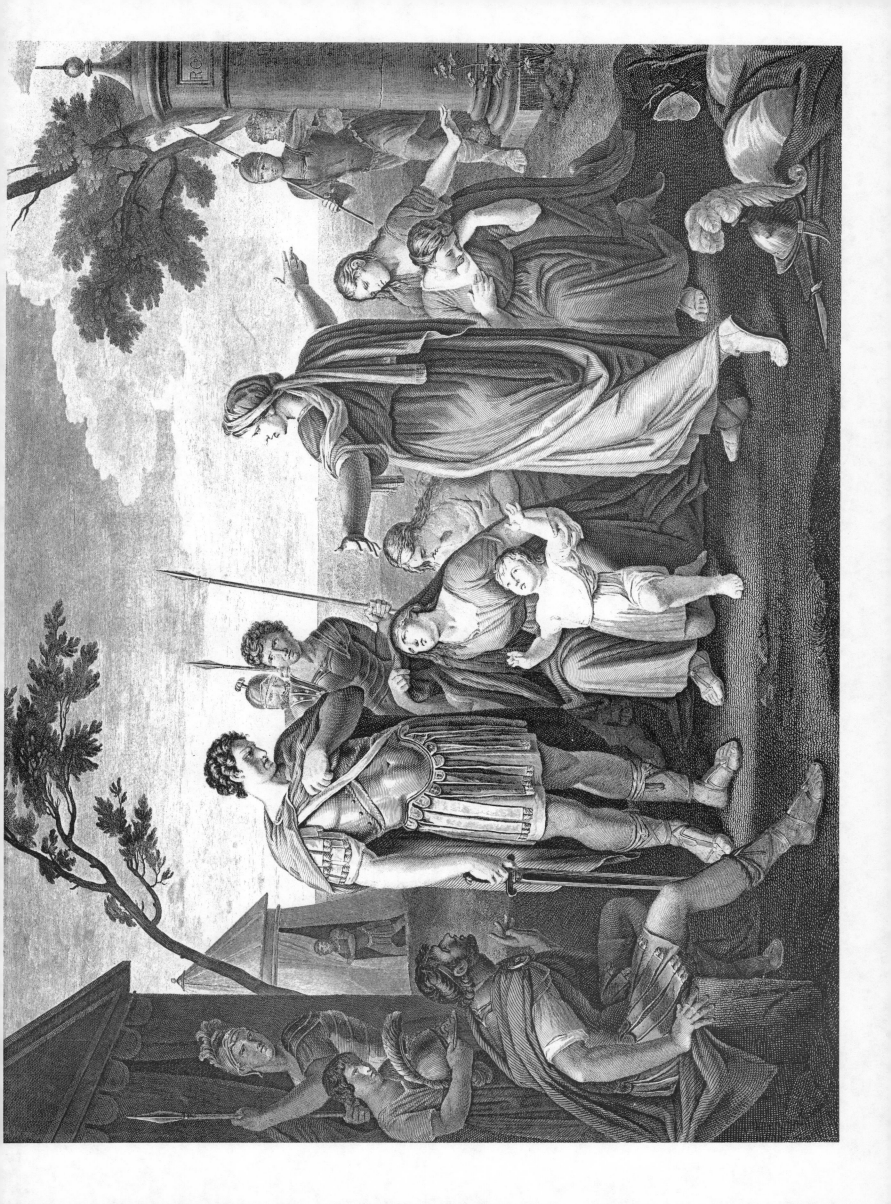

## XXX.

## JULIUS CÆSAR.

### ACT IV. SCENE III.

BRUTUS'S TENT, IN THE CAMP NEAR SARDIS.

*Brutus and the Ghost of Cæsar.*

Painted by R. Westall, R. A.  Engraved by E. Scriven.

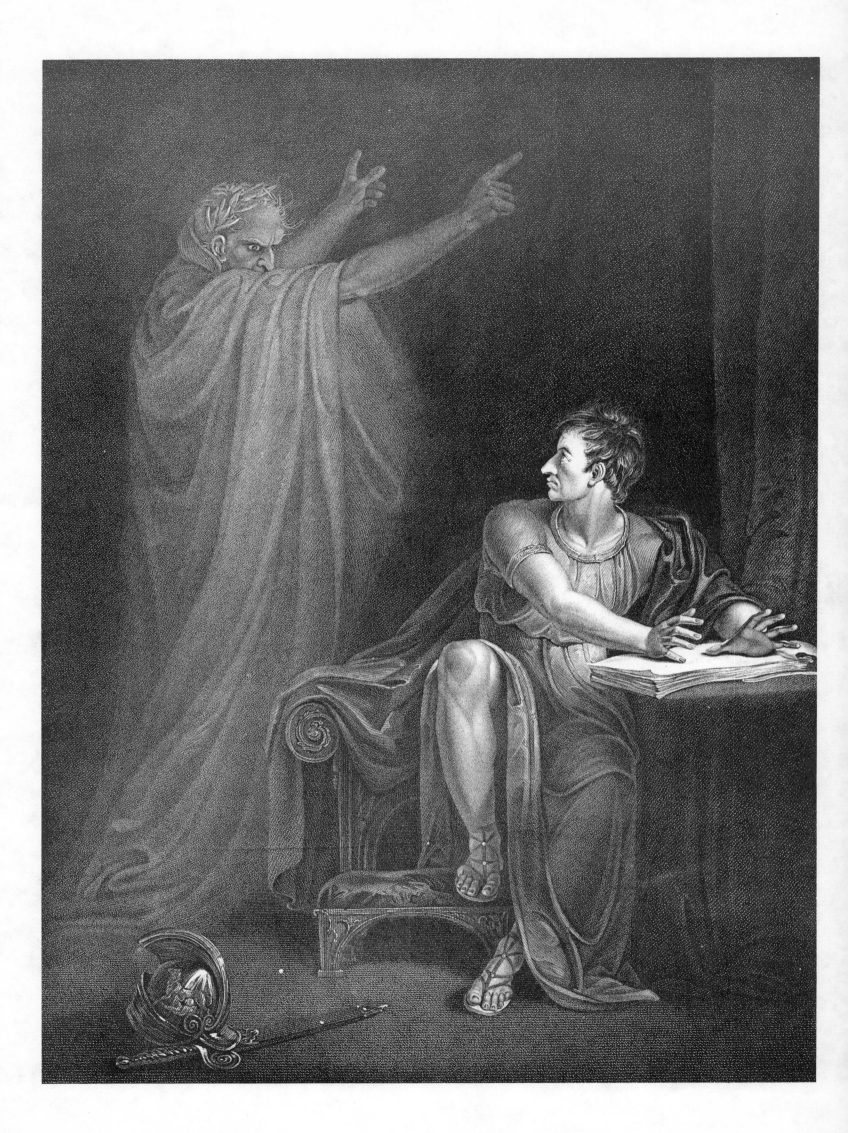

XXXI.

# ANTONY AND CLEOPATRA.

## ACT III. SCENE IX.

### THE PALACE IN ALEXANDRIA.

*Antony, Cleopatra, Eros, Charmian, Iras, &c. &c.*

Painted by H. Tresham, R. A.   Engraved by G. S. and
J. G. Facius.

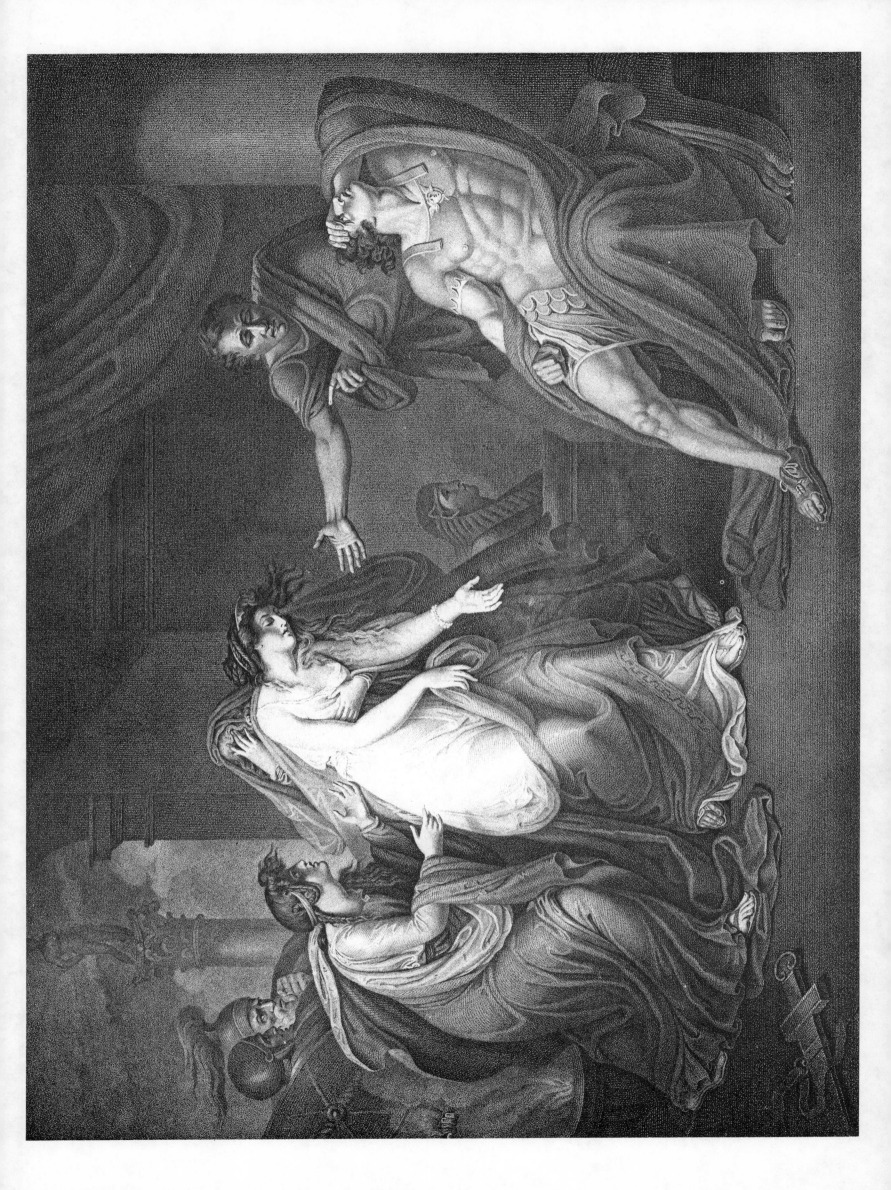

XXXII.

# TIMON OF ATHENS.

## ACT IV. SCENE III.

### A WOOD.

*Timon, Alcibiades, Phrynia, and Timandra.*

Painted by J. Opie, R. A.    Engraved by R. Thew.

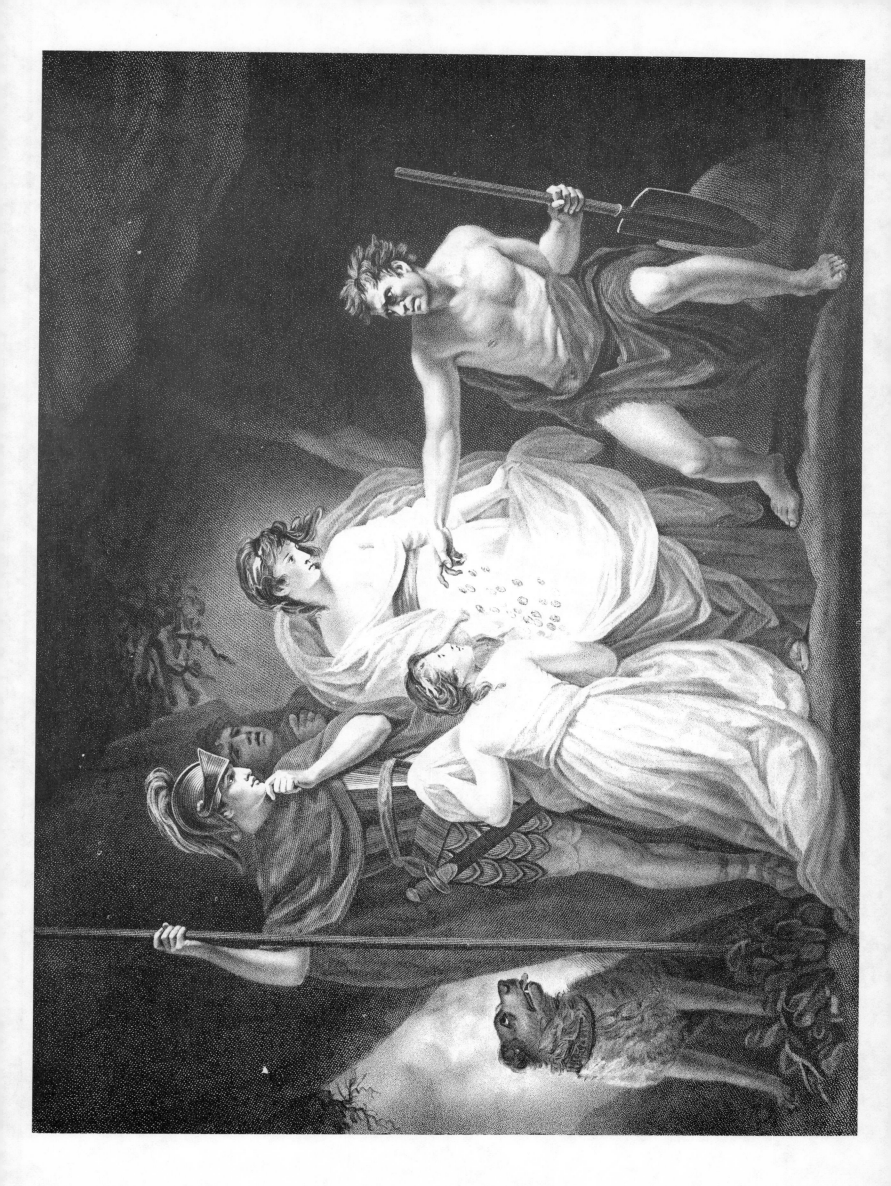

# XXXIII.

## TITUS ANDRONICUS.

### ACT IV. SCENE I.

TITUS'S HOUSE.

*Titus and Marcus. Young Lucius pursued by Lavinia.*

Painted and engraved by T. Kirk.

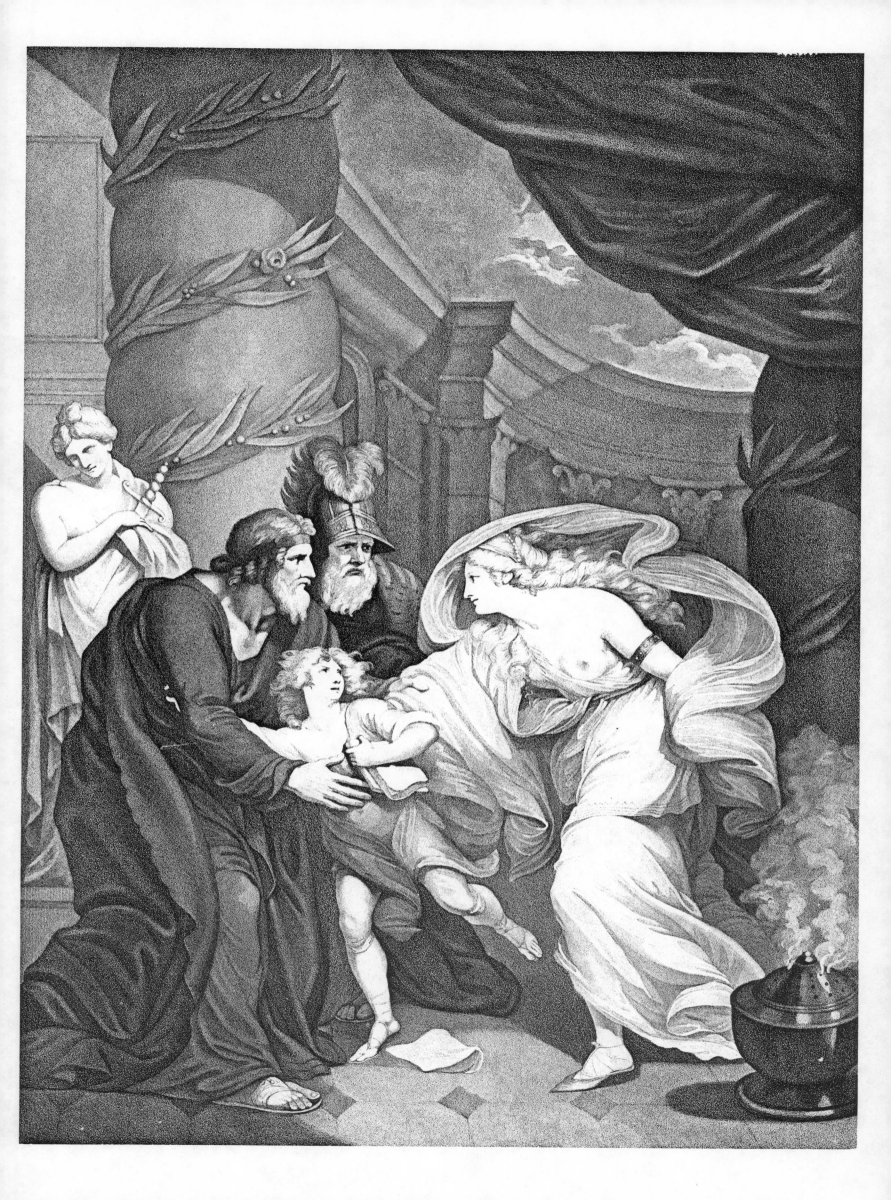

# XXXIV.

## TROILUS AND CRESSIDA.

### ACT II. SCENE II.

TROY.

*Cassandra raving.*

Painted by G. Romney.   Engraved by F. Legat.

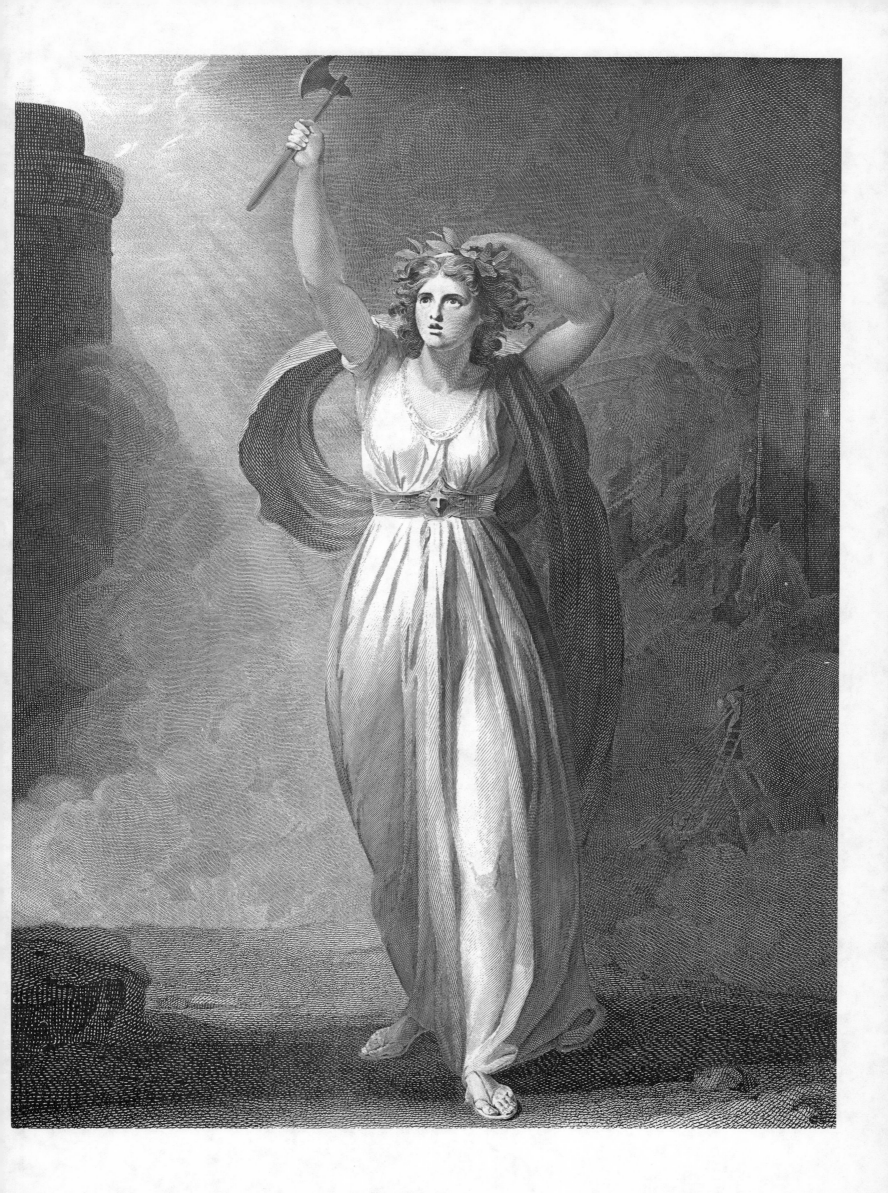

XXXV.

ACT V. SCENE II.

CALCHAS' TENT.

*Diomed and Cressida, Troilus, Ulysses, and Thersites.*

Painted by Angelica Kauffman, R. A.   Engraved by
L. Schiavonetti.

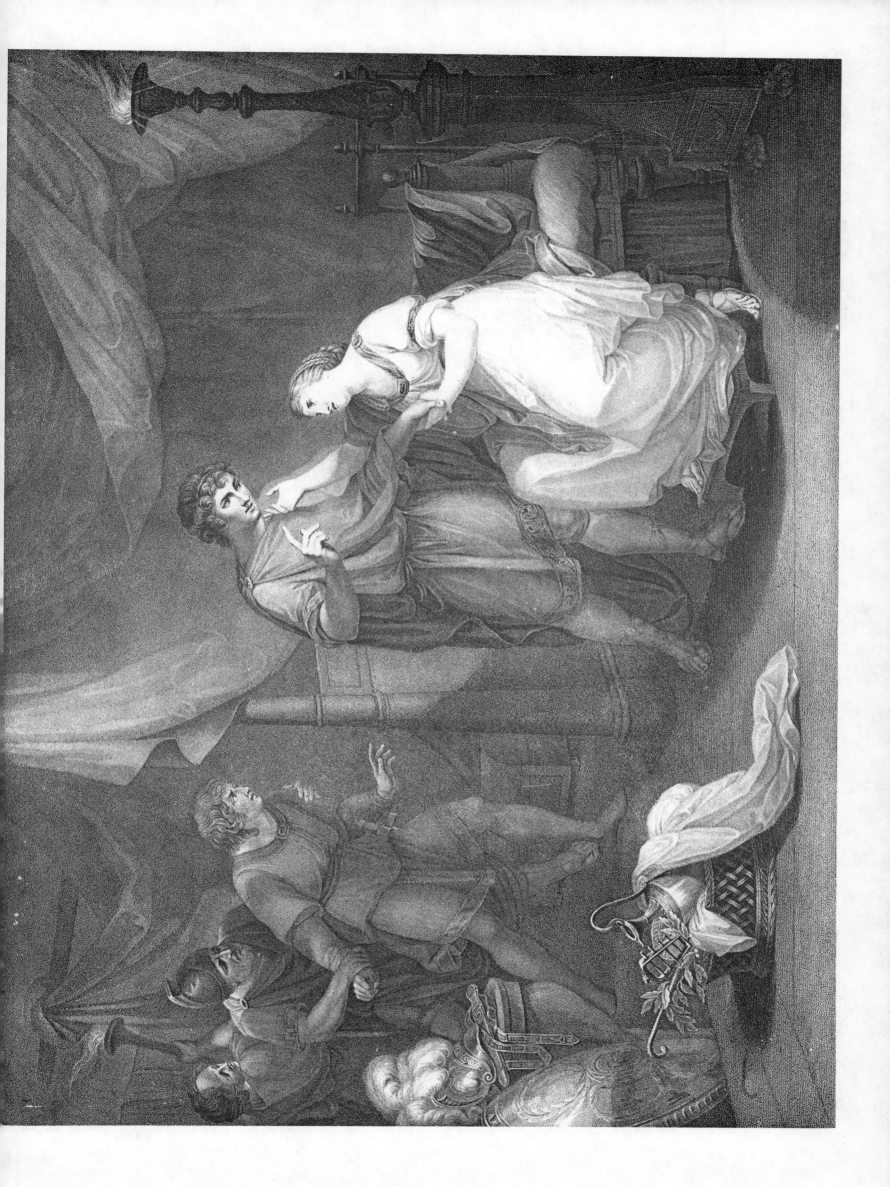

XXXVI.

CYMBELINE.

ACT I. SCENE II.

*Imogen, Posthumus, Queen, Cymbeline, &c.*

Painted by W. Hamilton, R.A.   Engraved by T. Burke.

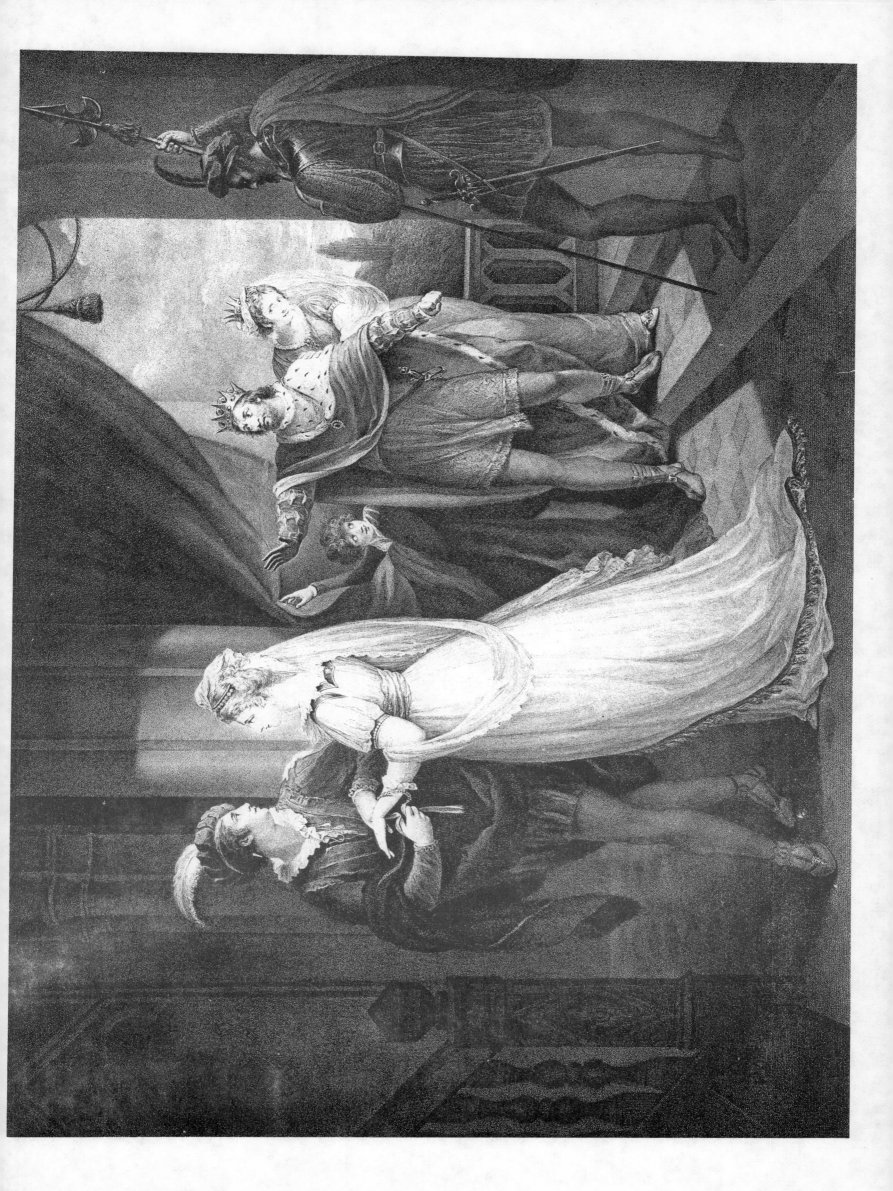

XXXVII.

ACT III. SCENE IV.

NEAR MILFORD HAVEN.

*Pisanio and Imogen.*

Painted by J. Hoppner, R. A.　Engraved by R. Thew.

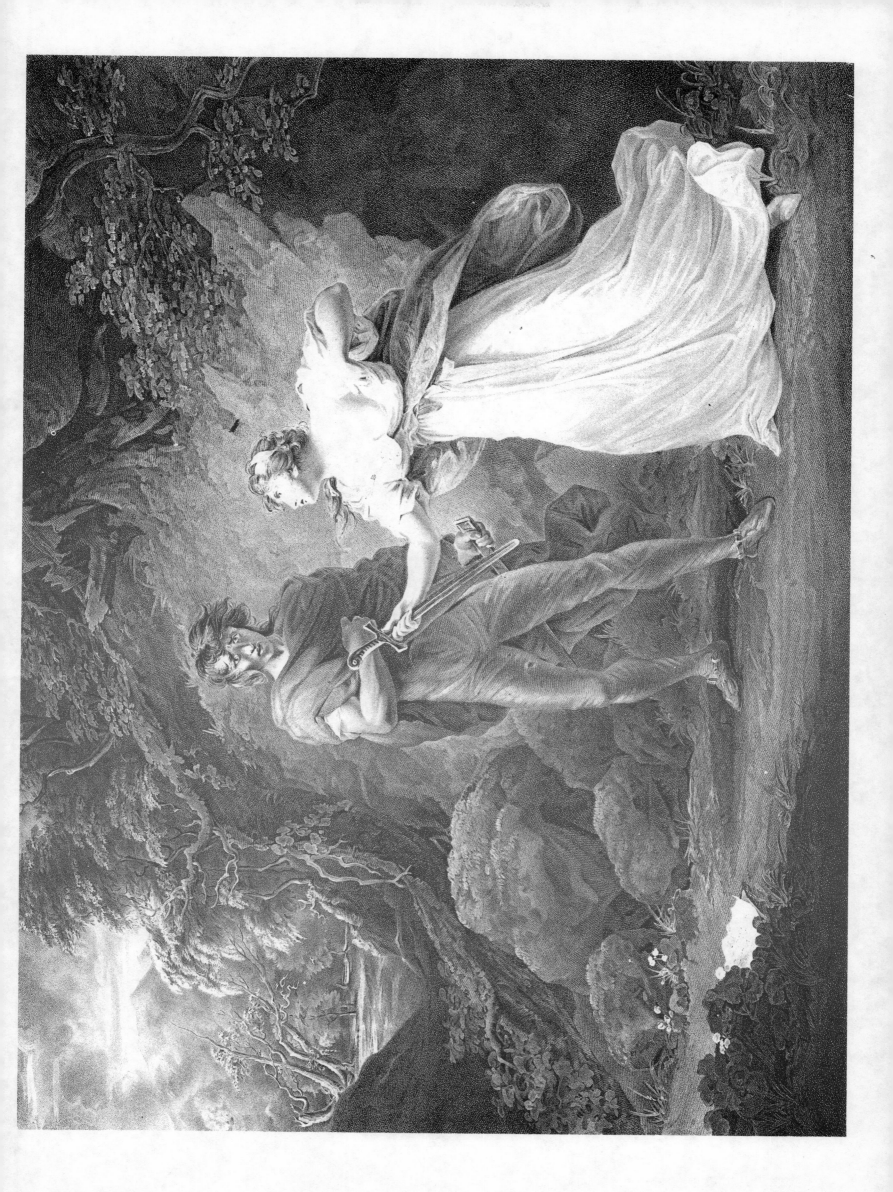

XXXVIII.

# KING LEAR.

## ACT I. SCENE I.

LEAR'S PALACE.

*Lear, Cornwall, Albany, Goneril, Regan, Cordelia, King of France, Duke of Burgundy, Kent, Attendants, &c.*

Painted by H. Fuseli, R. A.   Engraved by R. Earlom.

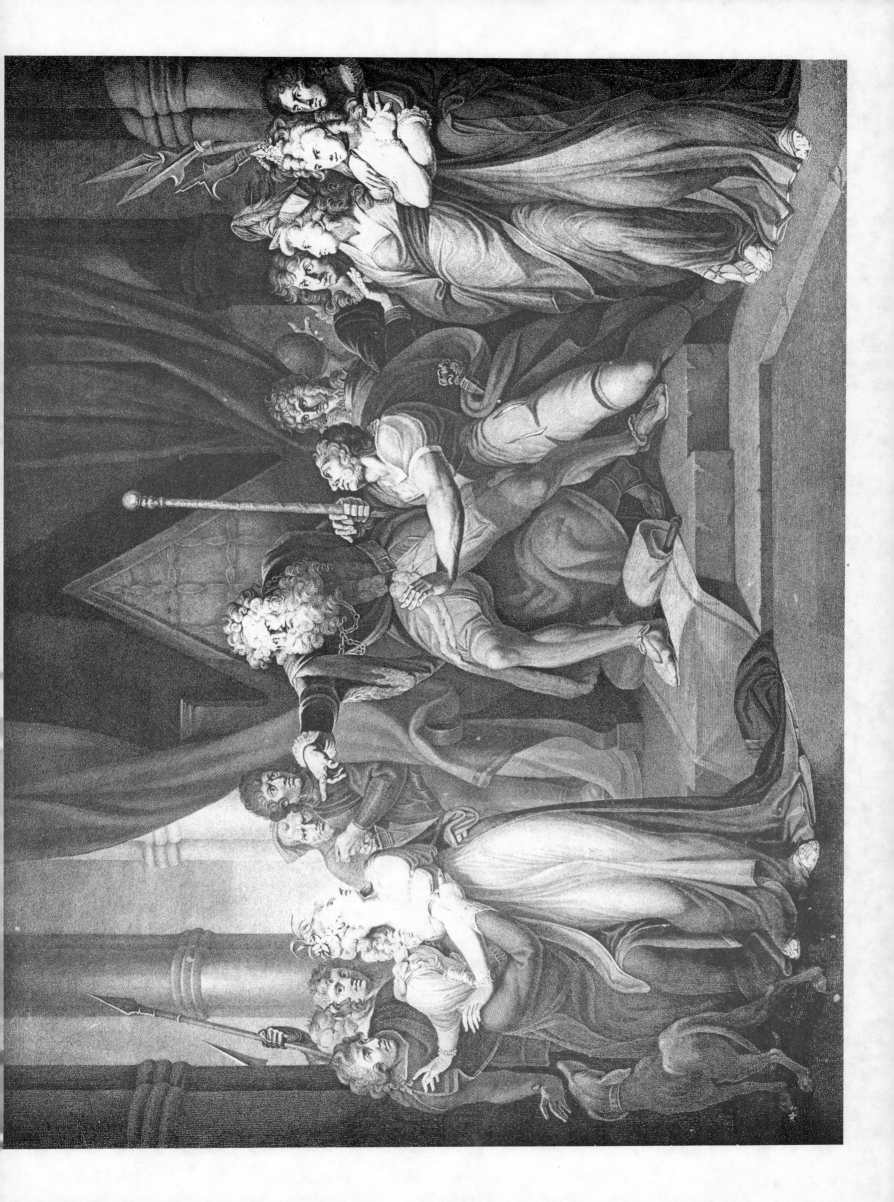

# XXXXIX.

## ACT III. SCENE IV.

PART OF A HEATH, WITH A HOVEL.

*Lear, Kent, Fool, Edgar, disguised as a Madman, and Gloster, with a Torch.*

Painted by B. West, President of the Royal Academy.

Engraved by W. Sharpe.

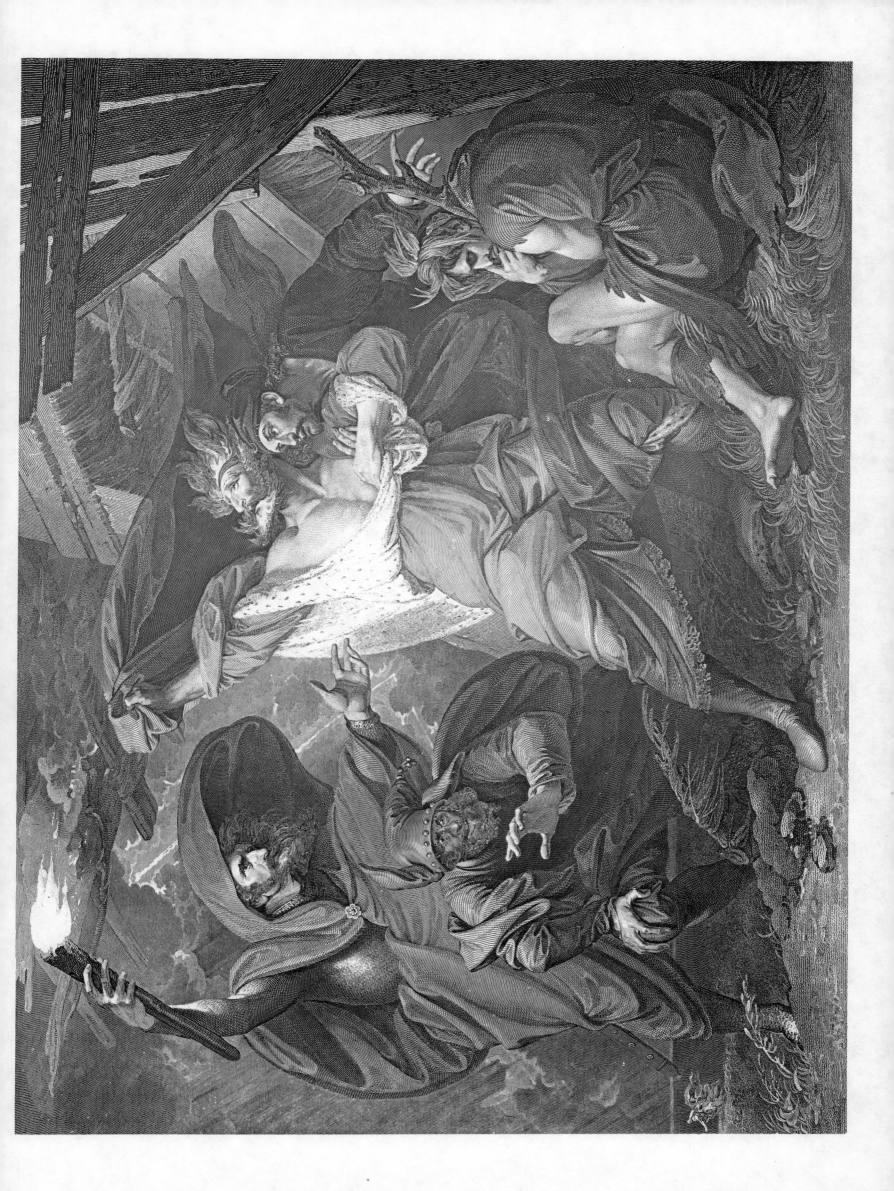

XL.

# KING LEAR.

## ACT V. SCENE III.

A CAMP NEAR DOVER.

*Lear, with Cordelia dead ; Edgar, Albany, and Kent. Regan,*
*Goneril, and Edmund, dead.*

Painted by J. Barry, R. A.    Engraved by F. Legat.

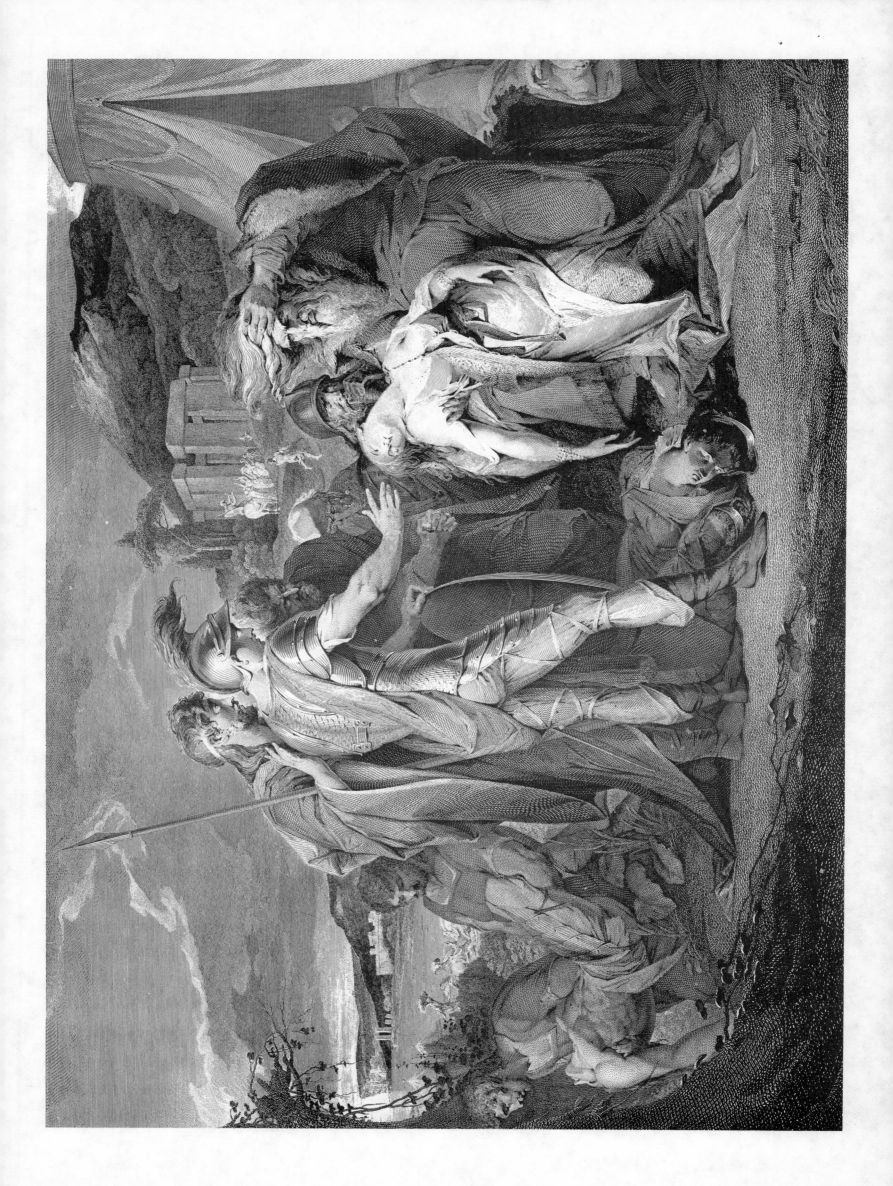

XLI.

# ROMEO AND JULIET.

## ACT I. SCENE V.

### A HALL IN CAPULET'S HOUSE.

*Romeo, Juliet, Nurse, &c. with the Guests and the Maskers.*

Painted by W. Miller.   Engraved by G. S. and J. G. Facius.

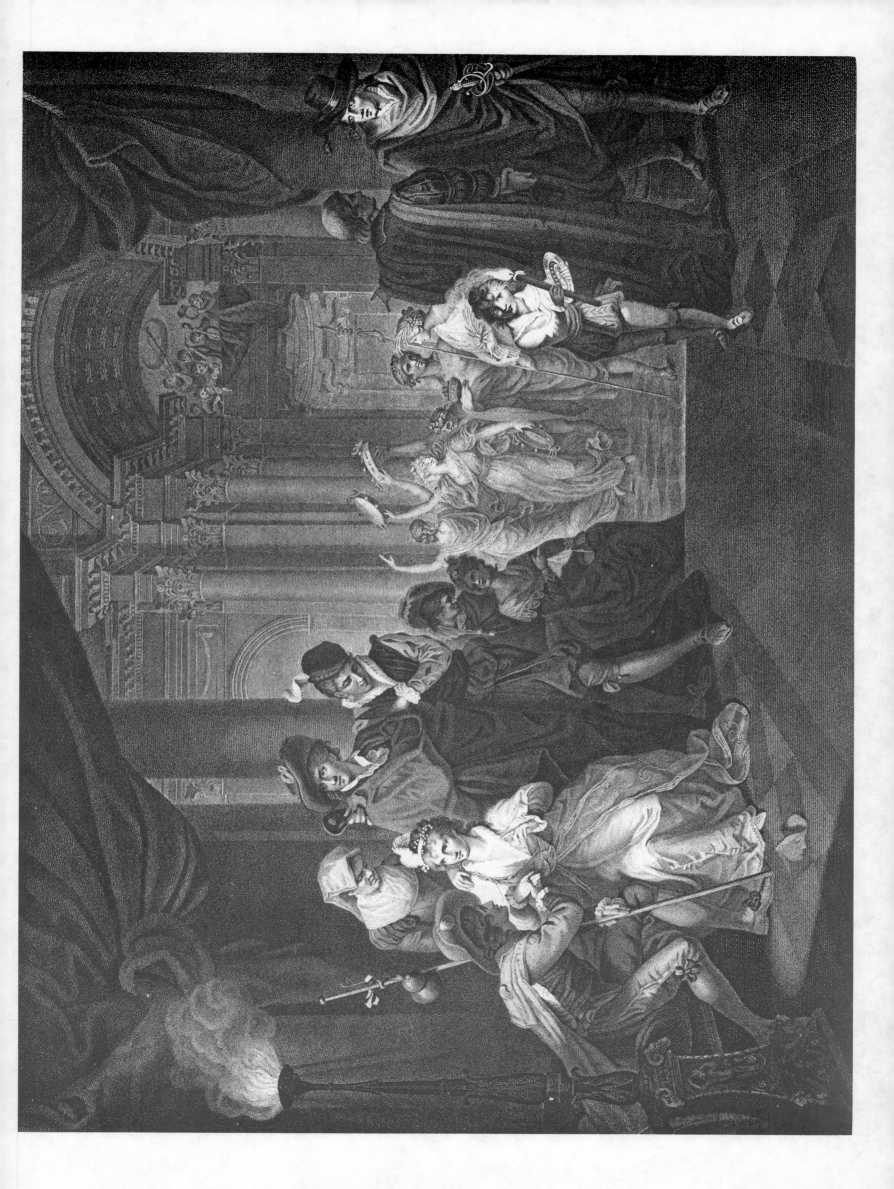

XLII.

ACT IV. SCENE V.

JULIET ON HER BED.

*Friar Laurence, Capulet, Lady Capulet, Paris, Friar, Nurse,*
*Musicians, &c.*

Painted by J. Opie, R. A.    Engraved by G. S. and J. G.
Facius.

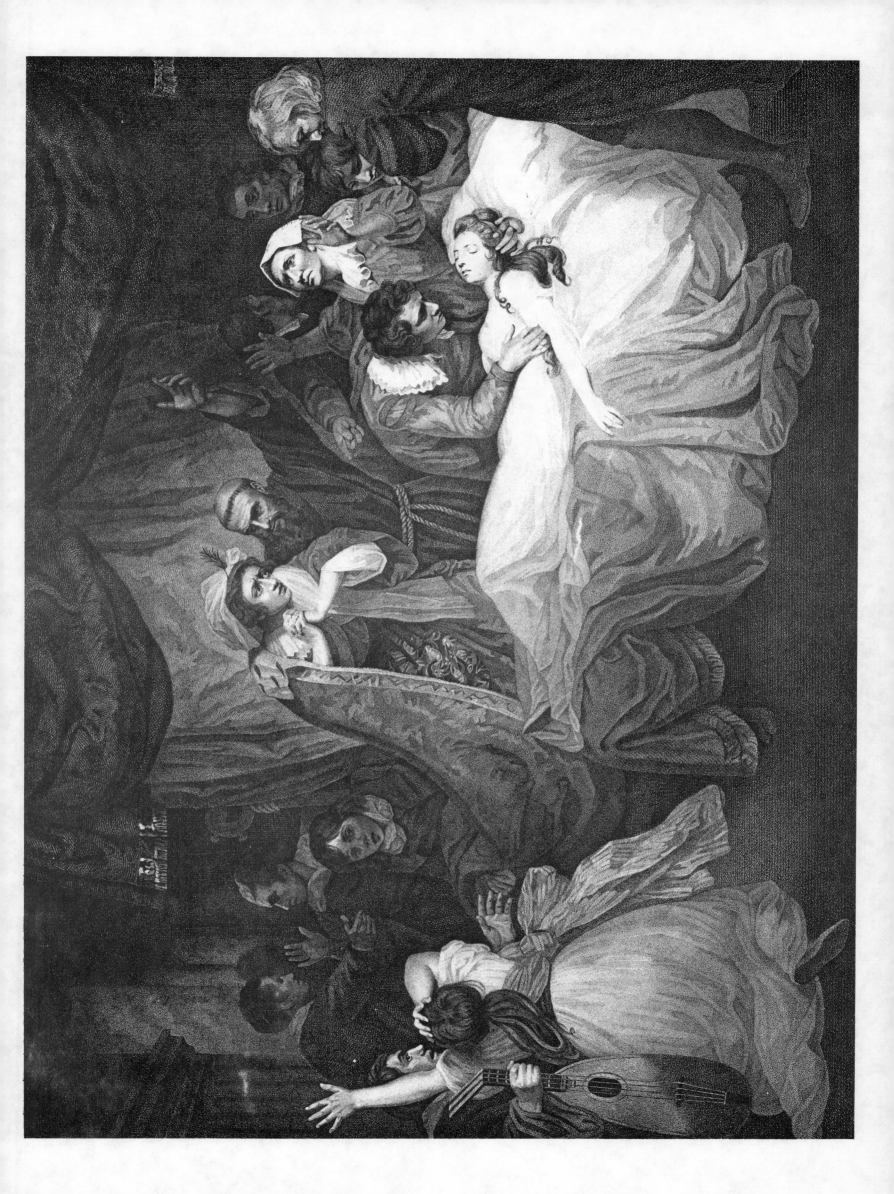

# XLIII.

## ACT V. SCENE III.

A MONUMENT BELONGING TO THE CAPULETS.

*Romeo and Paris dead; Juliet and Friar Lawrence.*

Painted by J. Northcote, R. A.   Engraved by P. Simon.

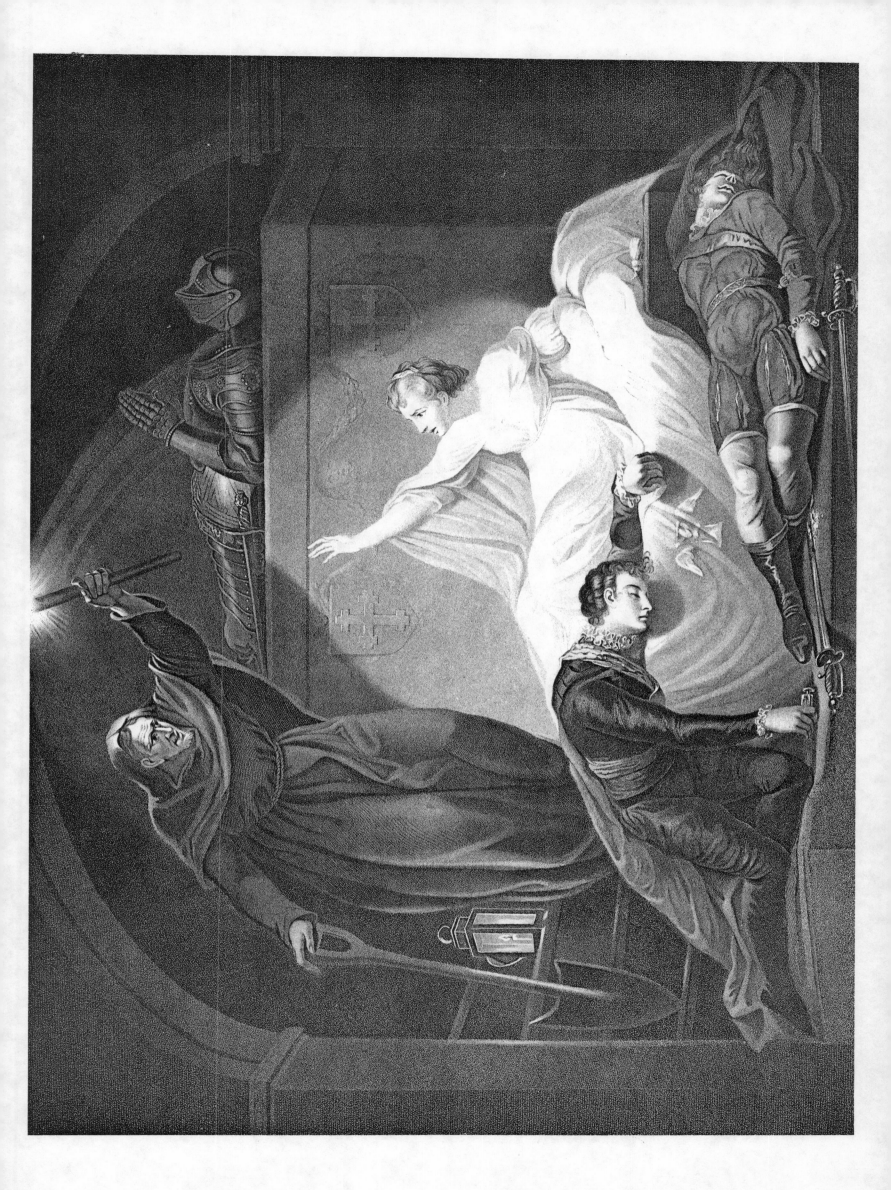

XLIV.

# HAMLET.

## ACT I. SCENE IV.

A PLATFORM BEFORE THE CASTLE OF ELSINEUR.

*Hamlet, Horatio, Marcellus, and the Ghost.*

Painted by H. Fuseli, R. A.   Engraved by R. Thew.

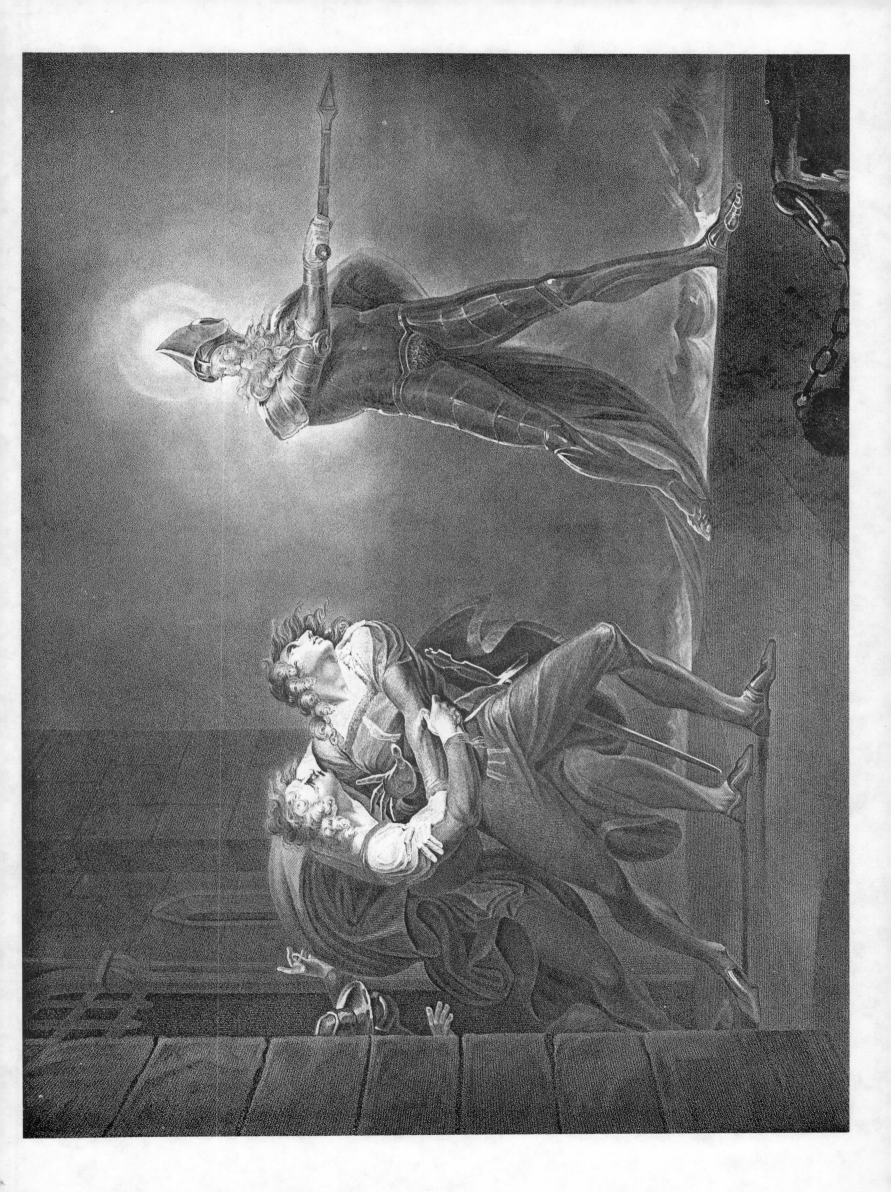

XLV.

ACT IV. SCENE V.

ELSINEUR.

*King, Queen, Laertes, Ophelia, &c.*

Painted by B. West, President of the Royal Academy.

Engraved by F. Legat.

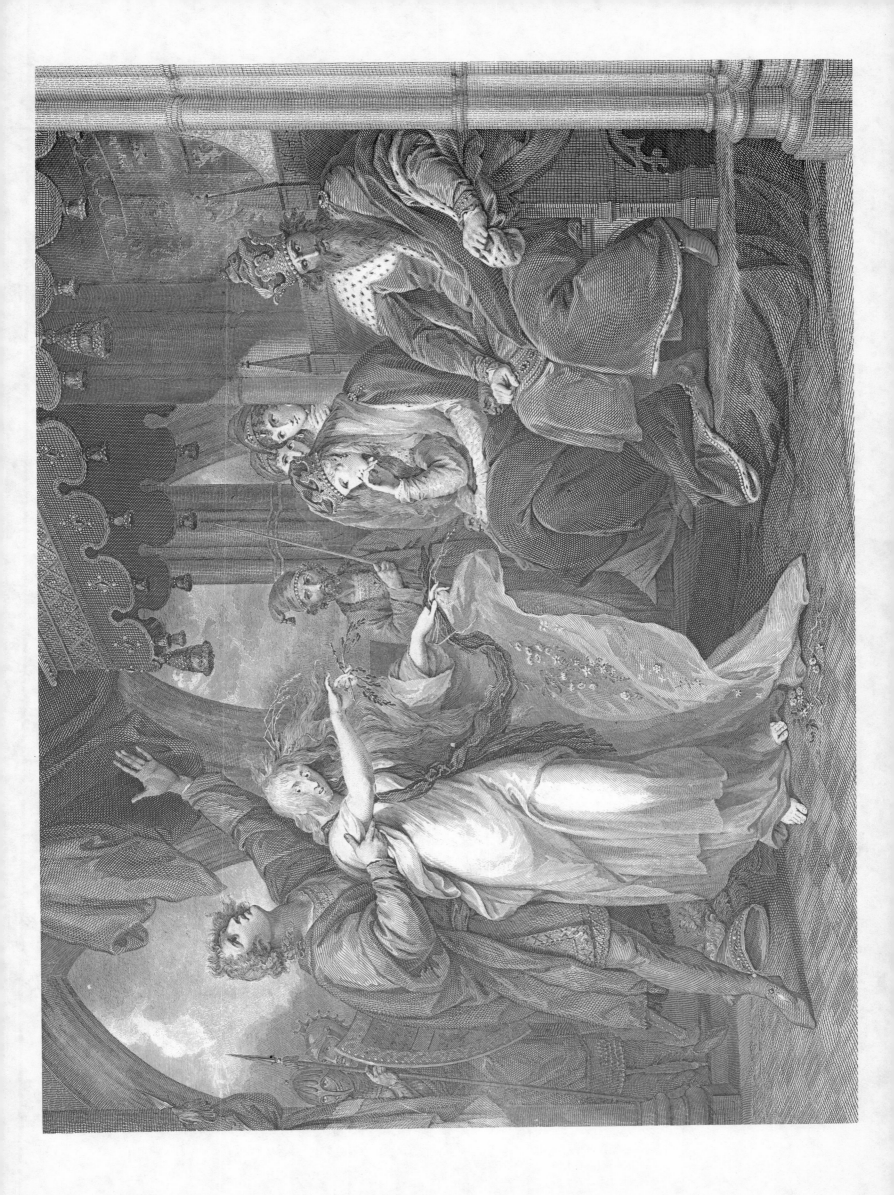

XLVI.

O T H E L L O.

ACT II. SCENE I.

A PLATFORM.

*Desdemona, Othello, Iago, Cassio, Roderigo, Emilia, &c.*

Painted by T. Stothard, R. A.   Engraved by T. Ryder.

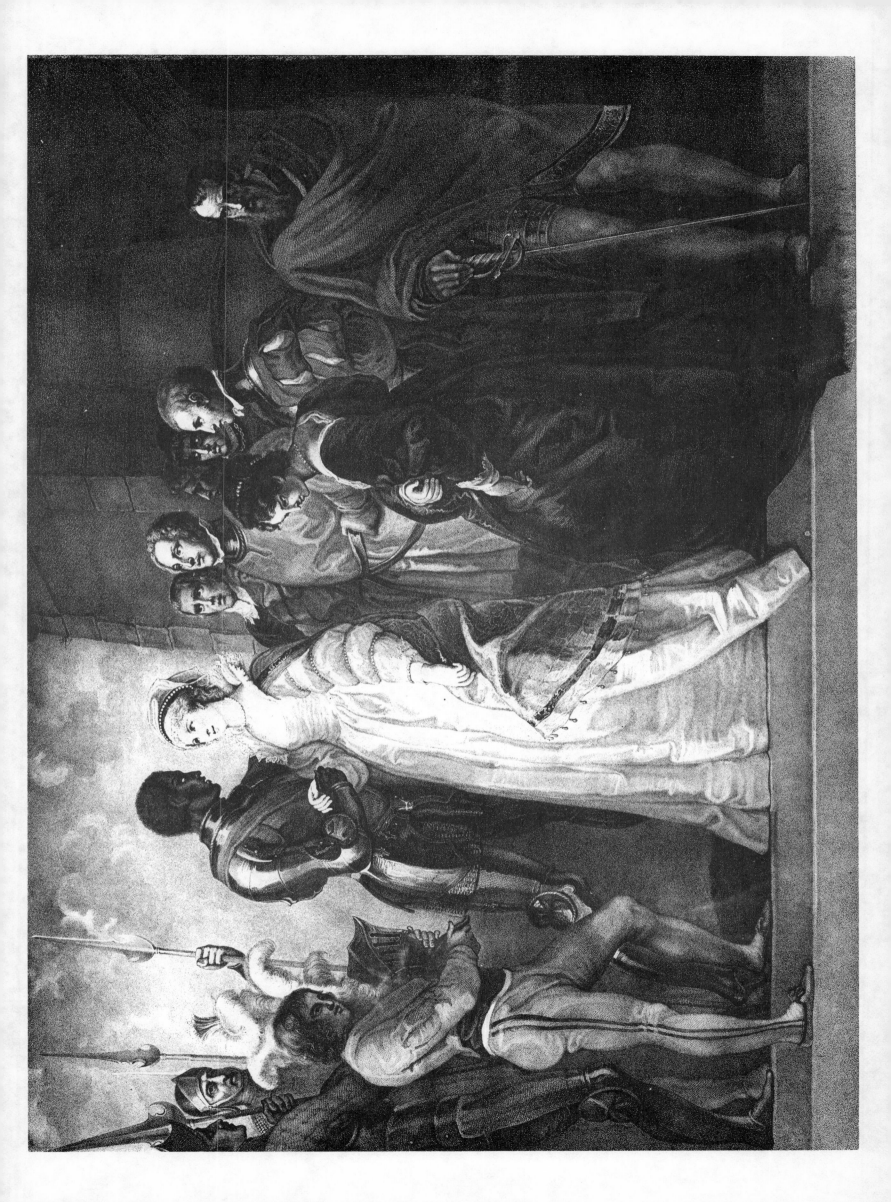

# XLVII.

## ACT V. SCENE II.

A BEDCHAMBER.

*Othello, Desdemona in Bed, asleep.*

Painted by J. Graham.   Engraved by W. Leney.

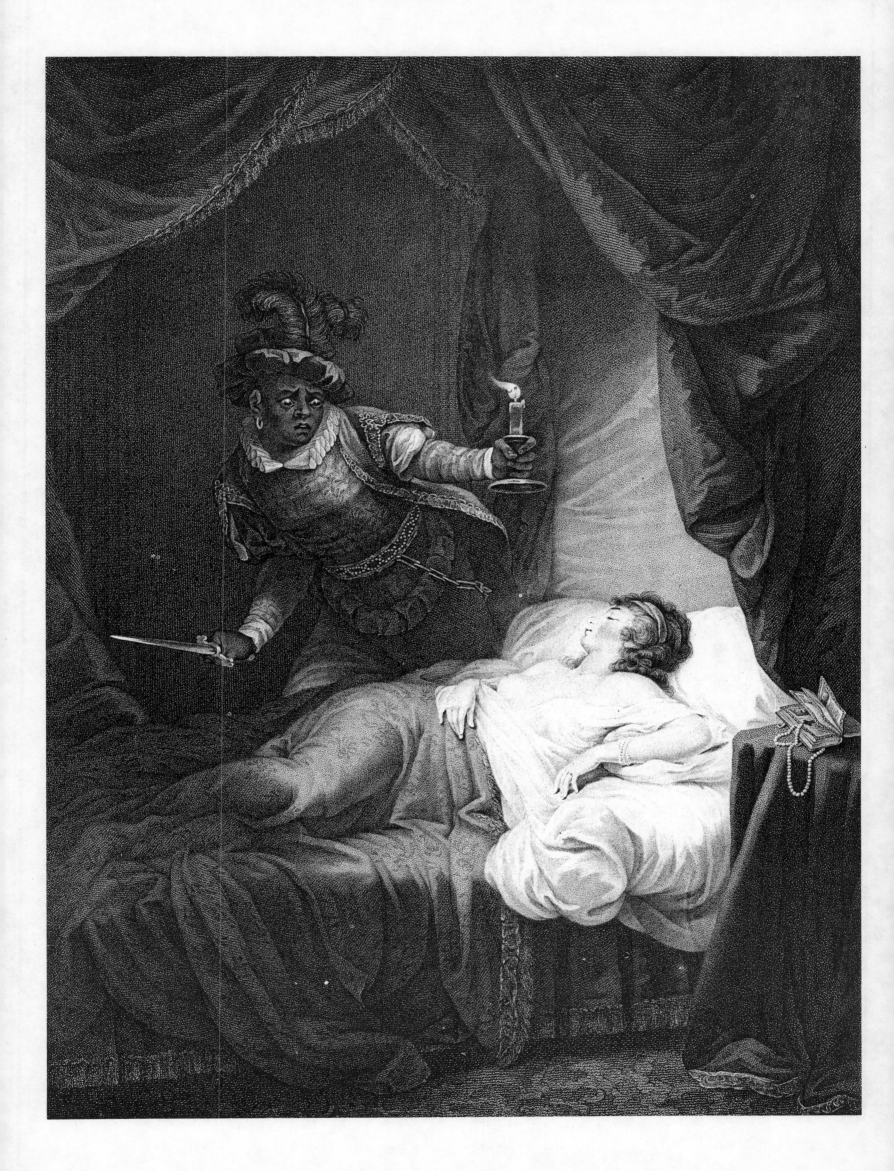

XLVIII.

SHAKSPEARE NURSED BY TRAGEDY AND
COMEDY.

Painted by G. Romney.    Engraved by B. Smith.

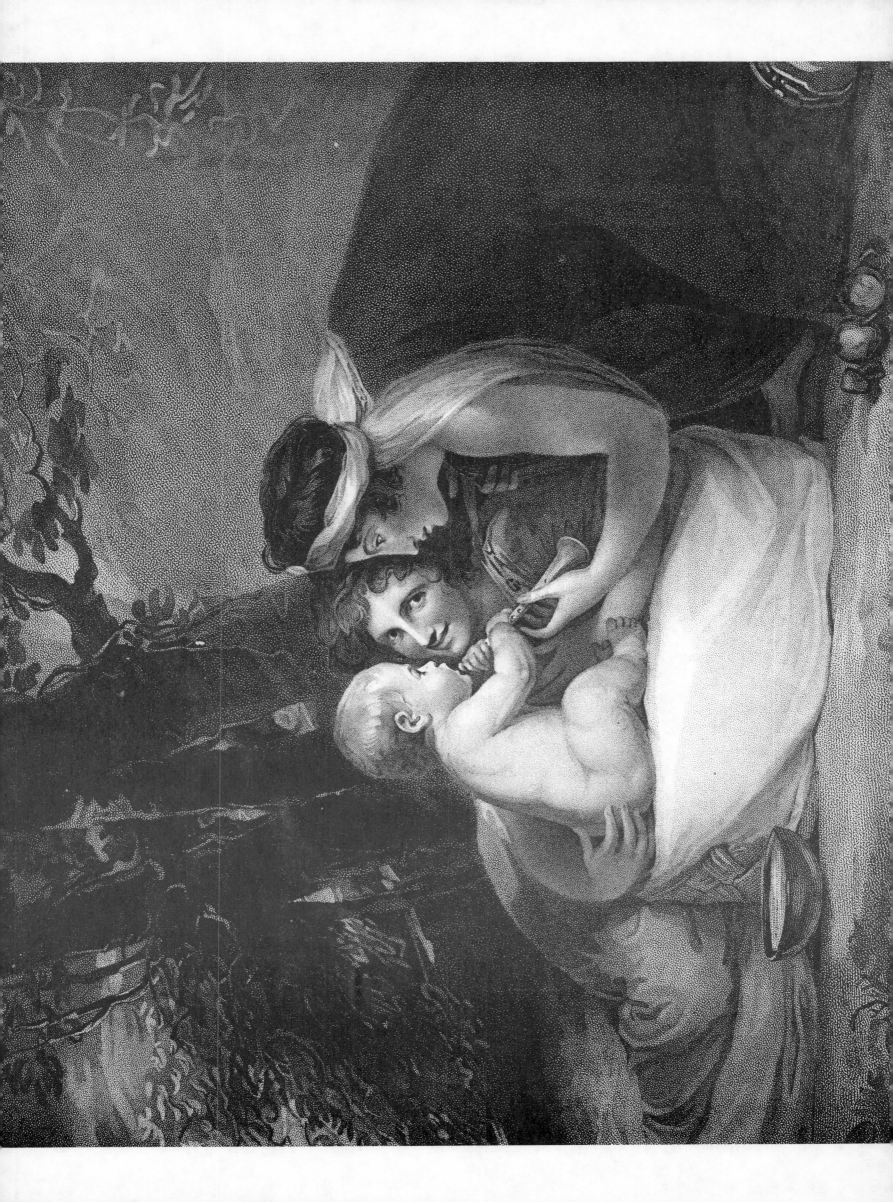

XLIX.

C Y M B E L I N E.

ACT III. SCENE VI.

*Imogen in Boy's Clothes.*

Painted by R. Westall, R. A.   Engraved by —— Gaugain.

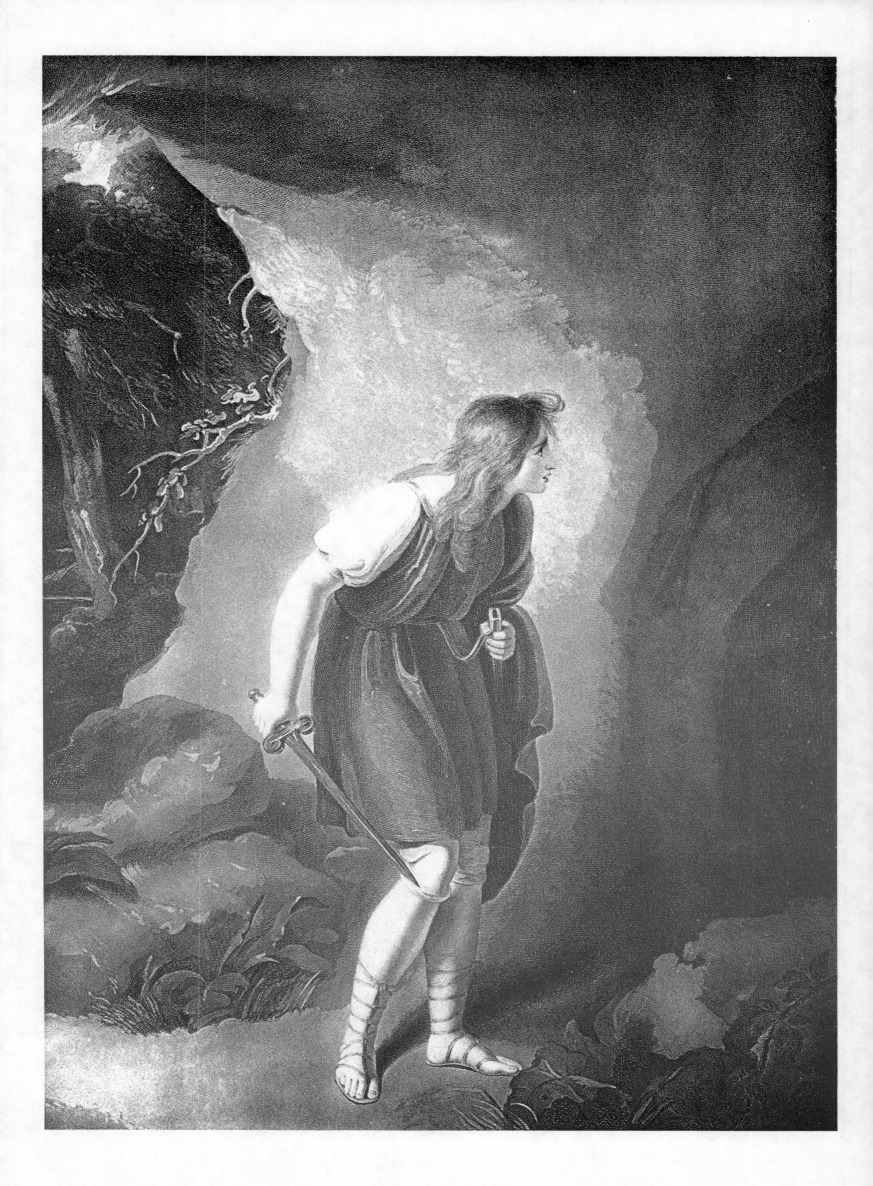

# L.

## OTHELLO.
### ACT V. SCENE II.

*Desdemona asleep.*

Painted by J. Boydell.   Engraved by W. Leney.

The above Three Plates were not engraved from the large
Pictures, but may be added to Vol. II.

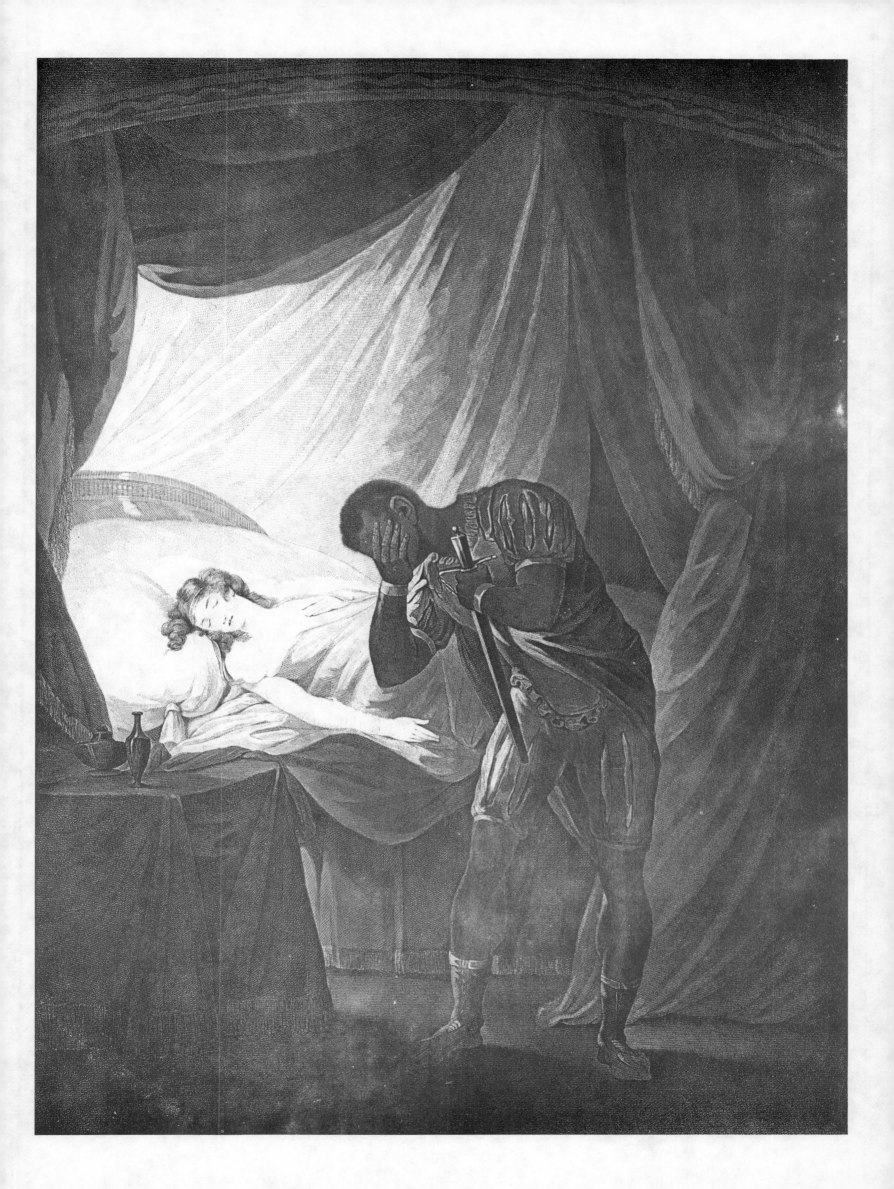

*a collection of the 100 prints from*

# THE DRAMATIC WORKS

*of*

# SHAKSPEARE

Edited by George Steevens, 1802

PUBLISHED BY JOHN AND JOSIAH BOYDELL

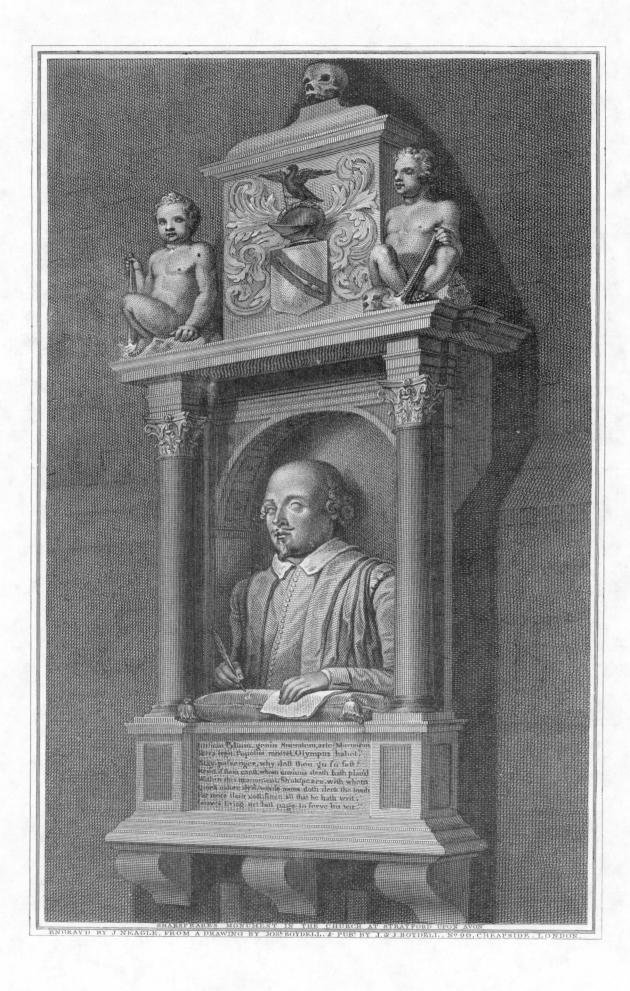

SHAKSPEARE'S MONUMENT IN THE CHURCH AT STRATFORD UPON AVON
ENGRAV'D BY J. NEAGLE, FROM A DRAWING BY JOS. BOYDELL, & PUB. BY J. & J. BOYDELL, No. 90, CHEAPSIDE, LONDON.

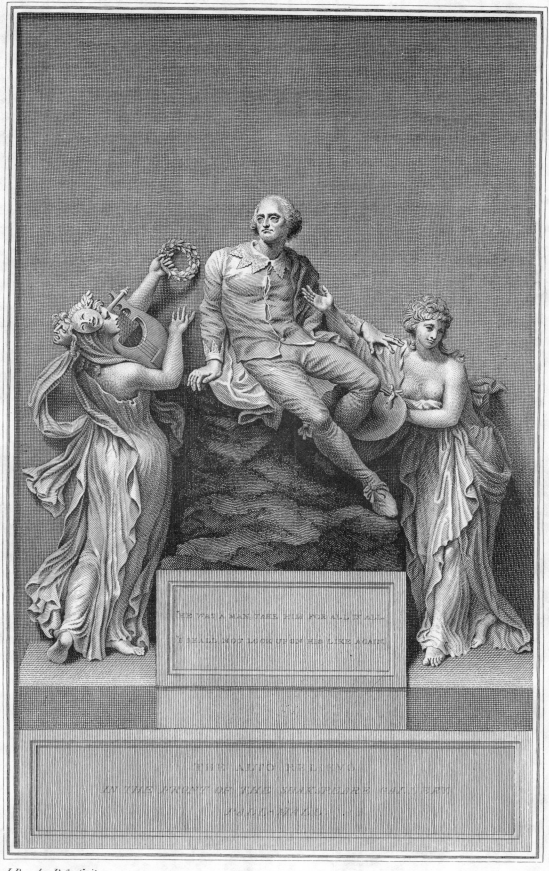

I. Banks R.A. fecit.                                                James Stow sculp.

*Represents*

SHAKSPEARE *seated between the* DRAMATIC MUSE *&* the GENIUS of PAINTING

*who is pointing him out as the proper subject for her pencil.*

*Pub.d Dec.r 1. 1798. by J.ᵃ & J. BOYDELL, N.º 90, Cheapside & at the Shakspeare Gallery, Pall Mall.*

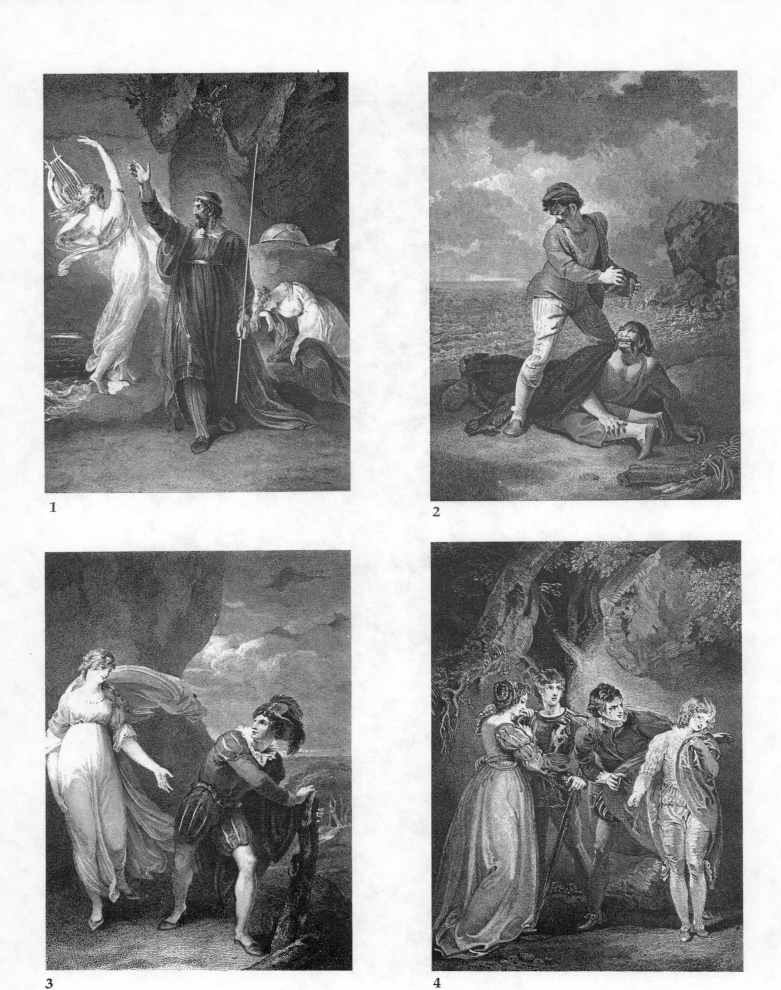

TEMPEST **1** Act I, scene 2. *Painter* W. Hamilton, *engraver* J. Parker **2** Act
III, scene 1. *Painter* R. Smirke, *engraver* W. Wilson **3** Act III, scene 1. *Painter*
W. Hamilton, *engraver* A. Smith TWO GENTLEMEN OF VERONA **4** Act
III, scene 4. *Painter* T. Stothard, *engraver* J. Osborne.

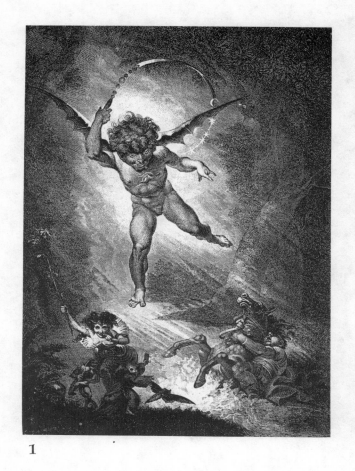

1

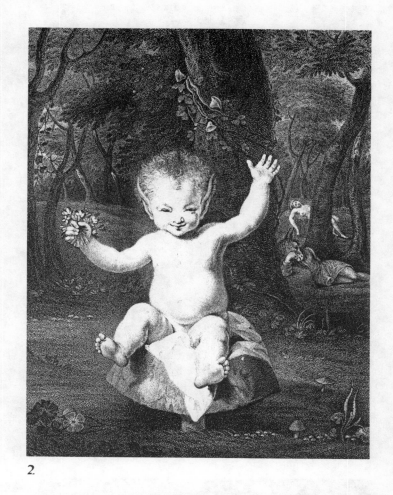

2

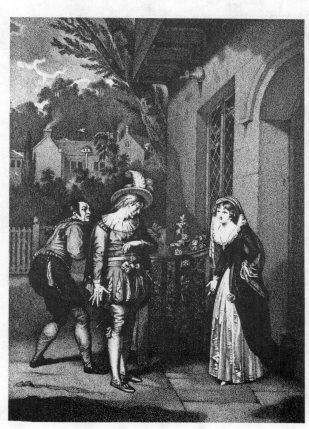

3

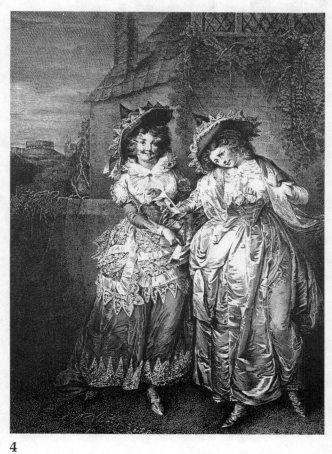

4

MIDSUMMER NIGHT'S DREAM  **1** Act II, scene 1. *Painter* H. Fuseli, *engraver* J. Parker  **2** Act II, scene 2. *Painter* J. Reynolds, *engraver* L. Schiavonetti  MERRY WIVES OF WINDSOR  **3** Act I, scene 1. *Painter* R. Smirke, *engraver* M. Haughton  **4** Act II, scene 1. *Painter* W. Peters, *engraver* I. Saunders

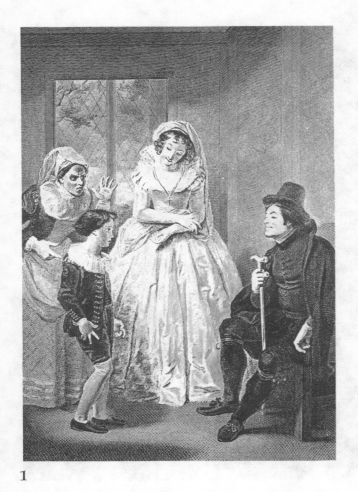

1

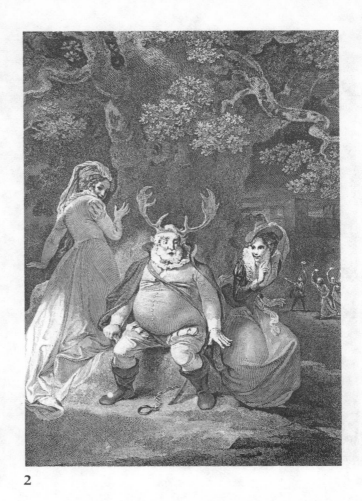

2

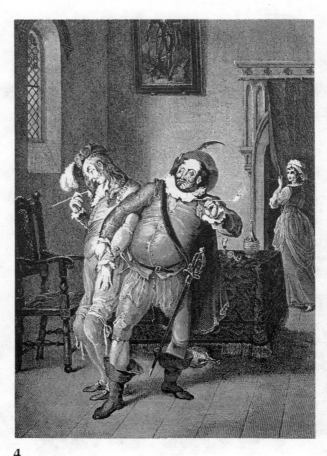

3

4

MERRY WIVES OF WINDSOR **1** Act IV, scene 1. *Painter* R. Smirke, *engraver* T. Holloway **2** Act IV, scene 5. *Painter* R. Smirke, *engraver* W. Sharpe TWELFTH NIGHT **3** Act I, scene 5. *Painter* W. Hamilton, *engraver* J. Caldwell **4** Act II, scene 3. *Painter* W. Hamilton, *engraver* J. Fittler

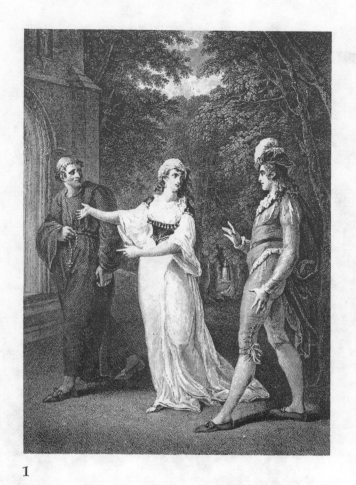

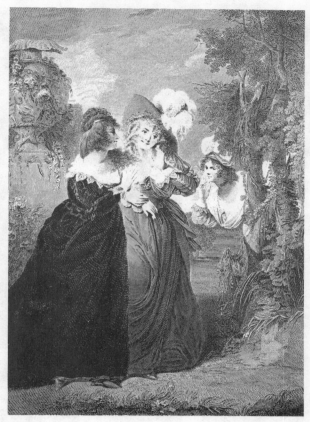

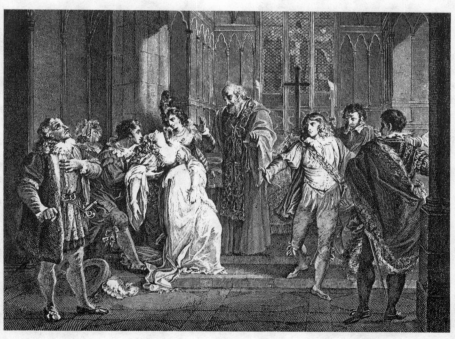

TWELFTH NIGHT  **1** Act IV, scene 3. *Painter* W. Hamilton, *engraver* W. Angus  MUCH ADO ABOUT NOTHING  **2** Act III, scene 1. *Painter* W. Peters, *engraver* J. Heath  **3** Act IV, scene 1. *Painter* W. Hamilton, *engraver* Milton and Testolini

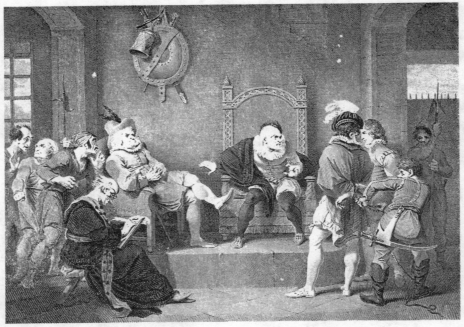

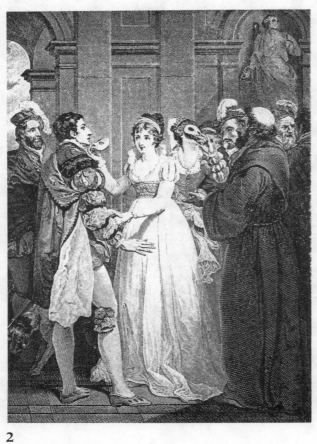

1

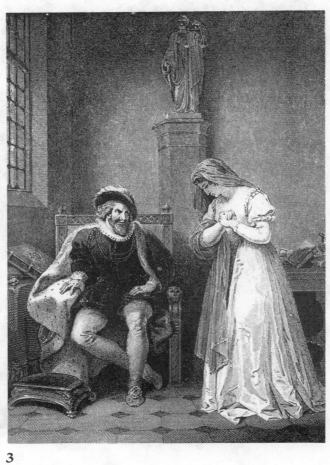

2

3

MUCH ADO ABOUT NOTHING  **1** Act IV, scene 2. *Painter* R. Smirke, *engraver* J. Heath  **2** Act V, scene 4. *Painter* F. Wheatley, *engraver* J. Fittler
MEASURE FOR MEASURE  **3** Act II, scene 4. *Painter* R. Smirke, *engraver* W. Wilson

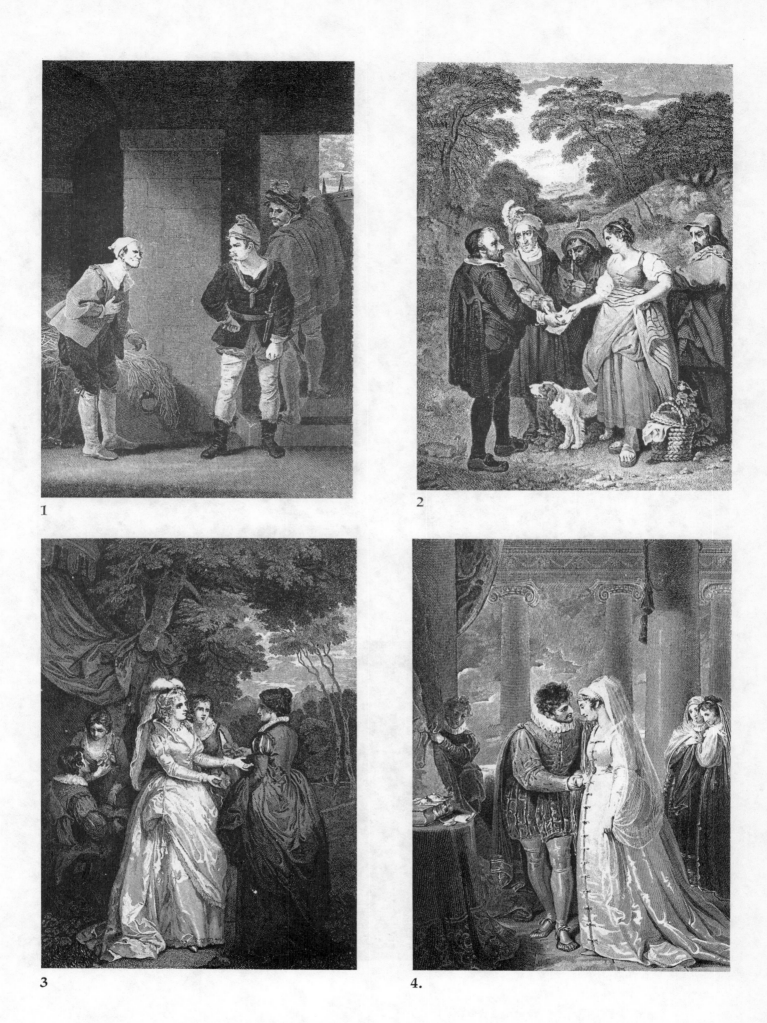

MEASURE FOR MEASURE **1** Act IV, scene 2. *Painter* R. Smirke, *engraver* W. Wilson  LOVE'S LABOUR'S LOST  **2** Act IV, scene 2. *Painter* F. Wheatley, *engraver* J. Neagle  **3** Act V, scene 2. *Painter* F. Wheatley, *engraver* W. Skelton  MERCHANT OF VENICE  **4** Act III, scene 2. *Painter* R. Westall, *engraver* G. Noble

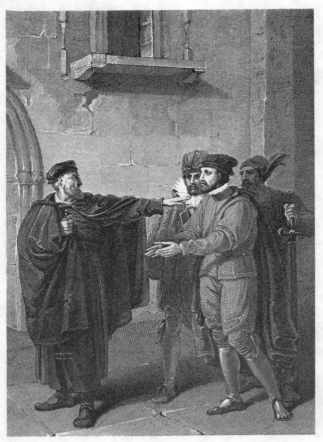

1.

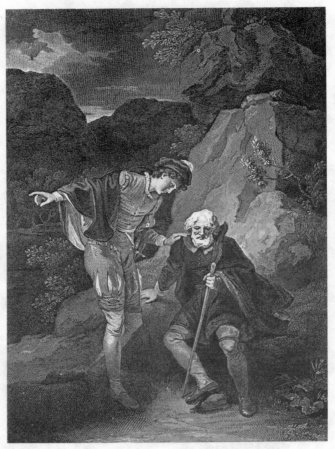

2.

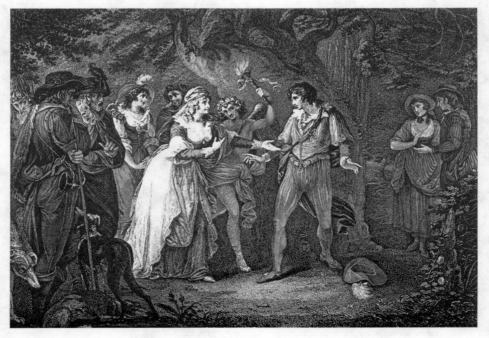

3.

MERCHANT OF VENICE   **1** Act III, scene 3. *Painter* R. Westall, *engraver*
J. Neagle   AS YOU LIKE IT   **2** Act II, scene 6. *Painter* R. Smirke, *engraver*
G. Noble   **3** Act V, scene 4. *Painter* W. Hamilton, *engraver* L. Schiavonetti

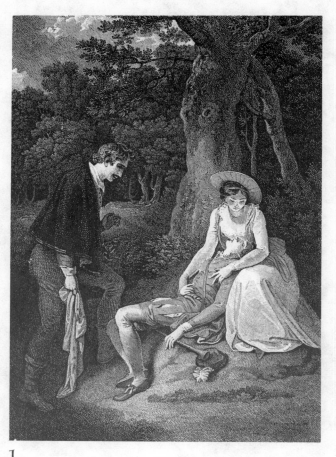

1

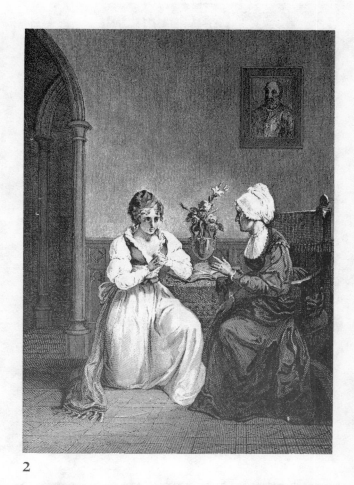

2

3

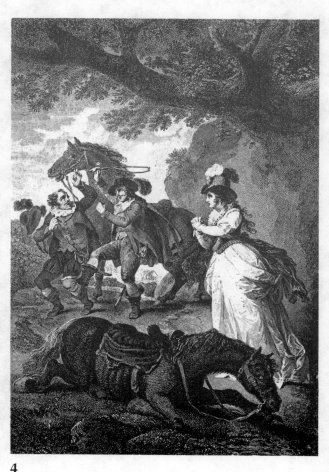

4

AS YOU LIKE IT   **1** Act IV, scene 3. *Painter* R. Smirke, *engraver* W. Wilson
ALL'S WELL THAT ENDS WELL   **2** Act I, scene 3. *Painter* F. Wheatley, *engraver* F. Legat   **3** Act II, scene 3. *Painter* F. Wheatley, *engraver* L. Schiavonetti   TAMING OF THE SHREW   **4** Act IV, scene 1. *Painter* L. Ibbetson, *engraver* A. Smith

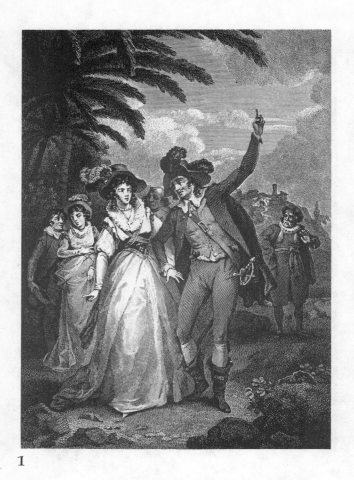

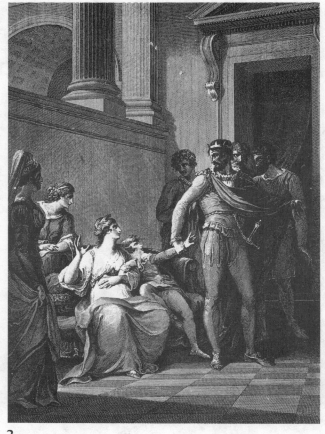

1

2

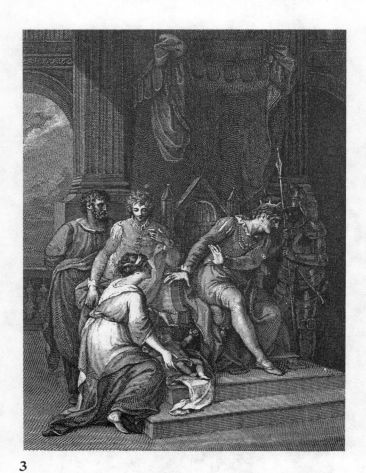

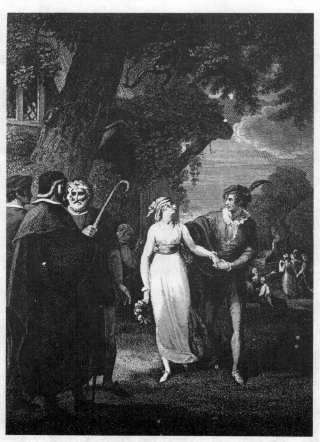

3

4

TAMING OF THE SHREW   **1** Act IV, scene 5. *Painter* L. Ibbetson, *engraver* I.
Taylor   WINTER'S TALE   **2** Act II, scene 1. *Painter* W. Hamilton, *engraver*
J. Fittler   **3** Act II, scene 3. *Painter* W. Hamilton, *engraver* F. Bartolozzi   **4** Act
IV, scene 3. *Painter* W. Hamilton, *engraver* J. Collyer

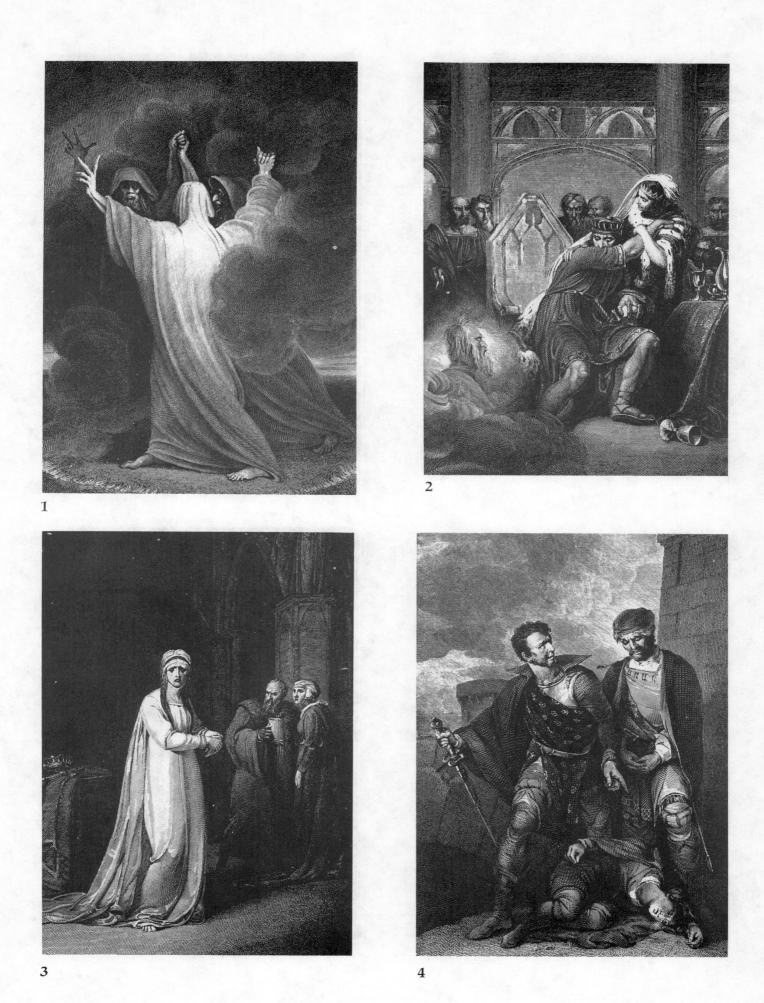

MACBETH   *1* Act I, scene 3. *Painter* R. Westall, *engraver* J. Stow   *2* Act III, scene 4. *Painter* R. Westall, *engraver* J. Parker   *3* Act V, scene 1. *Painter* R. Westall, *engraver* W. Wilson   KING JOHN   *4* Act IV, scene 3. *Painter* R. Porter, *engraver* I. Taylor

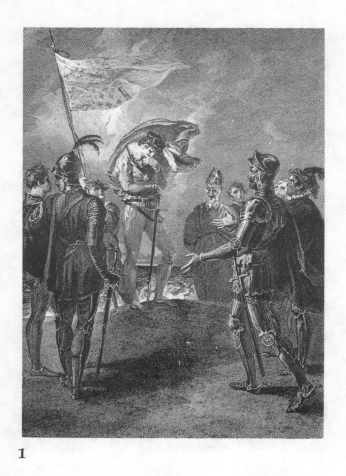

1

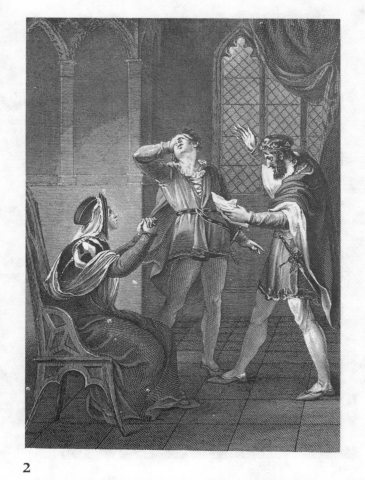

2

3

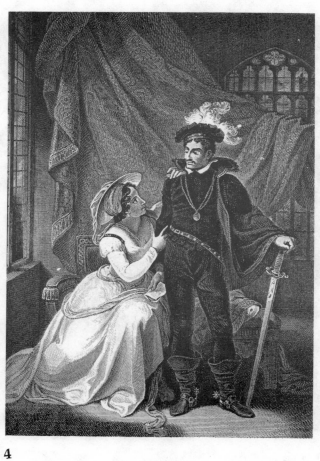

4

KING RICHARD II  **1** Act III, scene 2. *Painter* W. Hamilton, *engraver*
J. Parker  **2** Act V, scene 2. *Painter* W. Hamilton, *engraver* J. Stow  KING
HENRY IV, PART I  **3** Act II, scene 1. *Painter* R. Smirke, *engraver* J. Fittler
**4** Act II, scene 3. *Painter* R. Smirke, *engraver* I. Neagle

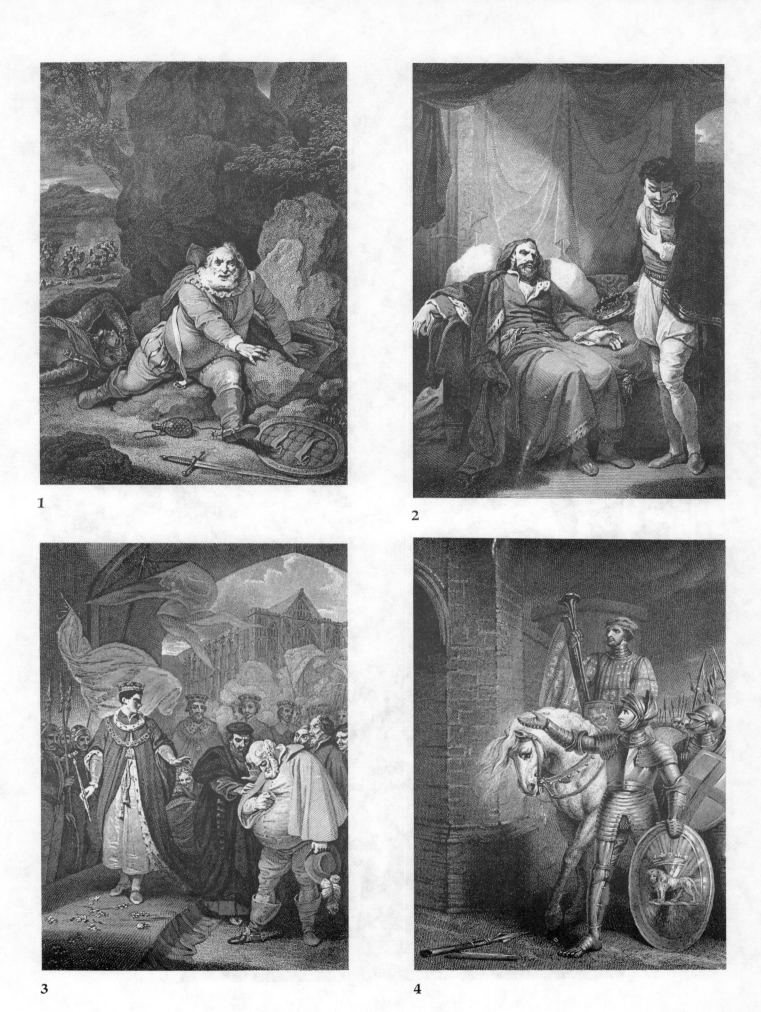

KING HENRY IV, PART I   **1** Act V, scene 4. *Painter* R. Smirke, *engraver*
F. Neagle   KING HENRY IV, PART II   **2** Act IV, scene 4. *Painter* R. Smirke,
*engraver* W. Wilson   **3** Act V, scene 5. *Painter* R. Smirke, *engraver* J. Collyer
KING HENRY V   **4** Act III, scene 3. *Painter* R. Westall, *engraver* J. Stow

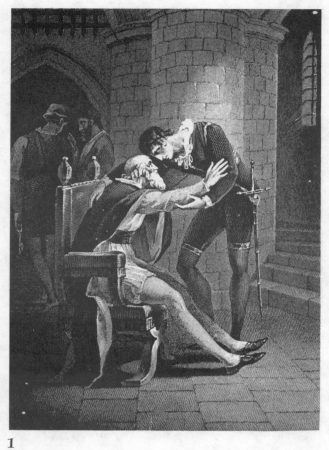

1

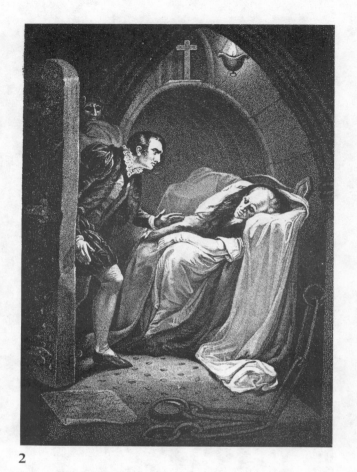

2

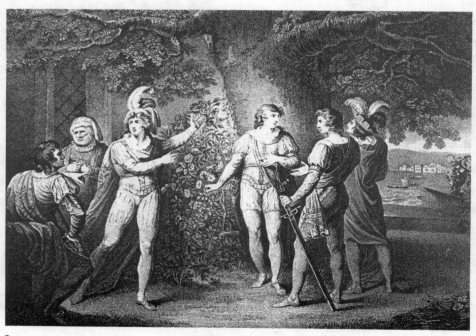

3

KING HENRY VI, PART I   **1** Act II, scene 5. *Painter* W. Hamilton, *engraver*
I. Taylor   **2** Act II, scene 5. *Painter* J. Northcote, *engraver* A. Gray   **3** Act II,
scene 4. *Painter* J. Boydell, *engraver* J. Osborne

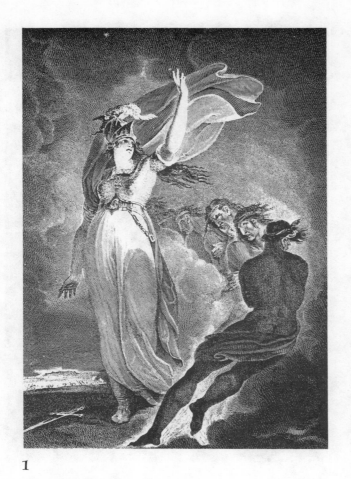

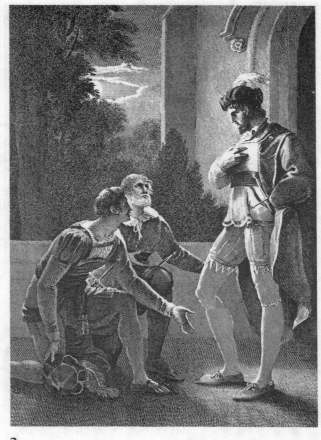

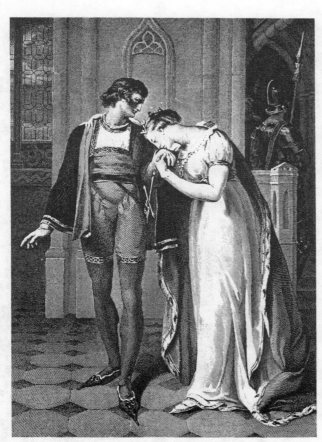

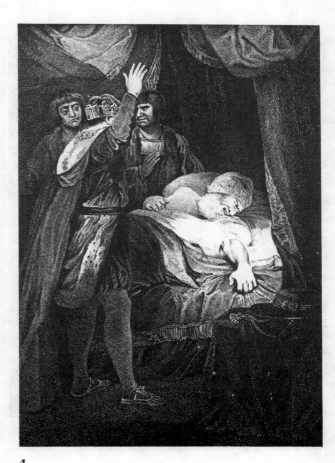

KING HENRY VI, PART I  **1** Act V, scene 4. *Painter* W. Hamilton, *engraver*
A. Smith  HENRY VI, PART II  **2** Act II, scene 2. *Painter* W. Hamilton,
*engraver* A. Smith  **3** Act III, scene 2. *Painter* W. Hamilton, *engraver*
I. Taylor  **4** Act III, scene 3. *Painter* J. Reynolds, *engraver* A. Gray

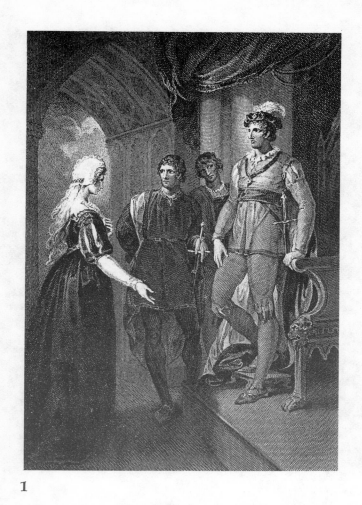

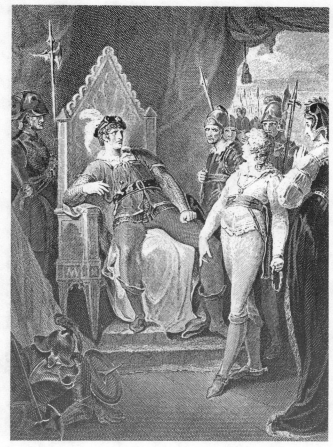

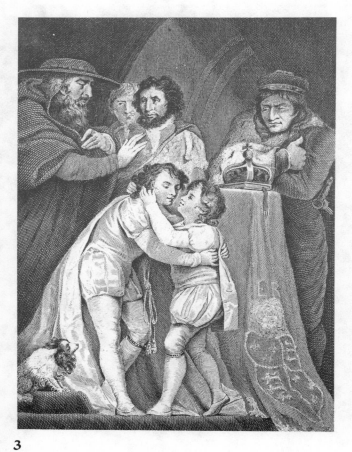

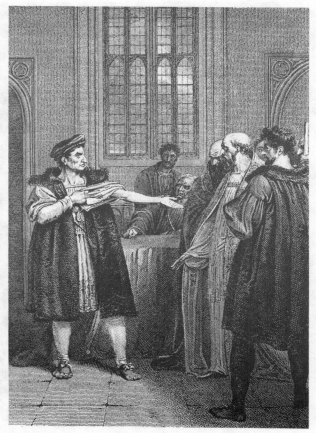

1

2

3

4

KING HENRY VI, PART III    **1** Act III, scene 2. *Painter* W. Hamilton, *engraver* T. Holloway    **2** Act V, scene 5. *Painter* W. Hamilton, *engraver* T. Holloway    KING RICHARD III    **3** Act III, scene 1. *Painter* J. Northcote, *engraver* B. Reading    **4** Act III, scene 4. *Painter* R. Westall, *engraver* A. Smith

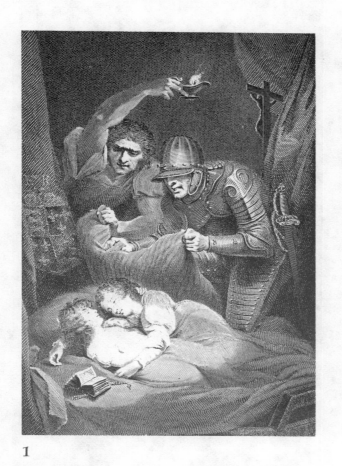

1

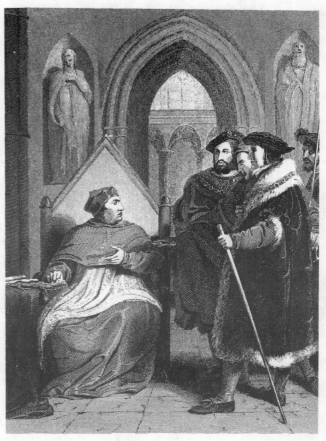

2

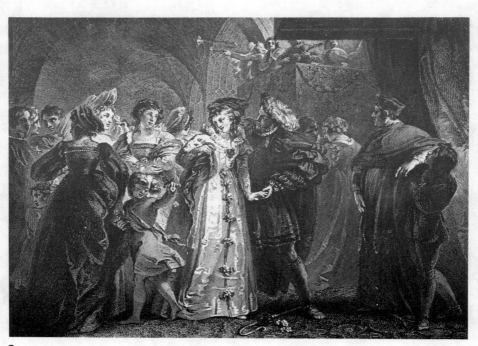

3

KING RICHARD III **1** Act IV, scene 3. *Painter* J. Northcote, *engraver*
J. Heath   KING HENRY VIII  **2** Act III, scene 2. *Painter* R. Westall, *engraver*
W. Wilson  **3** Act I, scene 4. *Painter* T. Stothard, *engraver* I. Taylor

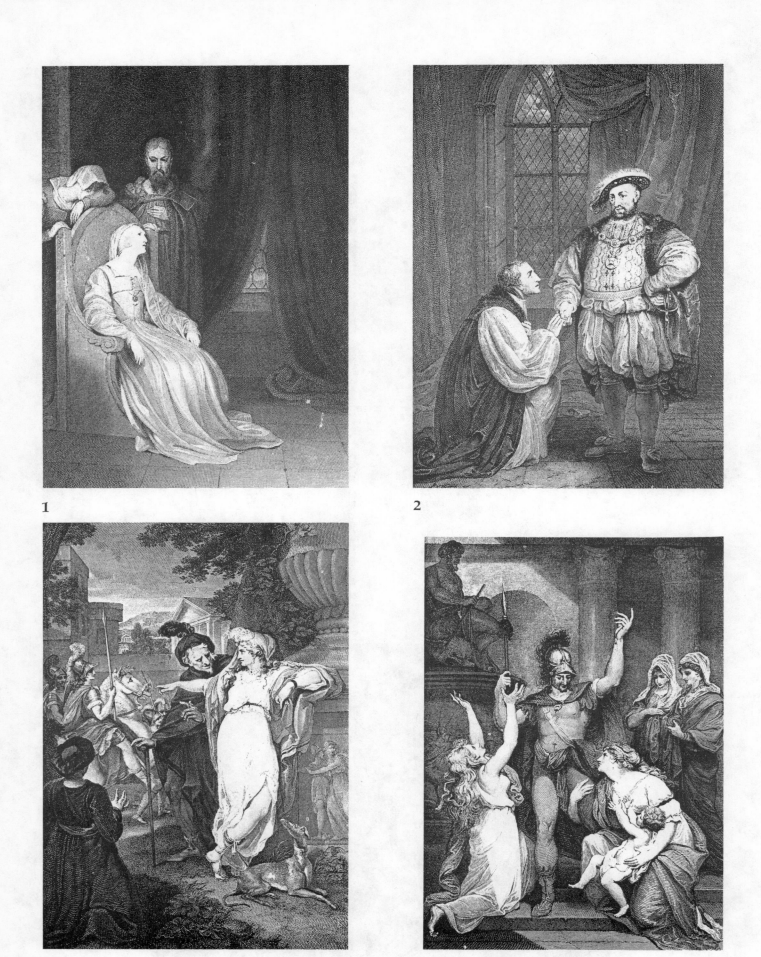

**1**

**2**

**3**

**4**

KING HENRY VIII   **1** Act IV, scene 2. *Painter* R. Westall, *engraver* J. Parker
**2** Act V, scene 1. *Painter* R. Westall, *engraver* W. Leney   TROILUS AND
CRESSIDA   **3** Act I, scene 2. *Painter* T. Kirk, *engraver* C. Warren   **4** Act V,
scene 3. *Painter* T. Kirk, *engraver* J. Fittler

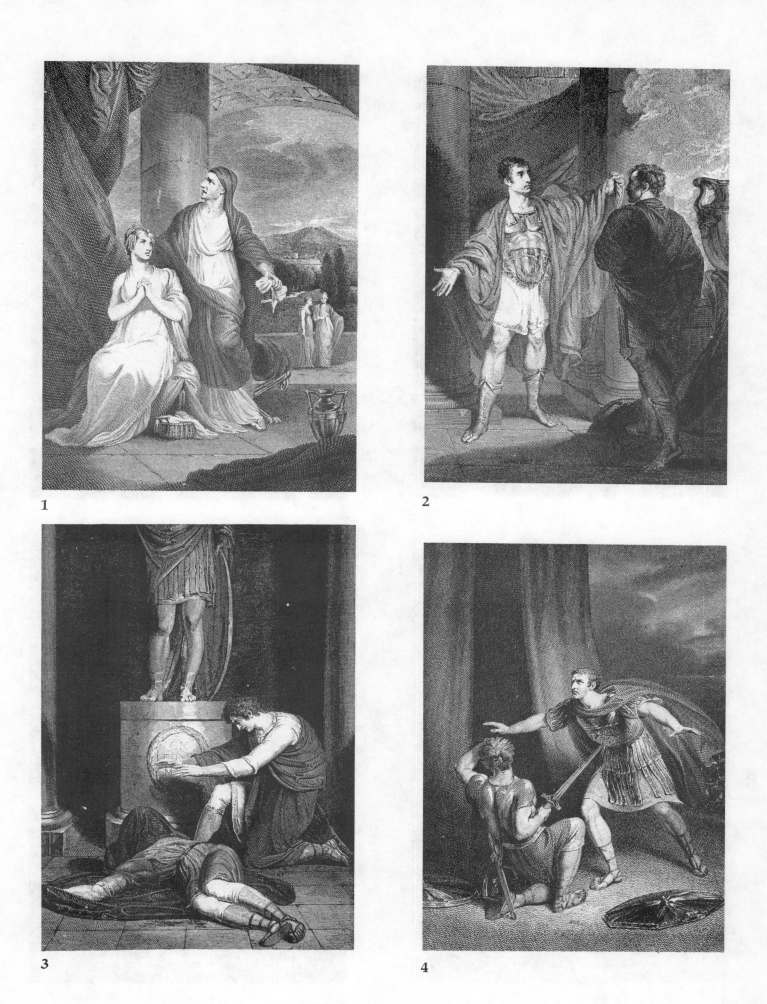

CORIOLANUS   *1* Act **I**, scene 3. *Painter* R. Porter, *engraver,* J. Stow   *2* Act
IV, scene 5. *Painter* R. Porter, *engraver* J. Parker   JULIUS CAESAR   *3* Act III,
scene 1. *Painter* R. Westall, *engraver* J. Parker   **4** Act V, scene 5. *Painter*
R. Westall, *engraver* S. Noble

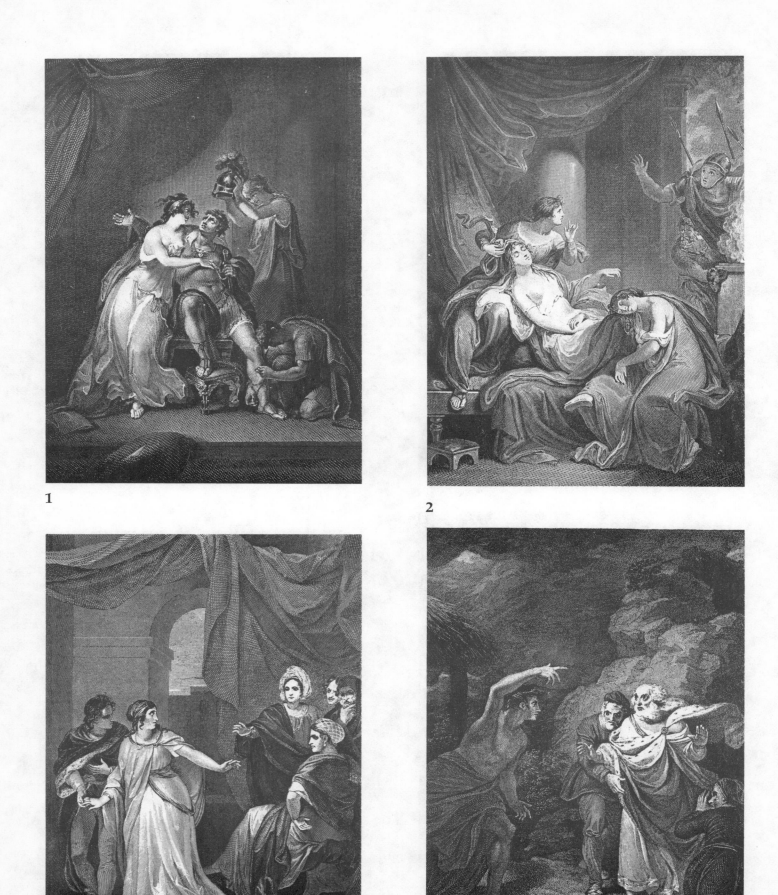

ANTONY AND CLEOPATRA  **1** Act IV, scene 4. *Painter* H. Tresham, *engraver* C. Warren  **2** Act V, scene 2. *Painter* H. Tresham, *engraver* G. Noble
KING LEAR  **3** Act I, scene 1. *Painter* R. Smirke, *engraver* W. Sharpe  **4** Act III, scene 4. *Painter* R. Smirke, *engraver* L. Schiavonetti

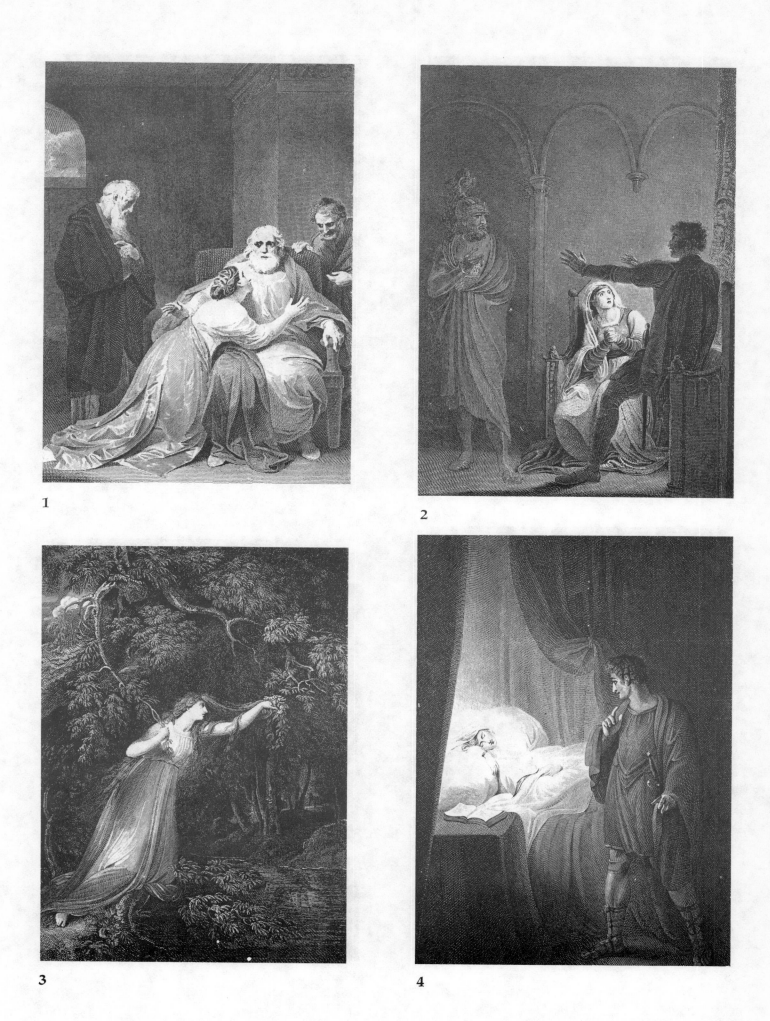

KING LEAR  **1** Act IV, scene 7. *Painter* R. Smirke, *engraver* A. Smith  HAM-
LET  **2** Act III, scene 4. *Painter* R. Westall, *engraver* W. Wilson  **3** Act IV,
scene 7. *Painter* R. Westall, *engraver* J. Parker  CYMBELINE  **4** Act II, scene
2. *Painter* R. Westall, *engraver* J. Stow

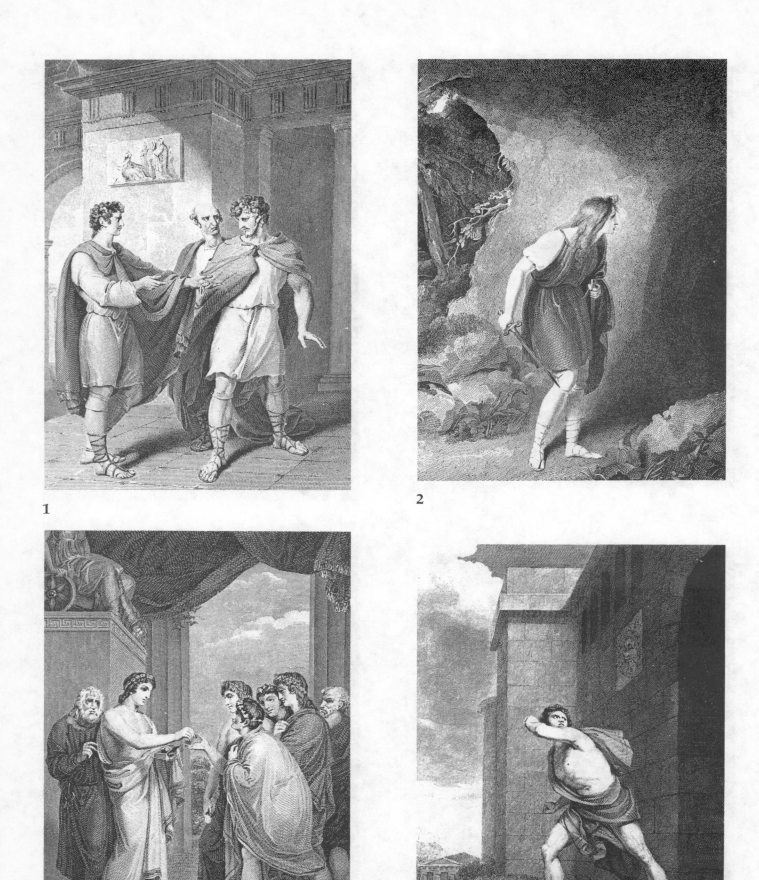

CYMBELINE **1** Act II, scene 4. *Painter* R. Westall, *engraver* C. Wilson **2**
Act III, scene 6. *Painter* R. Westall, *engraver* J. Parker    TIMON OF ATHENS
**3** Act I, scene 2. *Painter* H. Howard, *engraver* P. Rhodes **4** Act IV, scene 1.
*Painter* H. Howard, *engraver* I. Taylor

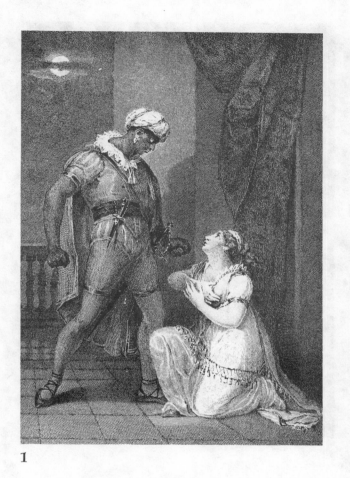

1

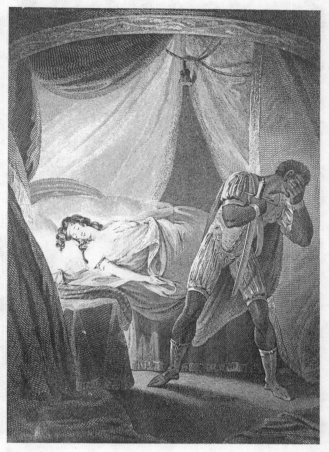

2

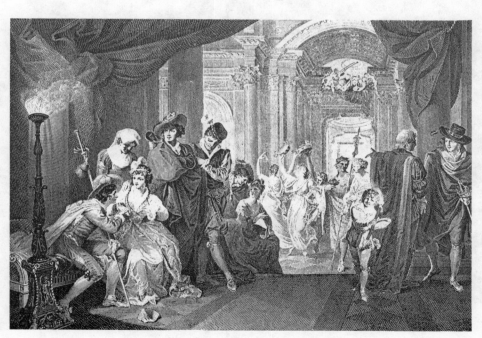

3

OTHELLO  **1** Act IV, scene 2. *Painter* R. Porter, *engraver* A. Michel  **2** Act
V, scene 2. *Painter* J. Boydell, *engraver* G. Noble  ROMEO AND JULIET
**3** Act I, scene 5. *Painter* W. Miller, *engraver* A. Smith

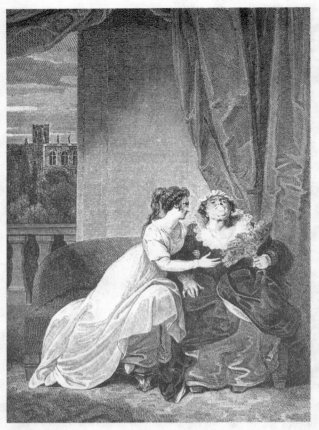

2

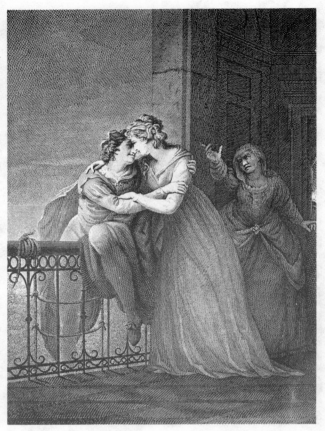

1

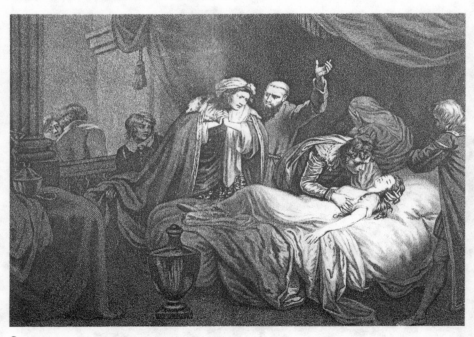

3

ROMEO AND JULIET  **1** Act II, scene 5. *Painter* R. Smirke, *engraver* J. Parker
**2** Act III, scene 5. *Painter* I. Rigaud, *engraver* J. Stow  **3** Act IV, scene 5.
*Painter* F. Opie, *engraver* J. Simon

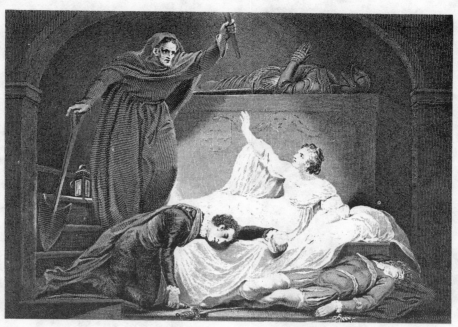

1

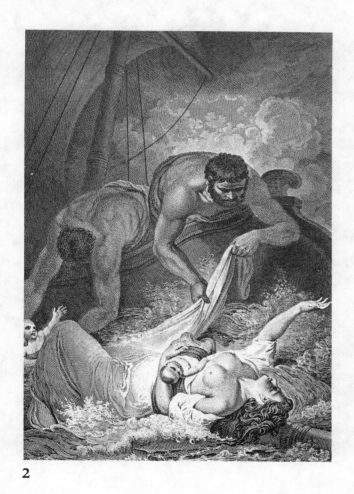

2

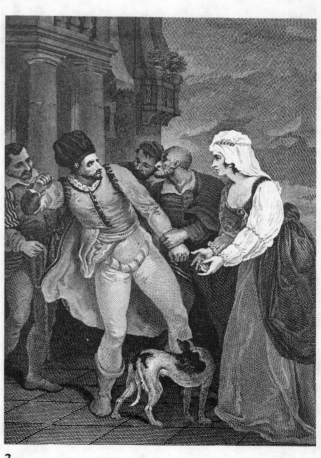

3

ROMEO AND JULIET   **1** Act V, scene 3. *Painter* J. Northcote, *engraver* J. Heath   COMEDY OF ERRORS   **2** Act I, scene 1. *Painter* F. Wheatley, *engraver* J. Neagle   **3** Act IV, scene 4. *Painter* F. Wheatley, *engraver* J. Stow

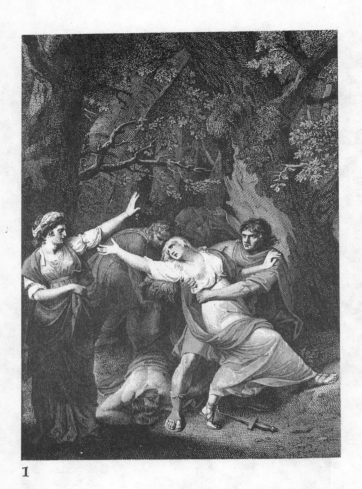

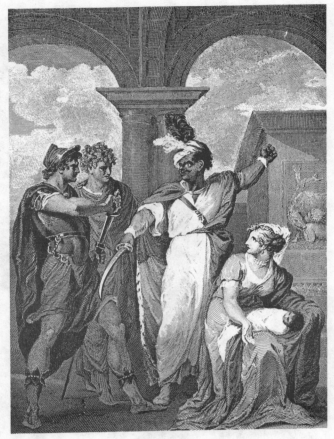

1

2

TITUS ANDRONICUS  **1** Act II, scene 3. *Painter* S. Woodforde, *engraver*
A. Smith  **2** Act IV, scene 2. *Painter* T. Kirk, *engraver* J. Hogg